Al Jaffee's
MAD
LIFE

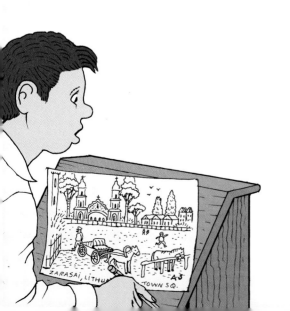

MARY-LOU WEISMAN

Al Jaffee's MAD LIFE

ILLUSTRATED BY AL JAFFEE

Colors for new illustrations
by Ryan Flanders
with Douglas Thomson

itbooks
AN IMPRINT OF HARPERCOLLINS PUBLISHERS

Grateful acknowledgment is made for permission to reprint the following illustrations:

Pages 166–67, from *MAD* #26 © 1955 E.C. Publications, Inc. All rights reserved. Used with permission. Page 190, from *MAD* #100 © 1966 E.C. Publications, Inc. All rights reserved. Used with permission. Page 191, from *MAD* #98 © 1965 E.C. Publications, Inc. All rights reserved. Used with permission. Page 193, from *MAD* #341 © 1995 E.C. Publications, Inc. All rights reserved. Used with permission. Page 194, from *MAD* #208 © 1979 E.C. Publications, Inc. All rights reserved. Used with permission. Page 194, from *MAD* #253 © 1985 E.C. Publications, Inc. All rights reserved. Used with permission. Page 195, from *MAD* #100 © 1966 E.C. Publications, Inc. All rights reserved. Used with permission. Page 196, from *MAD* #161 © 1973 E.C. Publications, Inc. All rights reserved. Used with permission. Pages 200 and 201, from *MAD* #102 © 1966 E.C. Publications, Inc. All rights reserved. Used with permission. Page 202, from *MAD* Special #7 © 1972 E.C. Publications, Inc. All rights reserved. Used with permission. Page 204, from *MAD* #172 © 1975 E.C. Publications, Inc. All rights reserved. Used with permission. Page 220, from *MAD* #184 © 1976 E.C. Publications, Inc. All rights reserved. Used with permission. Page 218, from *MAD* #501 © 2009 E.C. Publications, Inc. All rights reserved. Used with permission. Pages 222 and 223, from *MAD* #156 © 1973 E.C. Publications, Inc. All rights reserved. Used with permission.

HarperCollins books may be purchased for educational, business, or sales promotional use. For information please write: Special Markets Department, HarperCollins Publishers, 10 East 53rd Street, New York, NY 10022.

This book is not a *MAD* publication.

FIRST EDITION

DESIGNED BY KATE NICHOLS

Library of Congress Cataloging-in-Publication Data
Weisman, Mary-Lou
 Al Jaffee's mad life / Mary-Lou Weisman ; illustrated by Al Jaffee. — 1st ed.
 p. cm.
 ISBN 978-0-06-186448-3
1. Jaffee, Al. 2. Cartoonists—United States—Biography. I. Jaffee, Al. II. Title.
PN6727.J355Z94 2010
741.5'6973—dc22
 [B]
 2010005747

10 11 12 13 14 OV/RRD 10 9 8 7 6 5 4 3 2 1

For Joyce and

For Larry

THE CHILD
IS FATHER OF
THE MAN

WILLIAM WORDSWORTH,
"MY HEART LEAPS UP"

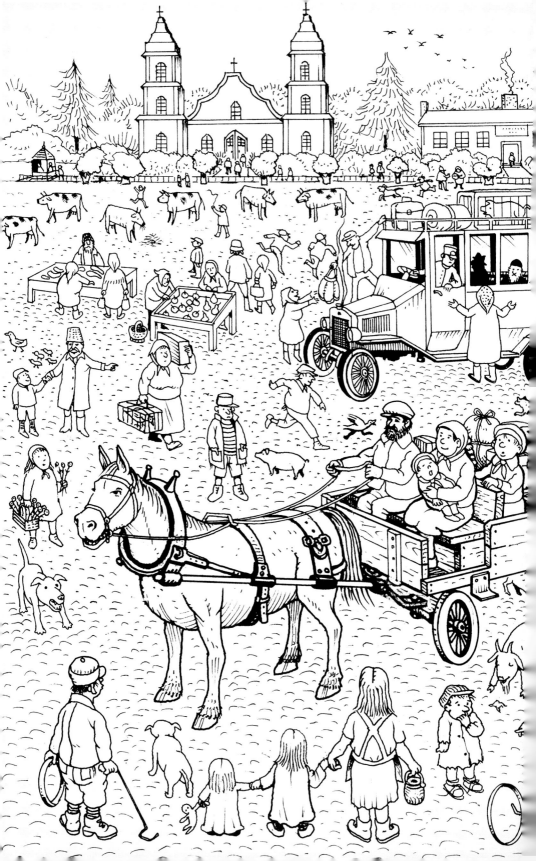

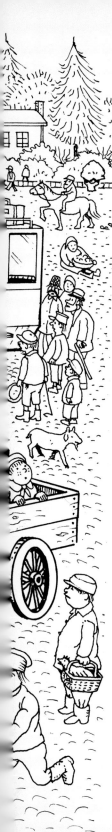

CONTENTS

Al Jaffee's
MAD
LIFE

PROLOGUE

"THE PLAUSIBLE IMPOSSIBLE" is a term of art unique to cartooning. It is what holds Bugs Bunny up when he runs off a cliff, traverses a yawning chasm, and continues running on the other side, completely ignorant of the terrible fate that, except for a magical, momentary suspension of the laws of gravity, should have been his. It is the guiding comic principle—at once thrilling and ridiculous—that lies at the heart of cartooning. This willing suspension of disbelief has a logic all its own. What keeps Bugs aloft, what makes the impossible plausible, is not looking down. It is a talent that eighty-nine-year-old Al Jaffee has displayed in his life as well as his art.

Al Jaffee enjoys a special relationship with the plausible impossible. For him it is more than a term of art; it is the story of his life. A résumé of Al's formative years reads like a comic strip of traumatic cliff-hangers, with cartoons by Jaffee and captions by Freud. Al was separated from his father, abandoned and abused by his mother, uprooted from his home in Savannah, Georgia, reared for almost six years in a Lithuanian shtetl, and returned to America—all by the time he was twelve years old. To this day, Al has a problem with trust. Everything is not going to be all right. "I experienced so much

humiliation that I became defensive about it. I am not trash. I am not garbage. Even homeless people, the lowliest of the low, have a strong sense of dignity."

Al wears his dignity like a carapace, a surprising cover, perhaps, for a man who finds so much about life ridiculous. "He is always a gentleman, very well mannered without being a stiff," says illustrator-writer Arnold Roth, who has worked with Al and been his friend for decades. Still, Roth notes, "There was always a certain sadness about Al. There were minor chords playing underneath. I knew nothing about the cause."

Nick Meglin, who was Al's editor and friend at *MAD* for decades, was stunned when he learned that such a funny man had emerged from such a sad and humorless childhood. "As a fan I'm as grateful as I am baffled that he did."

Unless someone asks, Al doesn't talk about his childhood—not the starved shtetl years in Lithuania or the indignities of living as a second-class citizen in other people's houses. "I don't volunteer the information. If somebody wants to know it, they have to get it from me."

His flamboyantly perverse youth has made him the man he is today—a satirist, an artist and writer, a raconteur, an arrested adolescent, and an alien—a person uniquely qualified to introduce young Americans to the world of adult hypocrisy in the pages of a magazine called *MAD*.

1
THE WILD INDIAN

"I was the terror
of the neighborhood."

AL REMEMBERS the day his childhood ended. He, his mother, and his three younger brothers had just disembarked from the boat that had taken them on a long ocean voyage. The journey had started when he said an angry, tearful good-bye to his father in Savannah and had ended in this big, scary place with the funny name—Hamburg. Was there a place, he wondered, called Hot Dog?

The Hamburg railroad depot was the biggest place he had ever seen. He was like Jonah in the belly of the whale, a hellish, frightening belly of soot, screeching metal, pumping wheels, and sulfurous coal smoke. Huge, dark engines crouched on the tracks, hissing and panting steam. A wilderness of rails ran out of the station until they were lost from view. If they followed one of these tracks far enough, Al wondered, would they lead to this place they were going called Lithuania?

Al had seen trains before, but never so many all at once. His father had always been with him in the train station in Savannah when they went together on Sundays to the Isle of Hope, an amusement park outside of the city. Al could remember standing with him on the platform. He could almost feel his father's hands resting

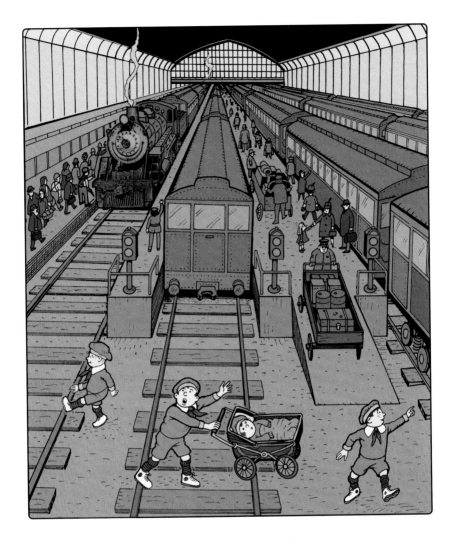

firmly on his shoulders, holding him safely in place, away from the tracks, while Al, thrillingly terrified, leaned against his father's knees and covered his ears against the thundering onslaught.

Where was his mother? Harry, his five-year-old brother, was running on the tracks. Bernard, two and a half years old, was waddling off in another direction. David, the baby, was screaming in his carriage. Standing on the platform, holding tightly to the handle of the carriage, Al didn't know what to do. Should he leave David and run after his brothers? Should he try to push the carriage through the crowd? Adults, exhausted and confused, labored under bundles

tied with string, lugged satchels, leather valises, and cardboard trunks, trying to find their place on platforms so long they seemed to lead to nowhere. None of these adults was his mother. He was paralyzed with fear.

"Mama!" he yelled. "Where are you?

"Mama!" he cried. "Come back!"

"It was chaos," Al remembers. "It is a moment that is as clear to me today as it was then. I realized that I must not rely on this woman for my survival. I must not. Either we are all going to get killed, or those of us who stay alert are going to survive, because she doesn't know what she's doing. I realized that she was irresponsible. That I knew better than she did. I knew I could not put my life in her hands. I knew I was on my own." Suspended between two worlds, he understood that this was no time to look down. Al was six years old.

The year was 1927. At a time when Jews all over Europe were trying to get to the United States, Mildred Gordon Jaffee, homesick for Zarasai, the Lithuanian shtetl from which she'd emigrated, decided to leave Savannah and take her four American-born children back to an increasingly anti-Semitic Lithuania.

Mildred Jaffee told her husband, Morris, who had also emigrated from Zarasai, that she was going for a brief visit to relatives, but she had probably never intended to return.

DOCUMENTS ARE INCONSISTENT about Morris's age when he first immigrated to New York's Lower East Side in 1905. He might have been as young as fifteen or as old as seventeen. He might have left Zarasai, as did many others, to keep from being conscripted into the czar's army. (Lithuania would not become independent of Russia until 1918.) A 1910 census lists his profession as a tailor. It is unlikely that Morris had plans at the time to send for Mildred Gordon, whose age, also listed variously in different documents, would identify her as anywhere from three to seven years his junior. They might have known each other in Zarasai, but their romance probably began in New York.

Morris Jaffee hit New York running. Al doesn't know what kind of work his father did in New York, but he was smart, well educated,

buoyant, confident, and ambitious. Already fluent in Hebrew, Russian, and Yiddish, he enrolled in night school and quickly became proficient in English. Although Jaffee was a small, frail man—no more than five feet four inches—his appetite for the challenges of the New World was immense. In a New York minute, he exchanged his black woolen cap for a dapper straw boater and set out to make this glitzy, noisy, crowded new world his own. He cheered for the Giants. He walked across the Brooklyn Bridge for the sheer joy of it. He had left a world lit only by kerosene, and now—he could hardly believe it—he stood basking in the lights of the Great White Way. Whenever he could afford it, he'd slip into the nickelodeon or the movies. His favorites were the Keystone Kops and Charlie Chaplin.

Mildred Gordon boarded the *Czar* in Libau, Russia's largest emigration harbor, and arrived in New York on December 9, 1913. According to the ship's manifest, which lists her name as "Michlia Gordon, daughter of Chaim Gordon," she was a twenty-year-old, five-foot-tall "Hebrew," a "tailores" with dark hair and eyes. She had twenty-two dollars in her pocket, the equivalent of almost five hundred dollars today. She listed her American destination as 305 Jackson Street, in the heart of the Lower East Side and the home of her cousin Morris Gordon.

Mildred's entry into New York City's Lower East Side was much more tentative than Morris's. She lived among her relatives, who, with the exception of her sister Frieda, one year her senior, consisted of great-aunts and second or third cousins from the provinces of Zarasai and Vilnius (Vilna in Russian, Vilne in Yiddish). Lithuania, as such, did not exist under the Russian regime.

However tenuous their relationships, they faced the stigma of marginality together. They shared a common language, Yiddish, and a common need to find lodgings, learn English, and make a living. Mildred went to night school and easily developed a fluency in English. She read and wrote beautifully. She took out books from the library. She loved the new language so much that in later years, when Al would make a grammatical error, she would slap him across the face. Frieda, who was an expert seamstress, probably secured apprentice work for her "tailores" sister. They stuck together in the vast, strange city, creating a tiny replica of shtetl life in which Mil-

dred Gordon must have felt safe. She might even have been happy. The relatives with whom she lived described her as cheerful, a clever mimic, and full of fun.

Mildred was eager to marry Morris, but her plans were frustrated when, in 1917, Morris was drafted into the army and sent to Yaphank, Long Island, for training, and then on to Europe. Morris persuaded Mildred to wait and see if he returned. He almost didn't. He was captured and held under near-starvation conditions in a prisoner-of-war camp in Germany.

Morris Jaffee abhorred violence so much so that he didn't even like to join in conversations with other men about the fighters Max Schmeling or Joe Louis. He was interested in politics and social issues. He was a liberal, a New Dealer. "My father was proud when the governor of New York was Herbert Lehman, but he was just as condemnatory of Jewish crooks. 'We're going to get hell for these guys,' he'd say." He would show Al his uniforms and medals. He would let him wear his kepi, but he refused to satisfy his son's little-boy lust for blood and guts. "When I asked him, 'What did you do in the war, Daddy? Did you shoot Germans? Did you kill lots of Germans?' he would answer, 'No, no, no. I was out shooting lions.'"

After his army discharge, Morris and Mildred married on June 19, 1919, in the Bronx and moved to an apartment on Bathgate Avenue. Their marriage certificate lists her name as a more Americanized "Milly." At about this time, Morris passed the civil service exam to qualify as a postal worker. Shortly thereafter, he learned through the Jewish grapevine that wound its way from Savannah to New York City that a Mr. Blumenthal had sent word north that he was looking for an "honest, young, Jewish man, preferably married," to run his Savannah pawnshop. It was common in those days to recruit young Jewish men from New York because southern Jewish businessmen didn't trust gentiles or Negroes as employees. Morris applied for the job and was hired. Morris and Mildred moved to Savannah, where, a year later, on March 13, 1921, Al (né Abraham) was born. Morris rented a house at 120 West Taylor Street, in a pleasant, if modest, part of town. Morris was such a success at the pawnshop that he was soon given the job of general manager of S. Blumenthal and Son, one of Savannah's leading department stores.

Al remembers his father as having two personae, with accents to match. "It was the most amazing thing. In New York, he spoke English with a New York accent and not a trace of Yiddish. Once in Savannah, he spoke English with a southern accent. He quickly became a member of the Shriners and the Masons. He couldn't wait to do the American thing.

"My father was a dandy. He walked around like he was on top of the world, and he was. Everybody bowed and scraped to him. He felt like a million bucks. My father was very, very eager to join the twentieth century. My mother was very happy being drawn back into the nineteenth. She was suspicious of modernity. She feared that eating salted butter could make her family sick. She knew that in Zarasai when butter was spoiled, merchants added salt to cover up the rancid taste. My mother was hopelessly attached to the Old World."

Mildred Jaffee—scrupulously religious—never got used to life in Savannah. Immigrating to New York City turned out to have been the easy part. Leaving the cocoon of the Lower East Side and moving to Savannah may have contributed to Mildred Gordon's undoing.

Although most people think of Charleston as the most "Jewish" of southern colonial cities, Savannah was just a few years behind, having established a synagogue, Mickve Israel, in 1735. By the time Mildred got to Savannah, Mickve Israel had become a Reformed temple, so "goyish" that Mildred wouldn't be caught dead there. The so-called Orthodox synagogue, B'nai B'rith—with its Moorish architecture and stained-glass rose windows, no less—bore no resemblance to her wooden shul in Zarasai. She attended but found little comfort or sociability there.

It didn't matter that she had traded the dirt streets, the outhouses, the lack of running water, and the long, freezing winters for a middle-class life in a white clapboard house on a pleasant, tree-lined street in Georgia. What mattered was that the Negro maid kept mixing up her milchig (dairy) and fleishig (meat) dishes. What mattered was that she missed the ghettoized Jewish life she had known in Zarasai and on the Lower East Side.

Al's mother had a lot of rules about what she would and would not tolerate. Morris, who was making good money, wanted to take driving lessons and buy a car, but Mildred wouldn't hear of it.

"Perhaps my mother had a genuine fear that my father would not know how to handle this newfangled machine and that he would kill us all. Automobile accidents were frequent in the 1920s. Nobody knew what traffic was. My mother trusted horses and wagons, not Model T Fords. Horses had enough sense not to bump into one another. Maybe that's what it was."

Mildred Jaffee could never come to terms with the fact that her husband's job at Blumenthal's department store required that he work on the Sabbath. Her fear of *trayf** kept her and her family from accepting any dinner invitations, including those from her husband's boss, Mr. Blumenthal, even though the Blumenthals themselves kept kosher. Al can't remember any social life, either inside or outside of their home. "If my mother would have given and attended parties, my parents could have become part of the southern Jewish semi-aristocracy, and I'd be the scion of a very nice family in Savannah by now." As scrupulous as Al's mother was about certain religious practices, Al doesn't think she qualified as an Orthodox Jew. She didn't shave her head, but Litvak women did not always shave their heads. *Sheitels*[†] were expensive, and many women might have preferred to wear a scarf. In other respects Mildred was clearly a nonconformist. "If she was totally religious, we would have had to wear yarmulkes when we ate, and we didn't; we only wore them in shul. She walked long distances on the Sabbath, when only short distances were permitted. In all matters religious and secular, my mother did as she pleased."

That her husband loathed the very rabbis that Mildred Jaffee revered had to have been the greatest source of conflict in the Jaffee household. Al's father would go into protracted and frequent rants against them. "They get free room and board. They're supported in luxury. They're a bunch of monkeys and freeloaders. I have no respect for any of these thieves."

"For all my mother's religious beliefs," Al remembers, "we were all born in a Catholic hospital, Saint Something or Other. My father says the nuns so respected her wishes that they covered up the crucifixes in her room and helped her to light candles on Friday night.

* Nonkosher food.
† Wigs.

"Our travels were no less eccentric. On the steamship to Hamburg, she demanded of the captain, 'Stop this boat, it's sundown.' There she was, with a lace doily on her head, trying to light the Sabbath candles in a dinky stateroom on a ship that was rolling from side to side in the middle of the Atlantic. It was madness."

THE MADNESS ONLY INCREASED on the next leg of their journey, the train trip from Hamburg to Berlin and then from Berlin to Memel. Fifteen minutes before the train was to arrive in Berlin, where they were to connect with the train to Memel, the conductor passed by Mildred Jaffee and her brood to encourage her to get them ready to leave the train.

"Shh, I have sleeping children," Al remembers his mother saying. "Do you expect me to wake up my children because of your timetable? When my children wake up, we'll get off the train."

"I was apoplectic. I pled with her. 'Mom, you gotta get off,' but

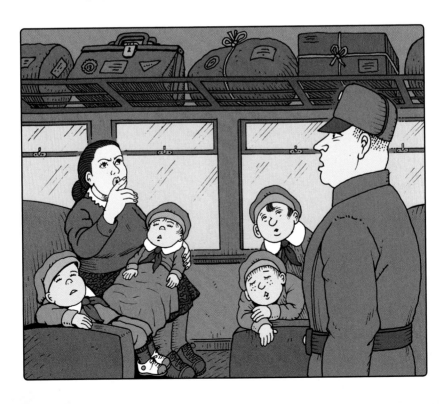

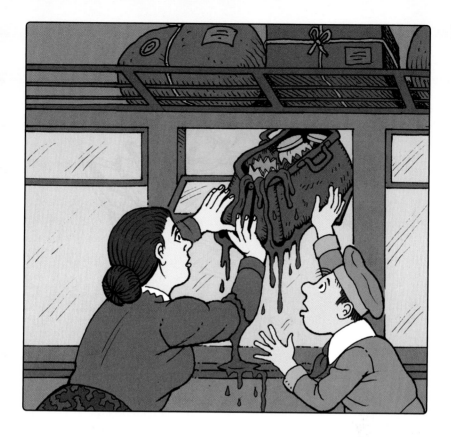

she let my brothers sleep until the train stopped. Then she turned to the conductor and told him that he couldn't start the train until she dressed her children and got them off. The conductor was going crazy. I didn't know whether to get off the train or to wait with her. My mother insisted on her way. She was very strong. She was never terrified. She terrified others. She had no sense of embarrassment about demanding what she wanted."

In addition to the many pieces of luggage that traveling with four small children required, Mildred Jaffee brought with her on this difficult and long journey four small Torahs* and a cardboard satchel filled with jars of homemade jam. En route from Berlin to Memel, the satchel fell from the overhead rack and broke, spilling shards of glass and gooey jam.

* Scrolls containing the first five books of the Hebrew scriptures.

"My mother didn't cry over spilt jam. We just threw it out the window, as we did with the dirty diapers." Why Mildred Jaffee was bringing jam to Zarasai, a place where she knew all kinds of fruits and berries grew in abundance, is a coals-to-Newcastle mystery, matched only by her insistence upon shlepping the Torahs, one for each of her children, to Zarasai, where, as Al puts it, "they already had enough Torahs, even for the gentiles.

"If you were to see some naked guy sitting on top of a mountain somewhere in India, with pins stuck into his body, how would you know whether the guy was nuts or religious? My mother was both."

Like many mothers living in America in the 1920s and beyond, Mildred Jaffee believed that castor oil was the dose of choice for growing children, but she believed it with a vengeance. "We had to get our daily castor oil. She would line up the three of us, Harry, Bernard, and me—not David, the baby. Bernard was only about one and a half, but he could stand, so he qualified. One day I said to her, 'I'm never taking any more castor oil. You can kill me.' The next time we were lined up, she turned out the lights and said, 'If you don't take your castor oil, you're going to have to face the witch that's in the closet.'"

"There *is* no witch in the closet, and I'm *not* taking the castor oil," Al shot back. But there *was* a witch in the closet. Al's mother had gone to the maniacal trouble of fabricating a life-sized witch, dressed in black, wearing a hideous, snaggletoothed Halloween mask. "She opened the door and shined a light on the witch, and I took the castor oil." The adult Al thinks of this incident as the original bathroom experience, the first of many scatological episodes that would influence his comic art to such a degree that he would become known as *MAD*'s "cocky-doody" artist. "There's an awful lot of cocky-doody in my life, starting with my mother's castor oil campaigns down the alimentary canal and ending in the outhouses of Zarasai. It's been sort of embarrassing until recently, when I read a glowing review of a new book about how the world is threatened by rising levels of excreta that make global warming innocuous by comparison. So maybe I was a visionary after all."

But for all her eccentricities, Mildred Jaffee was not the immigrant, stay-at-home babushka one might imagine—certainly not in

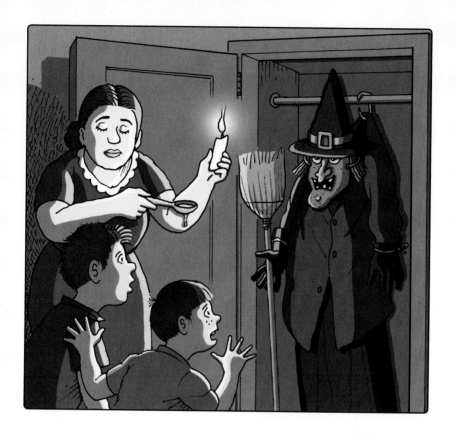

Al's eyes. "It seemed to me she was a normal mother. She had a trea-sured sealskin coat. She wore the fashionable chapeaus of the time. We did normal things in Savannah: we ate watermelon, salted pea-nuts, and Cracker Jacks. We bought ice cream from the ice-cream truck." Al remembers going to the movies with his parents. "Every-one was crazy about Chaplin except me." Al was frightened by Chap-lin's comic violence. When Charlie bopped someone over the head with his cane, a terrified Al yelled, "Get me out of here!" "I ruined all their movies."

"I knew there was humor in my mother. She was a wonderful storyteller. When she was in a good frame of mind, she could be very tender and affectionate, at least verbally. She would use English superlatives. 'Oh, my dearest darlings, what have we done today?'" But he doesn't remember hugs or kisses. "Having four children in six years will tax anyone.

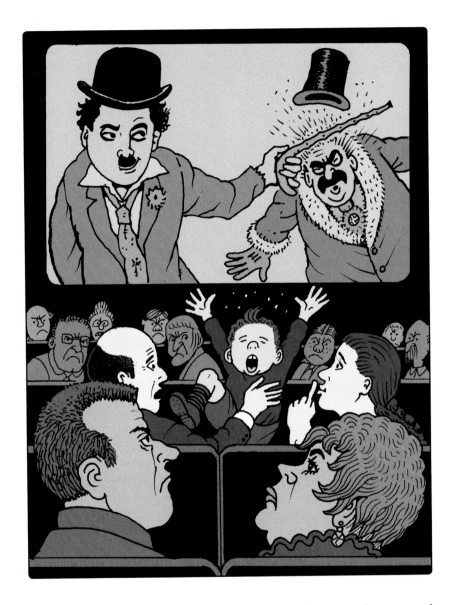

"She read to us. She taught us the Ten Commandments and lessons about right and wrong. She told us never to laugh at people who are crippled and to feel sorry for the poor.

"She was smaller than my father, and trim. I thought she was beautiful. She was like a star. All the photos I have of her show her with her brunette hair falling down to her waist. Her hair was her

glory. She braided it when she went out. Later, she sold her hair in Zarasai to get money."

Al's mother loved to sing. One might expect that Mildred Jaffee would soothe herself with liturgical melodies or folk songs from Zarasai, but in fact her favorite was a popular, romantic American tune, "When I Get You Alone Tonight."

> *All of my life they told me I'm wrong,*
> *I thought they were right, but then you came along,*
> *I finally believe, and now I can see,*
> *I was right all along, and it brought you to me.*

"To this day, the melody runs through my mind," says Al, "like *Citizen Kane*'s Rosebud."

Other than Zarasai—and subsequently, and in short order, four sons—Mildred and Morris Jaffee seemed to have little in common, yet Al believes that his father was "madly in love" with his mother. He vividly recounts two fragments of memory. Al was about three years old, seated on the kitchen table, naked, drinking a glass of milk. His parents were talking and laughing. "I sensed that they were having a laugh about my genitals. It pleased me to see them both happy." At another time, he caught a glimpse of his mother bent over the bathtub, scrubbing his father's back. "I don't remember much else about them being happy together." Mostly what Al remembers is a house wracked by constant, loud arguing, in English, and mostly about religion.

"My mother got my father to do what she wanted, and when he didn't, he caught hell. Her *mishegoss* with religion was something he was not going to be able to penetrate or prevent. If he was going to have any kind of peace in the house, he would have to go along as much as he could. The reason I could be found wandering all over town might have been because I didn't find it too pleasant being home."

If Morris Jaffee did everything he could to avoid conflict with his wife, Al seemed hell-bent on doing everything he could to invite it from his mother. As a child Al was, by his own description, an "adventurous

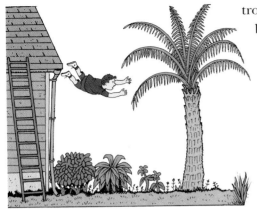

troublemaker. I got attention by being mischievous. It was my way of being creative, of being noticed. I was the apple of my mother's eye until the other kids started coming. Then I wondered, 'What the hell's going on here?' I figured nobody gave a damn what I did, so I went out and did crazy things.

"I was having a great time being the terror of the neighborhood. I was out playing, making trouble for myself and others. I didn't have a bike or skates. I was perfectly happy with a stick or a rock—anything I could lay my hands on. I was curious. I did all kinds of idiotic things like throwing various objects out of windows to see if they would bounce. I knocked out my front teeth trying to fly from the roof of my house to a neighboring palm tree."

The Jaffees lived in four different rented houses in Savannah. The move from the second house, on East Thirty-ninth Street, to the third, on the second floor of a two-family antebellum house on West Gaston Street, near Forsyth Park, was Al's doing. "My mother was extremely modest. Once, when she was nursing one of my brothers in the bedroom, she posted me on guard duty at the head of the stairs with instructions not to let anybody in." Al's mother undoubtedly intended Al to protect her privacy by politely turning away any visitors, but when the landlord's representative came to collect the rent, Al, ever the confrontational overachiever, told her, "You can't see my mother. If you come up here, I'm going to kick you down the stairs." In response, the landlord kicked out the Jaffees. "I was about five years old, still in my American tough-guy mode," says Al. That would change the first day he set foot in Zarasai.

When Al was hardly more than a toddler in Savannah, his play-time frequently concluded with the wail of a siren. While walking in the park one day with Harry, Al spotted a pile of burning leaves.

"Harry and I got into a discussion about whether or not the fire was hot. I don't know what devilish impulse got into me, but I talked Harry into finding out by sticking his hand in the bonfire. That didn't make me too popular at home."

He lit a fire in an abandoned store across from a fire station because he had promised his little friends they could see the fire engines come out. "So I got them all into the store and set a bunch of papers on fire. We all sat there with the fire and smoke billowing all around us, and of course the fire engines came out. My father got called at Blumenthal's. He had to come home from work and contend with the neighbors. Something like that happened once or twice a week. I'm probably one of the reasons he eventually lost his job. If it wasn't my mother calling him, making some unreasonable, hysterical demand, it was me." In spite of his tenuous hold on his job, on Saturdays Morris Jaffee would give Al and Harry free run of Blumenthal's third-floor toy department. "That must have been a big bone of contention with my mother. How she allowed us to go there on the Jewish Sabbath I don't know. Maybe her excuse was that we were underaged for committing sins." Morris would send James, the store's handyman, to pick up Al and Harry and ride them back to Blumenthal's on the handlebars of his bike. James wore a fedora hat. "In retrospect it seems impossible that two little boys could ride on his handlebars at the same time, but we did.

"My father would take us up to the toy department and leave us there. We ran amok. After we'd wrecked half the toys, we'd examine them and then go home and figure out how to make them even more interesting. Later, in Lithuania, we built toys out of scrap wood that dazzled all the shtetl kids."

Trips to Blumenthal's sometimes meant a chance to see the man who pulled taffy. "He sat in the store window facing out onto the main street, churning and pulling, attracting passersby into the store. I remember my father bringing me there to watch

him do his shtick. But as often as not, when I ran to the window, the taffy man wasn't there. My father took the time to explain to me that the taffy man was very nice but that he was an alcoholic. That meant that he'd go on what my father called 'binges,' alternating two weeks of working with two weeks of drinking. Of course, he must have been profitable to the store in spite of the binges. Still, the fact that we were living in the uptight Bible Belt and that my father wasn't judgmental, didn't discriminate against this man or punish him in any way, and instead showed him generosity and understanding, impressed me. Of course, I wasn't analyzing it then the way I am now, but I remember being filled with the warm, proud feeling that my father was good.

His mother's temperament was volatile and often punitive. "She didn't take a belt or a stick to me, but she would smack me hard. My brother Harry says he couldn't stand seeing how much she beat up on me, but I thought it was part of our relationship. She gave me instructions about what she wanted me to do, and I either disobeyed or got carried away by my fantasies and forgot. I did things wrong and she hit me. At the time it seemed like a reasonable quid pro quo. After all, she had a lot on her plate—four kids under the age of six. To keep this menagerie together would drive any woman crazy.

"By contrast, Harry was obedient and demure. He was very needy—much more than I was. He would hug her around the knees. I'd sass her. I'd stick my tongue out at her, and she'd slap me across the face."

"I can't control you," she'd complain. "You're a wild Indian." It's a title Al relishes to this day, because it confirms both his bona fides as a "bad boy" and his mother's reluctant affection, and perhaps even respect, for his defiance.

Al sees his cartoon career as beginning in Savannah, where he was drawing recognizable cartoon characters, while other five-year-olds could barely make stick figures. "Any white wall was fair game. It never occurred to me that anybody treasured white walls. I filled all the margins of books with my little cartoons, too. I remember getting a pretty sound beating for doing that to some of my mother's religious books—*Maggie and Jiggs* meets Genesis.

"The creative impulse must have been in me all my life. Being destructive is being creative," Al insists. "After all, geniuses create atomic bombs. Wanting to see how fire trucks come out of fire-houses is, I think, a pretty cre-ative impulse. When I get these crazy ideas now, I control them, but when I was a kid, I put them into practice."

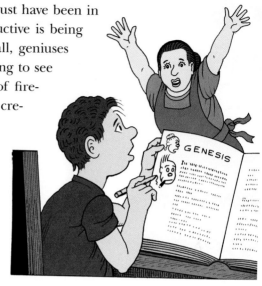

Actually, Al doesn't con-trol them. He puts them into cartoons. He tries to be serious—he thinks of himself as a very serious person, a brooder, even—but he can never completely black out the animated antics of the bad kid who is perpetually acting out in his head. In fact, when he's working in his studio, he'll get up from his drawing table and act out the cartoon frame by frame. "If anybody ever saw me, they'd think I was crazy." Long before the concept of the "inner child" was even a glimmer in pop psychology's eye, Al Jaffee was in constant touch with his.

For the first six years of his life, when Al was in Savannah, he could rely on his playful and indulgent father to provide him with affection, attention, and special treats. "Father was fun. He took me and Harry places. He was 'old European' in that he didn't kiss us, but he picked us up and carried us and took us for walks in the park." It was on one of these walks in Forsyth Park, amidst a profu-sion of pink azaleas, palm trees, and live oaks swagged in Spanish moss, that Al's father took him to meet the man who would be Al's first superhero, whom his father named "Fartman." Hardly a high-concept character, Fartman was a fat, uninhibited man in a straw hat who sat on a bench near the gloriously ornate two-tiered foun-tain, a replica of the one in the Place de la Concorde in Paris, and demonstrated to interested passersby how to fart at will. "He would challenge me to do it. Then he'd rip off another one. My father

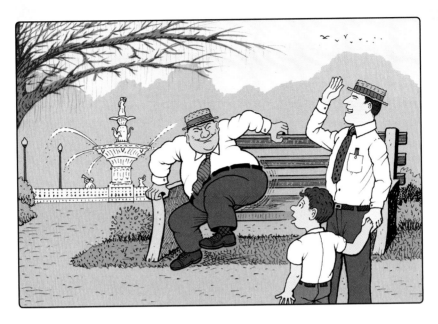

would laugh hysterically; my father was very loose about bodily functions. We'd go to the park often, and Fartman would perform.

"My father was always taking us places. He once took us to an airfield where they had a barnstorming show. There was no fence, so you couldn't charge admission, but they must have made a few bucks taking people up for rides. We wandered around, looking at the planes. My father had us both by the hand—maybe we were walking home—and we heard this roaring noise. My father looked back and there was a plane coming in to land. My father threw us both to the ground and lay down on top of us, with both arms around us. The plane came right over us and touched down a hundred feet away. We weren't really in danger, but it was scary as hell. My father was more shaken up than anybody."

One of Al's favorite destinations was an amusement park on the Isle of Hope on the Skidaway River, a seven-mile train ride from Savannah. "I thought it was one word, 'Ilahope.' My father took us on rides—nothing dangerous like the Loop-the-Loop, but I know we went on a merry-go-round. I remember my father standing next to me when I was on the horse and then next to Harry while I waited. It was a beautiful outing. There was plenty of popcorn

and hot dogs. We wouldn't let my father take us home until he got us a hot dog. He made us promise that we would not tell our mother what we had to eat, but I couldn't control myself. 'I'm not supposed to tell you I had a hot dog,' I'd tell my mother. I covered all bases. My father used to curse me out for years afterward. 'The minute we got home, you couldn't wait to tell her you had a hot dog.' He was feeding pig to her kosher children. I may have had some guilt about her eventually leaving my father; I don't know."

Why did she do it? Al will try to answer that question for the rest of his life. "Taking four little kids back to Lithuania with no schedule for bringing them back to their home in America is cuckoo. But if you give her the benefit of the doubt, perhaps she had some plausible reason for wanting to get away. First she got traumatized going to Savannah. Then she got traumatized having a baby every year and a half. In leaving Savannah, she was not only leaving a world she didn't fit into, but maybe she was also escaping the projection of what her life was going to be like if she kept having babies. Ironically, my father was bitterly critical of his own father for the endless pregnancies that prematurely killed his beloved mother. I think there's a tie there. The way things were going, perhaps my mother thought that would be her own fate.

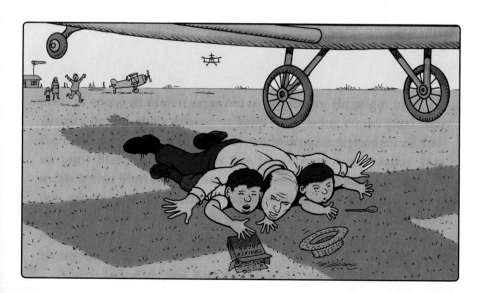

"If religion is anything, it's expedient. You can't have an abortion, you can't use contraception, and you can't deny your husband his conjugal rights—they're probably all sins in the Bible. I can identify with her wanting to get away from constantly being pregnant. If I were that woman, I'd be in East Timor, or as far away from my husband as I could get."

At the end of every working day, Al could be found at the front door, waiting to greet his father with a big hug. Morris would bring the newspaper home and read the comics to Al and Harry. But the best day of Al's week was Sunday; that was when a week's worth of brief evenings with the funnies would crescendo into a full day of cartoon fun. First their dad would narrate the funnies, pointing to each panel of *Bringing Up Father,* or *The Katzenjammer Kids,* exploding the balloons above each cartoon character's head into meaning and laughter. But what enthralled Al even more was his father's ability to draw each character perfectly.

Morris Jaffee had a small but spellbinding talent. He was not a creative artist, but he could make exact copies of almost anything. He seems to have passed his artistic talents to his two older sons and his specific aptitude for replication to Harry. "Harry was very bright and talented. Even as a little boy he could draw everything I could draw. Sprawled belly-down on the floor in the parlor with my father, drawing cartoons all day Sunday—you couldn't beat that. My father would take a piece of paper and put it alongside one of the cartoon characters. He would lean forward and meticulously copy them all—Maggie, Jiggs, and Boob McNutt. I was mesmerized, absolutely mesmerized. The magic of cartooning was overwhelming to me. I fell in love. It was magic. It was absolute magic. I drove my father crazy, asking him to draw those characters over and over again.

"My father copied all the cartoons with a massive orange Parker fountain pen. You could get a hernia lifting it. It's still being sold today as a classic. He must have gotten it as a gift from Mr. Blumenthal, the way a big executive or a rich bar mitzvah kid would get a Rolex today. It was the Rolls-Royce of writing instruments." Al would plead with his father—"Let me make magic with it"—but his father constantly put him off. "No, no. When you're older." "And I'd plead

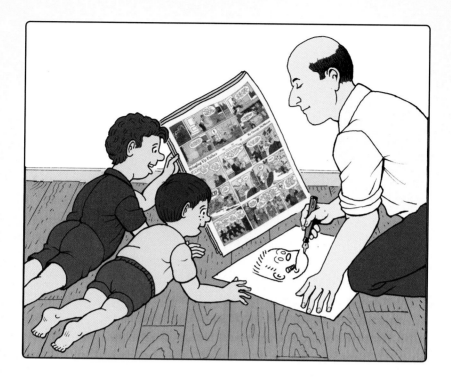

some more. 'Why can't I try it now? I want to make pictures like you're making.' He kept pushing me away with one excuse after another. 'You're too young for such a delicate instrument. There's ink in it. The ink will run out. Someday you'll inherit it.' But I never gave up. I pestered him to death about it."

AL DOESN'T REMEMBER precisely when his mother took him and his three brothers to Zarasai, only that he was six years old. He recalls something about being "shlepped on a very hot, steamy, southern day on some public conveyance to have our pictures taken, probably to get a passport." What he does remember emphatically was that he did not want to leave Savannah. "I was in a semi-hysterical state. I know I carried on, alternately crying and yelling at my father, asking him questions I cannot answer to this day. 'Why are you letting her take us? Why are we leaving? Why are you sending us away? Why aren't you coming with us?'

"He probably tried to reassure us. He must have picked us up individually and hugged us good-bye. 'Don't worry,' he said. 'Everything will be fine. Your mother is coming back in a short while.' But what does 'a short while' mean to a six-year-old boy?' I was livid with rage."

Al could not have known that this visit to a place called Zarasai would separate him for years from his happy, ritualized 1920s American childhood, the comfort of his home, and the protection of his father. What he did know was that he couldn't imagine life without the funnies. As he said good-bye to his father, Al managed to impress him with a single, desperate plea: no matter what, he must not miss the installments. " 'If you don't send us the comics, I will never speak to you again, I won't love you again, I'll never talk to you again.' All my carrying-on must have broken his heart. He didn't want us to go either."

Nevertheless, they left. And in spite of his anger and sorrow, Al's sense of adventure reasserted itself. "I was a free spirit on the boat. I don't even think Harry trailed around with me. I knew every part of that steamship. I went down to the engine room on my own. I went on deck. I sat on deck chairs next to people and chatted them up. I stuck my nose into everything." He was missing so often that search parties were sent out to find him. "One day, when I was killing time, *shpatziring** the ship, I walked past a deck chair on which an older gentleman was resting. There was a book underneath the chair, and on top of the book lay an orange Parker pen. I think I circled the deck five times, trying to figure out how to get my hands on that thing. Eventually I determined from the funny noises he was making that the man was fast asleep. I got down on my knees, grabbed the pen, and took off.

"I guess I must have had pangs of guilt, because I never used the pen. Ever. Maybe I was troubled by my mother's admonitions about 'Thou shalt not steal'—although that didn't seem to bother me when I was stealing fruit in Zarasai just a few weeks later—but the pen was somehow tainted. I put it away among my treasures, prom-

* Strolling around.

ising myself that I'd someday make magic with it, but I never did. I have no recollection of putting ink into it or using it. Eventually the pen just disappeared from my life. I think by stealing the pen I was sticking it to my father. 'You always promised that someday I'd get that pen. Well, now I'm going away and I'm never coming back, and you'll never get it for me, so I'll get it for myself.'"

2

WOLVES, BEDBUGS, AND LICE

"We were hungry all the time."

THE JOURNEY FROM SAVANNAH to the Port of New York, to Hamburg, to Berlin, to Memel to Kaunas to Zarasai, covered more than six thousand miles on sea and land and consumed more than three weeks, but effectively it transported Al, his mother, and his brothers from the twentieth century back into the nineteenth. The last leg of the trip—184 kilometers in a boxy, rickety bus on a gravel road, took them from the capital, Kaunas (Kovno in Russian), to Zarasai, a town just four kilometers south of the Latvian border and fourteen kilometers from what Lithuanians preferred to call "Polish-occupied Lithuania." Al remembers the trip as "an endless and fearsome journey."

At the time of his traumatic arrival in the spring of 1927, Al was in no mood to appreciate the evident beauties of Zarasai. The town sits on a hill plateau, surrounded by two lakes and a stunning topography of hills and valleys covered by dense forests of virgin pines and white birch. There is snow on the ground from October to April.

Present-day Eastern Europeans think of the town, with its current population of about eight thousand, as a spa destination. The 1939 Baltic Winter Olympics were held in Zarasai. Tourists call the town "the Switzerland of Lithuania." The locals call it "the Siberia of Lithu-

ania" because of its remote extreme northern location, where the temperature often reaches minus twenty degrees Fahrenheit. "Freezing to death" was more than a vain threat in Zarasai. Often a drunken peasant, returning home from market day across the frozen lake, would fall asleep and be found dead in the morning. But both tourists and locals agree that the region is spectacularly beautiful. So did Czar Nicholas I, who, in 1836, was so impressed by Zarasai that he ordered its name changed to Novo-Aleksandrovsk in honor of his son Alexander. That little bit of imperial presto change-o mattered little to the Jewish population, who continued to call the town by the name Ezerenai, linguistically derived from the word *lake*. It wasn't until 1929, two years after Al, his mother, and his brothers arrived, that the town's original Lithuanian name, Zarasai, was restored.

Centuries of warfare and shifting alliances in the region—dominated primarily by Russian influence—had taken their toll. The Poles still hated the Lithuanians, and the Russians still hated the Lithuanians and the Poles, which might be why, for the most part, they left the Jews alone. That relative détente would change with breathtaking speed in 1941 when the Nazis marched into Lithuania and found the Lithuanian partisans rabidly eager to participate in making Lithuania, by the war's end, a near record 95 percent *Judenrein.**

Mildred had left a czarist Russia and returned to what would be a brief "golden age" of Lithuania. Prospects for Jews, who had been strong supporters of Lithuanian independence, had never been better, but independence had not done much for commerce or modernity in Zarasai, since its eastern and northeastern neighbors were annexed by Latvia and Poland, and Zarasai was left without its business and trading partners. In between the two wars, the population of the town (Jewish and non-Jewish) had decreased more than 50 percent, from roughly 9,000 to 4,200, one-third of them Jewish, most of them poor, as many of the residents abandoned Zarasai and moved deeper into Russia. Some never returned.

Although there was no formal ghetto, except for a few friendships between gentile and Jew, segregation was total. Some of the streets in Zarasai were Polish, some German, Jewish, or Lithuanian.

* Jew-free.

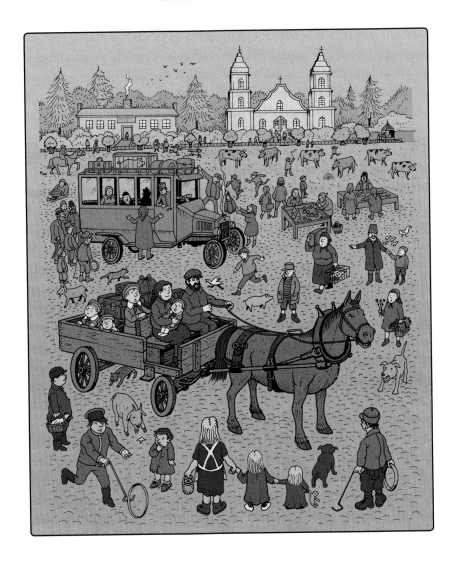

Al would soon learn that he was a second-class citizen, much as the Negroes were in his native Savannah. He had to be careful when he ventured into the wooded areas of town. "We never knew when a group of gentile kids would clobber us over the head with a stick, and there was nothing we could do about it. Even as kids we knew we couldn't complain to the police. For me that was a stunning realization. In Savannah the police were my friends. I used to seek them out and chat with them. In Zarasai, when we saw a policeman, we went the other way."

Still, in 1927, when Al and his mother and brothers arrived, anti-Semitism in Lithuania was benign compared with that of its neighbor Poland. But politics didn't much interest Mildred Jaffee.

It was near nightfall by the time Mildred wrestled her ragged, exhausted, and bewildered brood off the bus, along with their battered baggage, and into the vast marketplace of Zarasai. Here she stood at last, on the main commercial street, called the *chaussee*. (The Russian aristocracy's passion for the French language had made its impression even in remote Zarasai.)

What she saw was that, in spite of the tumult of the recent past, not much had changed since she'd left thirteen years earlier. Cobblestones the size of bread loaves, painful to walk on unless you were wearing shoes, still paved the square. She and her friends had preferred to play on the dirt streets during the brief summer months.

The arrival of the Kaunas-Zarasai bus was a big event that drew a large crowd of townspeople. Some were curious to see who was arriving; others gathered to bid farewell to those who were departing.

Even though it wasn't a market day, an enterprising merchant or two had set up stands, while children played and animals scampered about. Off in the distance Mildred could hear the once familiar lowing of cows as they wandered freely through the marketplace on their return from pasture.

The two white spires of the Lithuanian church created a monumental contrast with the primarily humble, darkly weathered wooden houses of Zarasai. The clapboard buildings with their steep mansard roofs, the better to shed the snow, lined one side of the marketplace, punctuated by the occasional brick or stone structure of the wealthier citizens. Before she left for America, most of these buildings were owned by Jewish merchants who lived above their stores. The poorer Jews lived down the hill, near the lakes. The Lithuanians, most of them peasants, owned the vast farmlands that surrounded the town. They cleared portions of the forested, sloping hillsides for their orchards, flax, wheat, and corn. During the daylight hours, a mill ground flour for the local merchants and farmers. The mill was powered by a waterwheel, turned by water cascading twenty feet from the lake.

In the dying light, Mildred Jaffee could read the crude signage on the hardware store, the apothecary, the liquor store, the seed store, Botwinik's photography studio, the grocery, the bottle shop, and Chavke die shmate's (Chavke the ragpicker's) used-goods emporium. She noticed that the wealthy widow Broiman's galoshes-and-refreshment store had a new tin roof, an indication in a town of many thatched roofs that she must be doing very well for herself. There was the hospital, the park, and the promenade, with its double row of shade trees, where she remembered as a young girl watching couples stroll on Sundays. Near the promenade was a row of white cement civic buildings, including the jail and the police station, where every morning several policemen in Napoleonic scarlet-and-blue uniforms, carrying sabers and wearing plumed top hats, would march and drill. Weary as she was, it felt good to be home.

The children had not bathed or had a decent meal since they'd stayed with a clutch of relatives on the Lower East Side in New York City while waiting for the boat that would take them to Hamburg. Nor had the Jaffee children changed their clothes. Al was anachronistically if shabbily dressed in the current young American boys' fashion of the 1920s, what Al called his "little-darling outfit"—velvet Lord Fauntleroy short pants with matching jacket, a once-white blouse, and a wool tam-o'-shanter hat.

Mildred Jaffee, true to her chaotic nature, had not bothered to inform her father, Chaim (Hyman) Gordon, that she and her four children were returning to Zarasai or, furthermore, that they were planning to stay with him until they could find permanent lodgings.

As a result, there was no one to meet them, but she had counted on the fact that one of the drovers with their horses and wagons would meet the bus, in the hope of picking up some business, and soon enough one happened by. Al gripped the back of the wagon's wooden seat as it lurched and bumped out of the marketplace and onto a dirt road that would take them half a kilometer to the house of a man he had never met, called Grandfather. He watched as the primitive, sharp-roofed buildings that lined the marketplace grew ever more gaunt and cheerless in the fading light and then disappeared from view. He heard strange, plaintive cries in the distance

and asked his mother what they were. She told him they were wolves.

"Like the wolf in 'Little Red Riding Hood', only lots of them?"

"If you don't bother them, they won't bother you," she answered.

Al was not reassured.

Chaim Gordon was surprised and not pleased when he saw his daughter, seated next to a drover holding a baby, and, in the back of the wagon, three little boys slumped over their luggage. Mildred's father lived in what Al would come to understand was, at least by Lithuanian shtetl standards, a mansion. That meant, for instance, that one entered the front yard through a tall, covered wooden gate, beneath which the horses and carriages of the local gentry stopped to let off their passengers. The portico protected visitors and residents alike from the elements.

Mildred's father was a wealthy and respected man, a member of the town's intelligentsia. The politically powerful Jews of Zarasai assembled frequently around his large dining room table. His position in town was due in part to his relative wealth and his status as a multilingual scholar that allowed him to act as a kind of unofficial advocate, representing the interests of both Yiddish-speaking Jews and Polish-speaking peasants in Lithuanian courts. Chaim Gordon may have been a bona fide lawyer—Al isn't sure—but even during Lithuania's relatively benign interregnum golden period, quotas limited the number of Jews who could practice law. In 1926, just a year earlier, Jewish enrollment in university faculties of medicine and law had been restricted. By contrast, Al's father's relatives were decidedly lower-class. They were teamsters who transported goods by horse and wagon. Soon, however, Al would discover, much to his delight, one distant Jaffee cousin in town who owned a record shop and a gramophone.

Al was at least as unhappy to meet his grandfather as his grandfather was to meet him. To an already terrified six-year-old, Chaim Gordon, with his bushy gray beard, his black clothing, and his walking stick, was an imposing and scary figure. "I had a funny feeling about this long, creepy house," Al recalls. Irinka, the Gordon family's Russian-peasant servant, took one look at the boys' filthy faces, dirty hands, and matted hair and hustled them off to the kitchen.

Al had never seen a kitchen like that one. It had a rough wooden worktable, a galvanized pail of well water for cooking, and another pail for washing dishes. Where was the icebox, the kitchen sink? And why was the floor made of dirt? Bins held fresh vegetables and fruits. A concrete-masonry stove was stoked with wood and connected to a chimney. Nothing so sophisticated as an icebox or a stove had yet found its way to Zarasai. By the end of the Jaffees' stay in Zarasai, water power was used to generate electricity during the evening hours; the Jaffees had one electric bulb that hung from the ceiling on a cord and functioned from 5 to 9 PM.

Al watched in amazement as Irinka filled a large black kettle with water from a bucket and set it over the open fire. When the water was hot enough, she poured out a bowlful for each child, and with Mildred's help, they did their best to wipe away weeks of grime. Later, Al was taken on a tour of the house, which was lit only by candles. His grandfather pointed out where each of them would sleep. All of the bedrooms had embroidered bedding, curtains, and a fireplace. There were so many rooms! How would he ever find his way? Later, Al's grandfather showed the new arrivals the backyard, which was the size of half a football field and filled with lumber. Moise (My-say), his grandfather's son-in-law, was a lumber merchant. (The fact that both the father and the son-in-law shared the surname Gordon was probably due to the fact that Chaim Gordon, who had no living sons, intended his son-in-law to inherit his estate.) In addition to a large vegetable garden, a well, and a barnlike shed for the horse and wagon, the tour of the compound included a visit to the outhouse. Al was bowled over by the stench. "That was the worst. When that smell hits you, you never forget it. You want to have your nose amputated."

At dinnertime the entire Gordon clan gathered in the dining room, around a long, polished wooden table. This room was elegant by Zarasai standards. The walls were decorated with paintings and had large windows hung with curtains. Unlike the kitchen, the dining room had floors made of shiny pine planks. Members of the Gordon family bought most of their household furnishings in Kaunas. The intelligentsia of Lithuania liked to think of Kaunas as their own little Paris. Some of the Gordons even spoke French. A

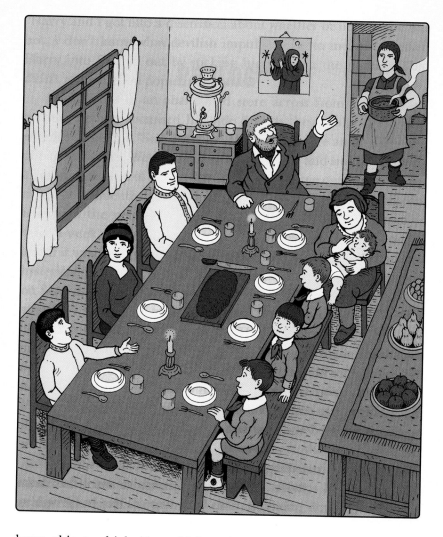

large object, which Al would later learn was a samovar, stood surrounded by glasses on its own table at the end of the room.

Irinka bustled around serving what was to Al an unrecognizable dinner of fried herring mashed with potatoes and carrots. Chaim Gordon, wearing a double-breasted dark blue jacket and a white shirt, presided at the head of the table. Al's mother sat in a chair near her father, holding baby David in her arms. On a bench next to her the three other children sat in ascending age order: Bernard, Harry, and finally Al. Moise, Lifa, his wife, and Danke (Daniel), their son, sat facing the newcomers. Nobody was wearing a hat or

yarmulke, an indication of what Al would come to call "Reformed Judaism, Zarasai-style." Al sat mute and mournful, across from Danke, trying to make sense of the bewildering Babel of conversation swirling about him. In the sophisticated Gordon household, it was not unusual for conversations to be conducted in several languages. "Arriving in Zarasai," Al recalls, "was like a moon shot."

While his mother and the relatives tucked into their meal, Al, who was ravenous, picked up his fork and allowed a bit into his mouth. He shuddered involuntarily at the intense, oily saltiness of what he would soon come to appreciate was standard Zarasai fare, if he was lucky.

Chaim Gordon's wife, Sora, had died in 1924, but he did not live alone. Moise Gordon, his wife, Lifa, the only Gordon daughter who didn't emigrate, and Daniel, a somber, scholarly boy who seemed to Al to be about his age, shared the mansion. Lifa was a slender, sensitive, pretty woman who suffered from consumption and was confined to the indoors most of the time. She occupied herself by painting biblical scenes in oil colors on velvet, decorated with glass beads. Looking back, Al realizes that her technique was pure glitz, "the kind of stuff they sell to tourists in the Caribbean," but as a child, he was wowed by her talent. She was one of the relatives who would be kind to him, providing Al with hard-to-find watercolor paints and paper. And while other relatives, his grandfather in particular, did what they could to suppress Al's high spirits, Lifa always took Al's side. "Lifa admired my spunk; she made me feel good when she said to my cousin Danke, 'Why can't you be more like Al?' meaning 'Why do you hang around the house with your nose in a book? Why not go outside and tear things down?'"

Al would come to look up to Moise, whom he described as a "very handsome, masculine type, when masculine types were important to me." Moise was an entrepreneur. In addition to his lucrative lumber business, he owned the primitive movie theater in Zarasai as well as one in Kaunas. That meant that Al and Harry could go to the movies whenever they pleased—for free. But at the moment, it was Danke, their son and only child, who interested Al most. Eventually, Danke looked up from his plate and said hello. Danke, whose parents also spoke English, would be Al's first friend in this alien world.

In time, everyone's attention shifted to Mildred. Why had she left America? What was she doing here? Where was her husband? Russian was the language of the intelligentsia of Lithuania. Mildred Jaffee spoke English, Russian, and Yiddish fluently, but she communicated with her father, who spoke no English, in Russian. Al sat listening to his mother argue with her father. He hoped his grandfather was saying, "You must go back to America right away." He might well have been saying that, but Mildred had no plans to leave. In a matter of weeks, Al, who proved to have his mother's talent for language, would be speaking Yiddish, the lingua franca of Jewish shtetl life, fluently. It would take a little longer for him to learn Lithuanian and Russian. "I had a good ear. Communication turned out to be very easy for me. I can still speak Yiddish like a native. A native of where I don't know. Maybe Yid-land.

"When we came to feel more at home in our grandfather's house, we used to enjoy screaming in Russian, 'Irinka, padavai chai!'* The Russian language wasn't big on articles." Soon, even two-year-old Bernard, another fast learner, would entertain everyone at the table by yelling politely, "Padavai chai!" and Irinka herself, amused by this baby's precocity, would yell back the Russian equivalent of "Go to the devil." But for the time being, except when he was with his mother and brothers or at his grandfather's house with Lifa, Moise, or Danke, Al was a boy without a country or a language.

That first night, when it was time to go to sleep, the candles were blown out, leaving Al alone in his bedroom. "It was so dark it was absolutely terrifying. I didn't know where anybody else was. I didn't know how to find my mother or brothers. I was afraid to yell or scream or cry. I was up all night. I was convinced there were rats walking around on the floor, but I couldn't see them. What if I fall asleep and my hand falls off the side of the bed and the rats eat my fingers? I was literally scared shitless. I was having such stomach cramps. At first light, I ran over to the door and relieved myself inside the room. I closed the door on it, figuring that no one would find it, and I forgot about it."

* "Irinka, give tea."

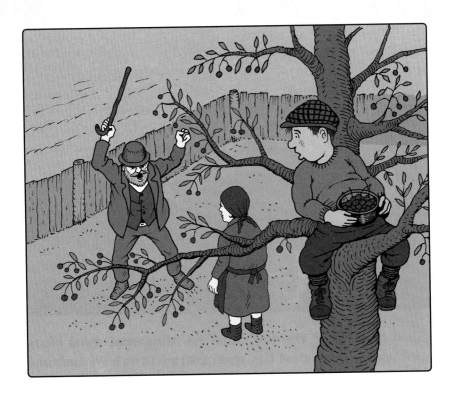

The next morning, his mother took Al and his brothers to pay a call on an elderly, gray-haired couple, Zalman the *feldsher** and his wife, Mildred's distant relative. Al can't remember her name, but he called her Mumeh, aunt. Mumeh kissed the little ones, David and Bernard, and then turned her attention to Harry and Al. *"Shain vie ah shaygetz,"†* she said, admiring Harry. She pinched Harry's soft, round cheeks between her rough fingers, making him look like a fish. Then she turned to Al and, without a comment, tousled his hair. On other occasions, when Al was introduced, the most frequent comment he elicited was *"Ehr zet ois vie ah shaygetz."* In time Al came to understand that the connotation was "He looks crass, like a gentile." "I always wondered how one could be pretty like a goy and ugly like a goy. I wasn't a large kid, but photographs from the time show that I had heavy features with big lips and a prognathic look. I

* Folk doctor.
† "He's so pretty, like a gentile."

resembled my grandfather. Harry was a sweet-faced, thin-lipped child. Harry took after our father."

Mumeh and Zalman had a huge cherry orchard in their back-yard; it was spring and the trees were filled with red and yellow fruit. Mumeh invited Al to pick all he wanted. While Harry stayed with the grown-ups, Al, employing the same tree-climbing skills he had per-fected in Savannah, shimmied up the tree and got to work. "I'm pick-ing a cherry and dropping it in the pail, and I'm picking another cherry and dropping it into my mouth." When the pail and Al were almost full, Al heard a commotion. From his perch in the tree, he saw his grandfather hobbling at full tilt toward his mother and the others, screaming and waving his cane wildly. "All I could figure was that he's found the poop behind the door and he's coming to kill me and I'm not getting down from this tree." Al was right about the poop. He stayed in the tree, out of sight, until his grandfather limped away. "Maybe my mother mollified him. Oh, he was a tough son of a bitch. He was never friendly after that, but at least he never mentioned the poop again."

Al figures they must have stayed with their grandfather for at least a week, long enough for Al to have to use the outhouse again. Raspberry plants, bearing fruit nearly the size of golf balls—nothing like the puny little ones Al knew from Savannah—hung down to the ground in bunches around the outhouse, at once tempting and repel-lent. Al refused to eat them, but Danke had no compunction. "I would ask him, 'How can you eat anything that grows out of a shit house?' The invading armies of Genghis Khan probably used this out-house." But Danke was unde-terred. At first Al refused to eat them, but eventually he suc-cumbed, both to the outhouse and to the raspberries. The rasp-berries were delicious, but Al never got used to outhouses; he

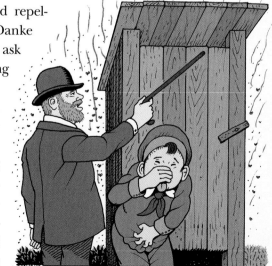

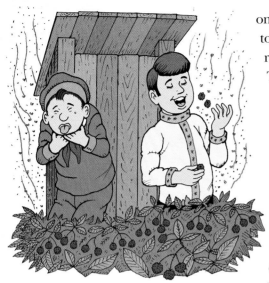

only tolerated them when he had to. Whenever possible, he would relieve himself in the woods. There, at least, grew a plant that bore a little white flower that, when squashed in your hand, created a soapy foam.

When the family left Al's grandfather's house, Al had high hopes that the visit was over and they were going back to Savannah, but instead they moved about a block away from Grandfather Gordon's into a house with a large main room, one small bedroom, a foyer, and a kitchen. Al has no clear memory of the furnishings of that house, but it is likely that they were sparse: a rough-hewn plank table and chairs. The beds had no springs and were probably made of unfinished birch wood. The mattresses in such primitive homes were usually stuffed with chicken feathers. The kitchen would have been equipped with a black, pig-iron stove for cooking and a long brick-and-cement oven for baking. The roof might have been made of thatch or wood.

"In the early days, I asked my mother when we were going to go home, but she simply evaded my questions. 'Oh, soon,' she'd say. 'I have to write to your father.'" But "soon" never came. After a few months, Al stopped expecting his father to appear at the door to rescue him. "Once I had concluded that, I had to figure out how not to let this woman destroy me. I think I also was dealing with the question 'Where is this other grown-up protector, my father, and how is he letting this happen?'"

Al's first encounter with his Yiddish-speaking, potential Lithuanian playmates was a disaster fueled by incomprehension. "We were very low on the totem pole when we arrived from America. First of all, I'm dressed like a Georgia peach. I must have looked absolutely ridiculous. In addition to the velvet outfit, I'm wearing Keds and colorful socks. Most of the Lithuanian kids wore pants that reached just below

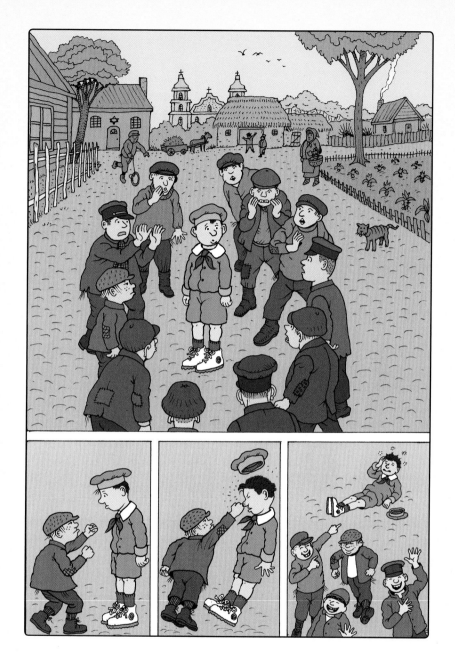

their knees and long black stockings that hung down to the tops of their big-buttoned, high-topped shoes, made by the local cobbler.

"These kids surrounded me. I heard them muttering, *'Buxer, buxer.'* If I turned around in one direction, they fell back; if I turned in another direction, they fell back. It was like a bad Fellini movie. I am six years old and I can't figure out what these kids are so scared

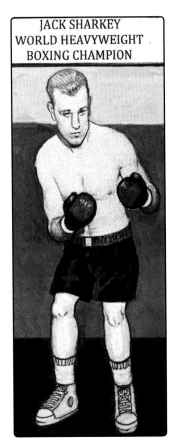

JACK SHARKEY
WORLD HEAVYWEIGHT
BOXING CHAMPION

of. Some of them were twice my size. Finally, one little pipsqueak comes up to me and says, 'You not *buxer*.' I thought to myself, 'What is he talking about?' But before I knew it, he gave me a shot and I was on the ground. They were all laughing, '*Buxer, buxer, ha, ha, ha*,' and they walked away, and left me crying and confused."

Days later Al recounted the incident to Danke, who explained that *buxer* meant "boxer," and that all the Lithuanian kids idolized a world-champion boxer of Lithuanian descent known as Jack Sharkey, né Joseph Paul Zukauskas. Sharkey was so popular, even in the hinterlands of Lithuania, that a poster depicting him, gloves on, arms cocked, ready to fight, had found its way to Zarasai, probably on the bus from Kaunas. In the poster, Sharkey is wearing Keds.

The humiliation of being exposed as a mere mortal, and a greenhorn at that, was made even worse when the Lithuanian kids learned that Al's given name was Abraham. "They were hysterical with laughter. They all started dancing around and singing, '*Über Hemd, Unterhemd, Über Hemd, Ünterhemd*.' My name, in Yiddish, it turned out, was a play on the words *overwear* and *underwear*." Being named Abraham had been just as big a burden in Savannah as it was in Zarasai. "I did get a little tired of fighting every kid in kindergarten because my name was Abraham. It was only sixty years after the Civil War, and here comes Abraham Lincoln's alter ego. I was born in Savannah, where I'm taunted as a 'Yankee.' I go to Zarasai, and I'm 'underwear.'"

It was Danke who helped Al and Harry segue into the local society. He introduced them to the kids who became their favorite playmates—Chaimke Musil, a bright, lively, freckle-faced boy with a good sense of humor; Berke Lintup, a small, dark, wiry, serious boy;

and Itzke Schmidt, a blond, dopey child, more a tagalong than a member of what would become a gang of five shtetl-style Dead End Kids whose macho attitude mimicked that of the older Jewish shtetl boys who were training to become pioneers in Palestine.

Al's cousin Danke was temperamentally very different from Al. He didn't run with the gang, but he was both mentor and friend. "He was a bookish boy. His parents were very sophisticated people, and he was a bright, worldly child. Danke knew a lot about a lot of things. We were both only six, but Danke explained sex to me, including that the male ejects a white fluid into the female. I remember that vividly. 'What is this white fluid? Where did it come from?' All I did was pee in the snow. We were all speculating about how it works. He explained it down to the last detail." Sometime during the first few months of Al's stay in Zarasai, when he felt displaced and miserable and was hoping daily that this wretched visit to this godforsaken place would come to an end, Danke told Al about the sinking of the *Titanic.* "I started to accept more easily the fact that maybe staying in Lithuania wasn't so bad," said Al, "considering how dangerous it could be to go back."

Still, Al bitterly resented the primitive life into which he had been thrust. Even at age six, shtetl-style personal hygiene shocked and revolted him. Sometime during his first month in Zarasai his mother took him to the women's bathhouse, which he found humiliating. "I walked around with my hands over my private parts." This was his first introduction to the *mikvah,* the ritual bath in which women must purify themselves after their menstrual period. Al watched with mounting concern as the women, supervised by a *tukerin,** submerged themselves so completely that he feared they might never reappear. The sauna, with its steaming rocks and clouds of vapor, was equally humiliating and frightening. "All these ladies were flopping around, hitting themselves with twigs, sighing with relief, '*Oy, a-mechaye! Oy, a-mechaye!*'† I wanted to get the hell out of there. I must have threatened to run away from home if she ever

* Dunker.
† "What a pleasure!"

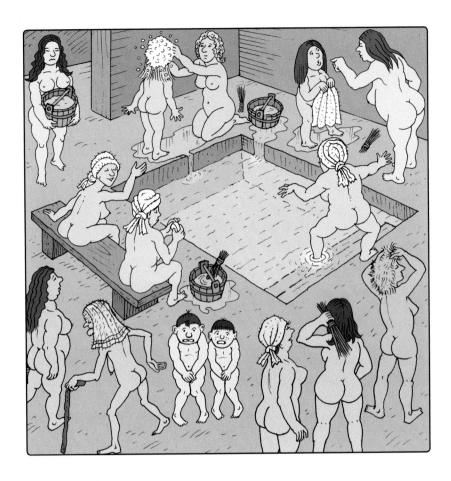

took me there again, so she found a man to take us to the men's side of the bathhouse, at which point I wished I was back in the woman's side.

"Lots of men had what was called a *killa*, a form of rupture. If you continue working at the jobs these people had to do—lifting logs and two-hundred-pound bundles into a drover's cart—little by little your intestines work their way down into your scrotum, eventually making it as big as a basketball. No doctor in town could perform a hernia operation, so you've got these guys walking around with this basketball between their legs. You can imagine how sickening that was for me. I couldn't look. The rest of the package—the schlongs hanging down—wasn't so inviting either.

"Once the steam cleared and you stopped smacking yourself, you'd climb back into the same old lice-ridden clothing you'd been wearing all winter. The mere fact that you wear your clothes all the time is just an invitation to these vermin. I never knew there was an alternative to wearing the same clothes. We were covered with lice everywhere, especially our hair and underwear. Some people used to crack them on their fingernails. We had lice combs. When you combed your hair, they would fall out by the dozens, even though we kept our hair very short, almost to the scalp, in an effort to dispossess the lice. Even the *tzitzit*, the fringes that hung from the four corners of a cloth rectangle undergarment that religious Jews, including children, were required to wear all the time, were infested with lice. It was de rigueur to kiss these fringes during prayer. I avoided this ritual after I discovered that the dispossessed lice had set up housekeeping there, too. And there were bedbugs. You'd wake up in the morning covered with blood. No matter how you tried, you couldn't get rid of them. Bedbugs and lice are bloodsuckers. In the wintertime they go to warm places, and they are sustained by unhygienic conditions. There were some people who washed their clothes—my mother might have done that from time to time—but it's a huge chore. You don't turn on a hot-water spigot. If you want to wash clothes, you've got to boil water. Boiling is the only way to get rid of lice in your underwear. The so-called nits are the eggs. They were in everything. I was covered with bites. It's like when you see children in terrible places in Africa with flies crawling in and out of their eyes. They don't even blink. People learn to conserve their energy. Eventually, I learned. You can kill yourself trying to fight these things."

After the "his" and "hers" visits, Al never went to either bathhouse again. When the weather was warm enough, he bathed in the lakes. "It's a good thing the streets were filled with defecating horses, cows, goats, and sheep, as well as cats and dogs and outhouses galore to boot—all of which made our personal body odor fade into insignificance."

Even though Al couldn't get back to America, America came to him in the form of the funnies. They served as a lifeline between

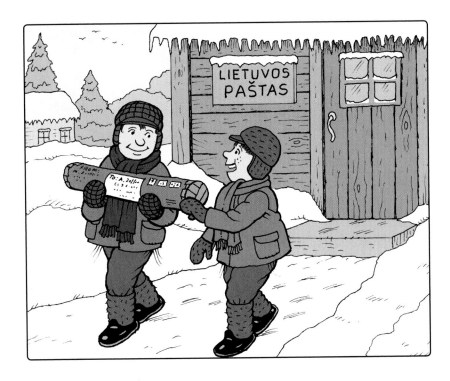

him, his native land, and his father. Just when he thought he could not suffer the homesickness another day, he'd receive word that a package had arrived. Al and Harry would rush to the post office and lug home a trove of newspaper installments, rolled into a cardboard mailing tube. Once home, after making sure that they saved the brown wrapping paper surrounding the funnies for future art projects, they would spread the comics on the cottage floor, lie down on their stomachs, and rediscover America in *Boob McNutt, Wash Tubbs, Little Orphan Annie, Winnie Winkle,* and *The Katzenjammer Kids.* Both of the boys had learned to read a bit of English from studying the cartoons with their father. Now it was their mother who helped them decipher the words.

They would conjure up the aura of home and of their father's love and attention from the funny pages of the Savannah Sunday newspaper. Part of the joy was the feeling of satiety that would accompany each shipment. The brothers could binge on Mickey Mouse all day and go to sleep at night, smug in the knowledge that installments yet unread awaited them.

Al soon ingratiated himself with the Lithuanian kids, the very ones who had teased him when he first arrived. They couldn't get enough of his tales of American life. He told them that his father was rich. "I regaled them with stories beyond their wildest dreams about tall buildings, trains, and huge oceangoing ships. They hadn't even seen pictures of them. They didn't have picture books. There were no newspapers or magazines. There was nothing printed other than the religious books." So Al drew pictures. His new friends were amazed. And then he drew pictures of his favorite cartoon characters. Paper was precious, so he often drew in the dirt with a stick. "The Lithuanian children had never seen cartooning; they were spellbound. They followed me around. They drove me crazy, begging me to draw the same characters over and over again.

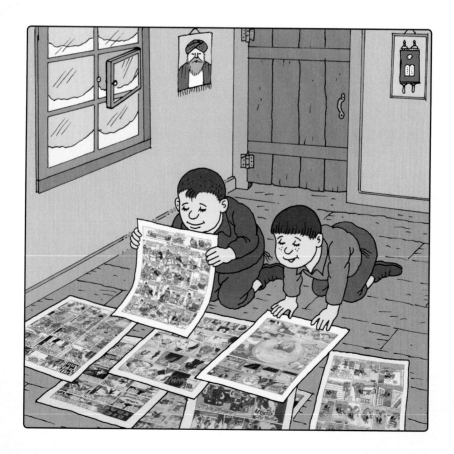

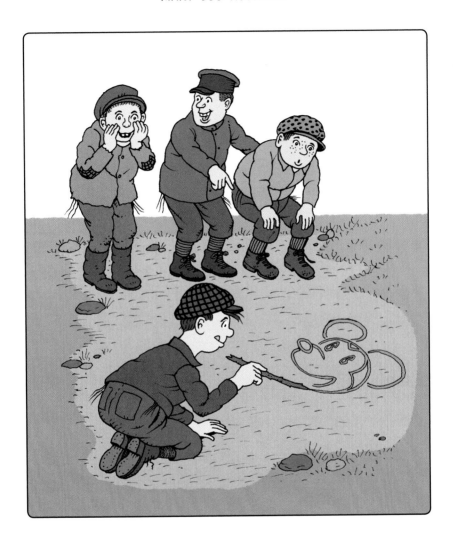

"It began to dawn on me that dreaming of returning to America was not working, and I was learning to live in Lithuania as a Lithuanian, and doing pretty well at it. I was more inventive than my contemporaries over there, so I was gaining some status." He and Harry were one of the gang. They played exclusively with Jewish kids. "We were learning Yiddish. We were integrating with them; they weren't integrating with us. At the beginning we were kind of strange creatures, but after a while we were just part of the ragamuffin crowd."

Al and his friends made a sport of teasing the girls. "Like most little boys, I had a disdain for little girls. When they came out of the

shul, we would throw thistles at them. The thistles had little Velcro-like hooks on them that would stick to the girls' hair and clothing and send them running and screaming." Perhaps, also like most little boys, Al made an exception for a little girl named Dena. "There was a photographer in town named Botvinik. He had a beautiful daughter. Boy, was I in love with her!"

Winter was coming. Ultimately, and out of necessity, Al exchanged his Georgia wardrobe for the uniform of Zarasai. He shed his Keds for cobbled shoes. "Fall is a critical time in Zarasai. If you don't prepare for winter, you're in deep doo-doo. Winter blasts in and you'd better have heavy clothing. There's a very strong possibility that my grandfather or some other relatives warned my mother to get cracking on winter, and we'd get outfitted. Every item of clothing was made by hand, which required a visit to the stocking maker and the woman who made heavy winter underwear. Then you needed *valenki*, boots made completely out of pressed felt that are about one-quarter inch thick. Rubber galoshes fit over the *valenki* to keep them dry, and then, of course, you needed a long coat and a peaked hat with earflaps."

Children, it is said, can adapt to almost anything, including primitive indignities and maternal neglect, and Al did. It helped that he was precociously self-reliant, having understood not to expect much by way of attention or affection from his mother. Still, Al clings to wispy memories of displays of what seemed like love. "I remember that she once licked the palm of her hand, smoothed back my hair, and treated me to an approving smile. I don't think she ever hugged or kissed me. Actually, maybe she once held me, maybe to comfort me. I seem to remember a warm feeling from her, but I don't remember where or why."

Often when the children woke up in the morning, their mother had already left to pray at one of the shuls on "synagogue row," three large communal wooden buildings, each with sumptuous vaulting supported by wooden

posts. Typically even the most Orthodox of Jewish women did not go to shul during the day. Women were supposed to stay at home and take care of their children. She may have been all alone in the balcony reserved for women, but there was nothing typical about Mildred Jaffee's religious observances. If she wasn't at shul, she was tending to the sick and needy Jews of Zarasai at the *linat tzedek* charity hospital and at the Jewish old-age home. Mildred was committed to practicing *tzedakah*, a special kind of charity required by the Torah. In Hebrew the word means "righteousness, justice, or fairness." In Judaism, giving to the poor is viewed not as a generous act of charity but as a religious and moral imperative. It was common for women to prepare food and drop the dishes off anonymously at the homes of poor families. This act of charity was called *metrogt teplech.** It was a duty that Mildred apparently extended first to the rebbe and the sick and needy and then to her children. If a beggar knocked at the door, as beggars often did, Mildred would give him either money or the food from her children's plates. Al doesn't know where she got the money. Maybe it came from his grandfather, or perhaps from his father. Al was called frequently to the post office— mail was not delivered in Zarasai—to pick up letters from his father. Apparently, at least as far as Mildred Jaffee was concerned, *tzedakah* did not begin at home.

When the door wasn't locked, Al and Harry would be on their way, but usually not to school. Jews, Poles, Russians, and Lithuanians each attended their own parochial schools, although ever since liberation, each child was required to study the Lithuanian language one hour a day. "At first she put us in *cheder†*, where we went briefly and episodically to study Jewish history and the Hebrew language. I do remember learning the Hebrew alphabet and the rudiments of the Lithuanian language." But at some point all schooling stopped. "First of all, she wasn't around, so playing hooky was easy. Second of all, there were no truant officers in Zarasai. But more likely, I think, when she got the bill, she didn't pay it.

"Harry and I spent as much time as possible out of the house.

* Carrying pots.
† Jewish elementary school.

We were pint-sized juvenile delinquents, the Katzenjammer Kids let loose in Lithuania. We were an odd couple. Harry was solemn and serious. I was noisy and outgoing. The two younger ones were my mother's responsibility. Most of the time she probably took them with her to shul. We had nothing to do with them, except on those occasions when all four of us were locked in the house from morning to night with no provisions. If we hadn't been locked in, Harry and I would have escaped."

If the door was locked, Al and Harry used a pail as an indoor toilet and waited for their mother to return. "To us it seemed an eternity, but it was probably sundown. I think everybody living in that village did things like that," says Al, in defense of his mother. "You may be doing your kids a favor by locking the door and leaving a pail rather than having them wander out in the freezing cold." Al sees his mother as negligent by today's standards but only careless by the standards of 1920s Lithuania. "In primitive societies, older children are given the job of becoming the mothers and fathers. Mother may have been taking care of some poor, sick, old person who was going to starve to death if she didn't come. Maybe that was it."

Opinion in the Jewish community varied on the subject of the woman who was known to her Yiddish-speaking community in Zarasai as Michle Gordon. "Some said of my mother, 'What an admirable pious woman she is!' Others thought, 'What's the matter with Michle Gordon? She's really overdoing it. She should be home with her children instead of spending so much time in shul.' It's difficult to tell the difference between duty to home and piety to God. It would have been much easier if she'd been playing mah-jongg all day.

"We were hungry all the time. My mother didn't have a hold of the day-to-day realities, such as providing food. I think if we didn't beg for food or yell for it, she might just have ignored feeding us altogether. David was her favorite. She would buy things for David. There was always something for him to eat, and we had to figure out ways of taking it away from him." Al learned to be grateful for a meal of fried herring with potatoes and carrots. "Dairy products were easily available, and we relied on them. When there was breakfast, our mother would mash butter and cottage cheese, or butter and creamed cheese together, and give it to us in a saucer. Otherwise, we'd eat leftover

bread. Every now and then we'd get borscht, or cucumbers and radishes in sour cream. It was always a treat when the Russian peasant woman came down the street calling '*Kupitsy bublichki, Kharachee bublichki.*'* She would be wearing garlands of small bagels around her neck. Each string had maybe twenty bagels on it. My mother would send me out with some money, and I'd buy a whole string of them."

Food was better on the weekends, when Mildred Jaffee would undertake more ambitious cooking projects such as gefilte fish, carrot *tsimmis*, chicken, and *cholent,* a stew made of chunks of meat, chicken, sliced carrots, onions, and potatoes. On Friday nights, in preparation for the Sabbath, Al would pick up horseradish for gefilte fish from the horseradish lady, and then he and Harry would carry the food, usually a kugel or *cholent* in a big iron pot, and deposit it with a gentile man who would shovel all the Jewish housewives' pots into a brick oven—like a pizza oven—and stoke it so that the coals were banked. It was his job to see to it that the fire was kept at a constant, low temperature for twenty-four hours. After sundown on Saturday, they would carry the pots home. "Kugels were very big; my favorite was a potato kugel. Sometimes it would come back undercooked and other times overcooked, but when it was just right, it would have this wonderful brown crust on top that was absolutely delicious." At the beginning of the week the boys could rely on Sabbath leftovers. They were hungriest as the weekend approached.

Sabbath was the religious apex of Jewish life in Zarasai, but the market, held on Tuesdays and Fridays, was the nonsectarian economic lifeline of the shtetl—its very reason for being. Preparation for the Sabbath did not compare in intensity with the frantic activity

* "Buy my little bagels, fresh bagels."

that preceded each market day as cobblers, tailors, and other arti-
sans worked feverishly and shopkeepers bustled about, sweeping,
printing signs, and arranging their goods on outdoor stands to
attract customers.

On market days, Al and Harry were awakened at dawn by the
distant, metronomic *clip-clop* of horses' hooves and the groan of
wooden wagon wheels grinding on the gravel road as dozens of gen-
tile farmers from the countryside converged in the large market-
place. Their wagons were loaded with fruits, chickens, eggs, cheese,
fish, butter, geese, grains, corn, and produce of all kinds. A veritable
barnyard of goats, hogs, cows, and horses trailed behind, adding to
the shouts of the merchants with their squawking, clucking, moo-
ing, neighing, and grunting.

It was about 8 AM when the noisy parade of wagons and animals
reached the square, which was decorated with banners of red, yel-
low, and green—the Lithuanian national colors—that hung sus-
pended from strings attached to candy-striped poles. By then the
mayhem resolved itself into an orderly, if still noisy, procession as
each wagon headed for its predetermined location in the square.
There the peasants unhitched and fed their horses and displayed
their produce on wooden pallets atop their wagons. There were sep-
arate aisles devoted to grains and hardware and others to fruit,
chickens, or knit goods. To attract buyers' attention, fishmongers
blew up fish bladders into balloons and hardware merchants banged
their pots and pans. Intense scrutiny of the merchandise followed by
loud bargaining was de rigueur. After a profitable day of symbiotic
buying and selling, many of the peasants would visit the Jewish inns
to fortify themselves with vodka and beer for the journey home. The
more they drank, the more abusive they became. The delicate equi-
librium of the relationship between Jew and gentile might be threat-
ened by the telling of an anti-Semitic joke. "Don't take offense, my
friend, we are only kidding." But after a few more drinks—in vodka
veritas—outright insults would often result in physical violence.

Harry and Al, excited by the prospect of so much activity, and
the possibility of organ grinders, balalaikas, fortune-tellers, magi-
cians, puppet shows, and dancing Gypsies, would throw off their
covers, pull on their clothes, and head for the center of town. Al's

favorite destination was the horse market. "There would be a horse race—mainly to sell the horses. Faster, of course, meant better, but local lore had it that in order to impress potential customers, the seller would insert a hot potato up the horse's rectum, which would make the animal very lively."

Eventually, Al discovered on his own that he had a distant relative from his father's side in Zarasai, a young man named Moshe Jaffee. He had a bicycle-and-gramophone store. "I hung around there from early morning until late at night. He sort of looked like my father. I liked him. He was very nice to me. He let me sit in his store and play records over and over again." Al's favorites were Russian songs, often accompanied by balalaikas. "They were full of such schmaltz and pathos—so emotional. I used to sing along. Some of the lyrics could tear your heart out, and that appealed to me. The songs were about what I was feeling— alienation, loss of love, family, and loss of hometown. He had Yiddish records, too. They all had the same flavor. '*Vein mein shtetele, vein.*'*I just loved sitting around listening to these songs. This was the music I came to know as popular music, music that's played on a magic machine. It's always about losing. 'My little town, how I long to see your streets again.' These songs were very much like country and western, except that instead of losing your pickup, you lost your horse, or even bigger things than that. You lost your town and the places and people you loved. I guess the reason they wrote songs like that is because people were constantly being driven from pillar to post by new regimes, revolutions, and by armies chasing them out. They had to start life all over again in a strange, harsh land."

Unfortunately, these bittersweet, sentimental binges that spoke so profoundly to Al's own condition didn't last long. Somebody, Al suspects his grandfather, wrote to his father in Savannah, telling him that his six-year-old son was working at a phonograph shop. It was a *shanda.*† "I wasn't working, but they made me stop going there." Al was bereft. He loved hanging out in the record store, and

* "Cry, my little town, cry."
† Shame.

he enjoyed the company of his only Jaffee relative, a kindly man who even looked a little bit like Al's father.

"While I was still there, though, a fascinating thing happened. The store was on a main street. It was a dirt street that, whenever it rained, became a quagmire. A street crew started to dig up the road. They had to dig down pretty deep in order to grade it and install cobblestones. One of the workers found a skeleton and propped it up in a seated position on the side of the road. Pretty soon both sides of the road were lined with skeletons. Imagine if I'd had a

camera at that time! What a sight that was! It was Halloween for real. I told my friends about it and they all came to see. It could have been a cemetery, but I don't think so. I think it was a war burial place. People must have dug a deep pit and put all the people who were killed in World War I in it."

WHAT MILDRED JAFFEE had said was to be a brief trip to Zarasai to visit relatives had lasted a full year; but to Al, too young to think in terms of weeks, months, and years, it seemed an eternity. Al had found friends, learned new languages, and figured out how to live successfully in what had at first been a frightening and alien society. "I was making the best of the situation." By now his only links to his father and Savannah were letters, separated by months, that vaguely referred to a time "when we would all be together," and the much-anticipated funnies.

Every now and then someone would ask Al if he wanted to go back to America, but as the months went by, the question had less and less relevance. He didn't give up on the idea of going home, but he no longer thought of going home when he woke up each morning. "After a while I concentrated on life as it was and resigned myself to giving up the dream of life as it might have been in Savannah."

It was then, when Al had nearly abandoned all hope of ever seeing his father again, that Morris Jaffee showed up in Zarasai to reclaim his family. Al remembers little about his father's arrival, except that he drew a crowd of curious children when he appeared at his grandfather's house in a Model T with a driver whom Al assumed he had hired in Kaunas. "One of the big-shot Jewish kids who'd rarely seen a car of any make before made fun of it. *'Ach, ah shtick Ford!'** His taunt may have been payback for all the times Al had bragged to the kids about his rich American father.

Mildred Jaffee could not have been pleased to be "rescued," but she acquiesced. What neither she nor the children knew at the time was that Morris Jaffee had sacrificed his job to make the lengthy

* "Ach, a stinking Ford."

and expensive journey to Zarasai. Moreover, it had taken every penny he had to provide passage back for his wife and children. Before he left, Mr. Blumenthal, who had put up with Mildred's hysterical demands and Al and Harry's destructive Saturday visits to his toy department, delivered an ultimatum to the beleaguered Jaffee: "If you go, don't come back to Savannah." Mr. Blumenthal had understood from their earliest association in Savannah that Mildred Jaffee and the kids could be Morris Jaffee's undoing.

Predictably, Mildred raised hell at the port of embarkation in Germany. "We were required to go through the bathhouse to be deloused in order to pass quarantine. The rest of us took the requisite showers, but my mother simply would not undress, not even in front of a matron. I don't know how the problem was resolved; perhaps they gave in to her stubbornness, her religious principles, or both." Al, as always, gritted his teeth at his mother's embarrassing behavior and focused with renewed enthusiasm on the happy prospect of returning home to Savannah.

"I thought we would be going home to Savannah, but that didn't happen." After a year of keeping alive the hope of returning home, Al was bitterly disappointed. Instead, Al and his family found themselves back on the Lower East Side, broke and exhausted, sleeping on mattresses on the floor of a relative's apartment. "When my father brought us back from Lithuania, it wasn't the same. After a year of separation and alienation, we were strangers to one another."

Luckily, Mr. Blumenthal's son took pity on Al's father and set him up in a little cigar, cigarette, and candy store in the lobby of a bank building in Charlotte, North Carolina, a job with far less prestige and salary than his department store job. This relocation and demotion was the first nail in what was to be Morris Jaffee's career coffin.

Mildred Jaffee refused to follow her husband to Charlotte and insisted instead upon living with the children near the water, in Far Rockaway, Queens. No one knows why. Perhaps it was because there was a significant Orthodox Jewish population and plenty of shuls in Far Rockaway. Nor does Al understand why an increasingly depressed and depleted Morris Jaffee continued to bow to his erratic wife's demands. "My mother always laid down the law. She had lots of

conditions. 'Either I get this, or something terrible is going to happen.' We ended up on the top floor of a three-story, rickety, stucco building near the beach. The higher up, the lower the rent.

"I think my father learned early on, when the honeymoon was over, that he'd married somebody who didn't care what people think—and my father cared a lot. I think he recognized that he had someone who was so totally unpredictable that in the middle of the street she could start a screeching argument, so I think he just simply shrank and would not challenge anything. To challenge was to stick your head in the lion's mouth. He became very passive in order to avoid humiliating spectacles. Divorce was not an option in those days. Having four little boys and trying to save them was what the rest of his life was about. In all my adult years, from the time I was a teenager on, I never heard a critical word from him about my mother. Never. So I think my father just simply took his lumps." And his children took theirs.

Al hated Far Rockaway. It didn't matter that he was back in the United States, among people who spoke English, and living in an apartment with plumbing. "Sure there are automobiles and trains, but what have I got to do with it? I was longing for the company of my friends in Lithuania. I wanted to be able to walk around all over town. I missed visiting people and stopping over at my grandfather's house. I felt that if there was anything in me that was worthwhile, it was beaten out of me. Rockaway was nearly a complete blank. Everything was temporary. I never knew how long anything would last. I kind of drifted through it all."

In the summertime, a desultory Al and Harry roamed the beaches, picking up and smoking cigarette butts. There they joined a gang of ne'er-do-well kids who had established a pint-sized casino under the boardwalk. "They were gambling friends, not real friends like our friends in Zarasai. It was strictly a commercial deal." For stakes as high as a dime, they'd roll marbles into slots cut out of Philadelphia cream cheese cartons. "There were as many as eight of these games going at one time. It was almost like Las Vegas. If your marble went inside, you won five marbles from the proprietor. If you missed, he took your marble."

Again, they were on their own, as they had been in Zarasai the

year before. Again, much of the time, they were hungry. And again, Al and Harry escaped into the funnies. Al knows that he attended school, but he can't remember a thing about it. He doesn't remember having any friends. What he does remember are months of sickness. "It was as if a plague had descended upon our lives. The apartment was a pest house. One kid after another got chicken pox. They were screaming and crying. They were covered with sores." After chicken pox came whooping cough. Al became infested with worms. He disgusted himself. "Meanwhile, my mother was calling my father, demanding money, and my father was commuting on weekends into what had to be a shit storm of troubles."

The only bright spot during the wintertime was Christmas. Al was drawn to the holiday lights on Rockaway's main thoroughfare, where he caught a glimpse of Santa Claus standing on the other side of the street, ringing a bell. Heedless as ever, Al darted across the street and got hit by a car. His injury was minor—a bruise on the leg—but it was enough to pitch his frequently neglectful mother into hysterics. She sent a message to her husband in Charlotte that

Al was dying; he must come to Rockaway immediately. Al's father put his assistant in charge of the store, went to Rockaway, saw that Al was not seriously hurt, and returned to Charlotte. In his absence, the assistant had emptied the store of merchandise, and once again, due to his wife's instability, Morris Jaffee found himself fired. He'd been ruined in Savannah. Now he was ruined in Charlotte.

It was 1929. Jobs were hard to find, but Morris Jaffee was hardworking, smart, and resourceful. He had four children and a wife in an apartment in Rockaway to support. Ultimately he landed a job, but only as a part-time mail carrier in the Grand Central Post Office in New York City. If he wanted to make anything resembling a living, Morris Jaffee, once the proud manager of Blumenthal's department store, had to hang around the post office for eighteen to twenty hours a day to snag four hours of work, for which he was paid fifty-nine cents an hour. He would remain a substitute postal carrier for years. "He was a slave. He had to take the postal exam every year to prove himself," Al would later recall bitterly. "He did that for years, waiting to become a regular."

But while Morris was scrambling for a way to support his family, Mildred had her own agenda. Somehow, in one year's time, from what must have been her husband's meager earnings from the smoke shop in Charlotte, Mildred had managed to salt away enough house money for one-way tickets back to Zarasai for herself and her children. This time Al, now eight years old, remembers no arguments between his parents, no anguished parting scenes as he pleaded with his father not to let his mother take them away again. It might be that Mildred "kidnapped" her children while Morris's back was turned. Nor does Al remember any details of the journey. What he does remember feeling was the weight of resignation. "There we were again. Back in Zarasai. Actually, it seemed quite natural. We just picked up where we left off."

3

NINETEENTH-CENTURY BOY

"I needed a father."

ALTHOUGH HE WAS ONLY eight years old, Al was already a master adapter. He never looked down, at least not for long. Sad as he felt about repeatedly losing his home, his friends, his language, and his father, the moment he climbed off the bus in the Zarasai market-place in 1929 he once again transformed himself into a nineteenth-century boy. He resumed speaking Yiddish. He traded his American clothes for the Zarasai uniform, lice and all, braced himself for out-houses and frigid winters, and resigned himself to whatever was going to happen next.

Al's grandfather reacted predictably to his daughter's return. He held his head in his hands in disbelief and dismay, muttering repeatedly to no one in particular, *"Oy, Gottenyu, oy, Gottenyu."** But Danke, Aunt Lifa, Moise, Irinka, and all of Al's playmates welcomed him back to the shtetl that was increasingly becoming "home," the place you come back to.

This time, Mildred rented a small, one-story cottage about five kilometers outside of town, disturbingly close to gentile farming territory and the forest. The cottage was located on a large estate

* "Oh, dear God, oh, dear God."

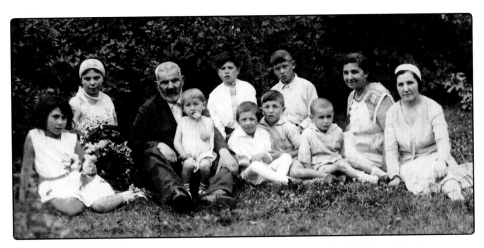

Back row, left to right: Aunt Lifa, Grandfather Gordon, cousin Daniel, Al, and Aunt Frieda Slom. *Front row, left to right*: cousin Nancy, cousin Sonia, brother David, brother Harry, brother Bernard, and Mildred Jaffee.

owned by three Polish siblings: Anna, Sigmund, and the eldest, Karolka Mikutovistsch. Al and his brothers had scarcely benefited from their father's love and presence for two years. Although their father continued to send them the funnies, Al, who desperately needed his father, came to lose all hope of ever seeing him again."

Serendipitously one appeared, in the improbable form of Al's Polish-Catholic landlord, Karolka, whom Al describes as "a handsome, strapping young guy of twenty-one." Karolka would fill the affectional vacuum left by Al's father, becoming both surrogate father and big brother. Unlike most gentiles, he seemed not to be infected by the low-decibel anti-Semitism that played through Lithuanian shtetl society like an ominous descant.

Maternal attention was also in short supply. For that, Al would look to his "soul mate," Aunt Lifa, and his playmates' mothers. "They felt sorry for us. They would always ask, 'Have you had anything to eat today?' You've got to give grown-ups credit in that kind of a world. They looked out for us. They took care of us." It took a shtetl to raise Al and Harry.

Al has concealed the pain of his childhood in Lithuania like a rock in a snowball, packaging it instead as a comic myth of survival. When his mother left him and his brothers locked in the cottage for

hours on end, with no access to an outhouse, they took their revenge out on her indoor rubber tree, even though she had provided them with a potty. "I can still see the four of us standing around watering it. We thought that was rather jolly. She couldn't figure out why by springtime her favorite rubber tree plant had died."

A round, metal chimney, located in the center of the house, went straight up through the roof. The chimney had an opening into which one stuffed wood to make a fire. A quarter of the fireplace was exposed to each of the four rooms.

Al can't remember where the others slept, but he had his own bed in his own small room, which he would abandon on the coldest nights to sleep instead on the *pripichuk,* a masonry counter built against the wall and connected to the flat-topped chimney. "In the wintertime we loved to sit and play on this platform because it was so toasty warm. Of course if your mother wasn't too 'ept' at fire making, you woke up in the middle of the night, freezing your ass off."

Getting ready for a Siberian-like winter required more than warm clothing, felt boots, and plenty of firewood. The cottage had to be sealed tight against the frigid weather, but not so completely that it would become uncomfortably airless. Each window had a *fortke,* a primitive, minimalist version of a storm window. One pane, on a hinge, was for allowing air into the cottage in the warm weather. But to air out the house in the wintertime, it was necessary to position a matching second "storm" window on the inside. With the outside windowpane opened outward and the inside windowpane opened inward, fresh cold air—but not too much—could enter through that one little square. It was Karolka, in his role as landlord, who arrived at the cottage each fall to install the *fortke.* Harry and Al helped by tearing paper into strips and mixing them with a paste made of flour and water to create a strong seal of papier-mâché around the windows.

The Jaffee boys made ingenious use of the *fortke*. During this, their second protracted stay in Zarasai, Mildred Jaffee continued her habit of leaving the house in the early morning to attend shul and fulfill her missions of *tzedakah*, often not returning until evening. Similarly, Al and Harry picked up where they left off, also leaving the house as early as possible, to embark on a day's worth of adventures, often returning after dark, having cadged a meal at a friends or relative's home. These mutually absentee lifestyles suited all concerned, except in the wintertime, when Mildred Jaffee, seized by her random version of maternal concern, would lock her children in the house before going out for the day, leaving them a pail for a chamber pot. "Every now and then somebody had to make doo-doo and, never mind the smell, the pail would threaten to overflow. I got this great idea. The opening of the *fortke* was very small, so small that only three-year-old David, the baby, could fit through." Al and Harry would hoist David through the *fortke* and lower him onto the snowy ground. Then they'd pass him the slop pail through the open pane and David would toddle off to the outhouse to dump it.

Karolka was as interested in the two Jewish brothers as they were in him. He took them spearfishing in the winters and fly-fishing in the summers. He showed them how to dig a hole in the ice, then tap on the surface to draw the fish to the hole, and spear them, using a sharpened stick. He walked in the woods with them, leading the boys through stands of tall, slim birch and the enormous, bushy pines. He helped them choose just the right saplings or branches from which to fashion fishing poles. Al was never afraid of wolves when he was in the woods with Karolka. They spent so much time together that Al, in his eagerness to communicate, learned how to speak serviceable Russian.

One night, after they'd gone fishing, Karolka, as he often did, invited Al to dinner. "Everything was pork and I knew it was pork and I didn't care that it was pork." He was so happy to be with the Mikutovistsches that he'd gladly eat *trayf*. Besides, he liked it. Remembering the hot dogs at the Isle of Hope, he thought briefly about how upset his mother would be and then tucked right in.

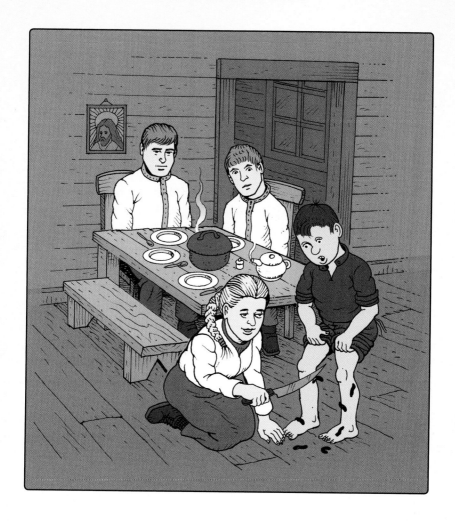

While he was scarfing down *trayf*, Anna noticed that Al was constantly leaning down and scratching and asked to have a look. "I'm wearing shorts—not short shorts American-style—but shorts that stopped below the knee. I got up from the dinner table. Both legs were covered with leeches. 'Don't do anything,' Anna told me. 'Don't pull. Don't scratch.' She carefully slid a knife under the leeches and removed them. She took care of me.

"Karolka would take me and Harry to his sauna about once every four to six weeks. The sauna was not a wonderful experience in the wintertime when it was twenty degrees below zero outdoors

and two hundred fifty degrees above inside. We were parboiled in this place." But it was a whole lot better than the town bathhouse. The sauna was a two-room masonry box of a place, with an entry for disrobing, and the sauna room itself. Benches were located at three levels. A stovelike apparatus about three feet high and made of stone and cement stood in the middle of the room. Inside, large rocks that had been cooking for at least a day glowed gold and red. "Karolka would pour water over the stones, making steam like Mount Etna. The challenge was to climb up to the highest level, because it was as hot as hell up there near the ceiling. Almost immediately we'd retreat to the second or first level—there it was cozy and warm—where we'd smack ourselves with willow branches to clean out our pores. Even though there was no soap, you got very clean." For a grand finale, Karolka would chase them out of the sauna and into the cold, where he'd engage the naked, shivering brothers in a playful snowball fight.

The intimate role that Karolka played in Al's and Harry's lives had its price. "My mother's reputation was being sullied on two counts. Everyone thought she was crazy to return to Lithuania and bring her children along—for the second time no less—when they could have grown up in the land of milk and honey. From that point of view, they were right. But what most upset me was that Karolka and my mother became the focus of filthy rumors that my mother was having some sort of sexual liaison with her landlord. With a gentile? It was just so preposterous I dismissed it. But I resented it. Even if my mother had reached the limits of celibacy, certainly her piety would not have allowed her to go to bed with a Polish Catholic."

In addition to the main house and the cottage, the property included the requisite outhouse, a barn, where the cow lived, and the sauna. The Jaffees' cottage was located at a forty-five-degree angle to the main house, right next to an enormous orchard. The bushes and fruit trees were laid out according to color: yellow on one side and red on the other, and stretched for the equivalent of half a block. There were red and yellow apples, red and yellow cherries, red and yellow lingonberries, as well as plums, pears, currants,

and gooseberries. To this day, Al raves about the superior sweetness of yellow over red fruits. "People are so dumb. They think that red is sweeter." The siblings also had a vegetable garden that produced carrots, potatoes, lettuce, cabbage, beets, scallions, radishes, tomatoes, and cucumbers—Al's favorite. "I would just wipe them on my clothes, hack them in half, give one half to Harry, and eat them—skin, dirt, and all."

The Mikutovistsch family made their living renting out the orchard to professional fruit pickers, so Al and Harry were under strict orders from Karolka not to take any fruit from the orchard. They did anyway, although out of respect for Karolka, they kept their incursions to a minimum and never invited their friends to feast on the forbidden fruit. The rest of the town, however, was their orchard.

"We always figured out how to get food from someplace. One of our big projects in the summertime was fruit stealing. Everyone watched carefully over their gardens because they lived off them. Except for cucumbers and radishes, we were primarily interested in fruit, especially apples and berries. Stealing appealed to Al's sense of adventure—"It was fun being a thief"—and to Al's and Harry's genius for engineering. "These crazy ideas I have now, that I submit to *MAD* magazine as 'Al Jaffee's Mad Inventions,' I put into practice when I was a kid." Their ingenuity fascinated other children. "We invented fruit-stealing devices. We would tie a wire hook to the end of a long fishing pole, lasso the fruit, give the pole a yank so that the fruit dropped into an attached basket, and then run like hell because the farmer's dog was usually after us."

Al knew that stealing was a sin, and he worried about God's wrath, but not too much. "I wasn't quite ready to say, 'There is no God, it's all a bunch of baloney,' but I was ready to say that if God is supposed to be nice and almighty, why would he punish a hungry little kid for stealing fruit or playing ball on Saturday? It didn't make any sense to me. God couldn't be that bad. What I wasn't accepting was my mother's belief that all problems would be solved if you put your faith in God because he would provide. I began to see a lot of evidence that God wasn't reliable. Hell would freeze over before

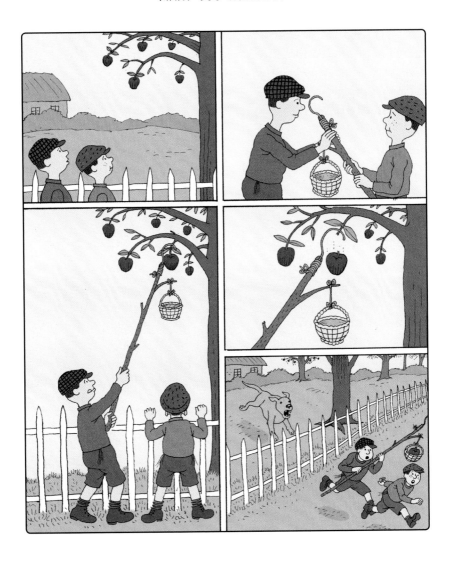

God provided me with apples and pears, so I had to steal them. When you have no money, stealing is the coin of the realm.

"We lived in a virtual ghetto." The rulers of the ghetto were the rabbinical organizations. Simply being a Jew in anti-Semitic Zarasai was to be a second-class citizen. Then, as if to add to that ignominy, the Jews levied further prohibitions on themselves. At least that's how it seemed to Al. "No one worked on Saturdays. No one drove horses. No one cooked or lit kerosene lamps. Everyone put his *cholent* into the communal oven. You shouldn't walk too far, you

shouldn't breathe too much." Most Jewish children attended cheder daily, but even truants like Al and Harry always wore *tzitzit*. "A kid goes to school all week. Then on Saturdays he's free to do nothing, not even play with a ball. On Sunday everything is closed. Not even eight-year-old boys could get away from religion. Zarasai was not a child-friendly place." In spite of or perhaps because of these dreary, oppressive conditions, it was in Zarasai that Al solidified his particular brand of humor—adolescent. Adults were his targets. Satire would be his weapon.

"I became aware that I could not trust adults. My father let me be shlepped to Europe; my mother did the shlepping. What good were adults to me? The only thing adults were good for was telling you things were sinful and trying to destroy any notions of your own. 'You can't do this; you can't do that!' I felt stifled. I developed my own brand of anti-adultism. At an early age, I set out to prove that adults were full of shit. I'm still doing that now, at the age of eighty-nine. I think like an adolescent." When most people open a newspaper, they see news; Al sees bullshit—adults behaving like silly, pompous hypocrites, always asking stupid questions. Making fun of them is Al's best revenge.

Setting aside the Sabbath, hardly a week passed when it wasn't time to celebrate one or another religious holiday. Al's feelings about these holidays were mixed. On Simchas Torah, Al and Harry got to parade around the shul carrying their homemade candle lanterns, so that was fun. Rosh Hashanah was long, boring, and solemn. Yom Kippur, a day of fasting, was worse. To a perpetually hungry boy, making a holiday out of starving seemed perverse.

Succoth, the festival of the harvest, was a particular favorite, since it was all about food and conviviality. The Jaffees never built a *succah** of their own, but they were often invited to Chaimke Musil's house, where Al took particular pleasure in helping to build their *succah* and furnishing it with a makeshift table and chairs so the family could take their meals there during the eight days of the holiday. It was a lean-to made of worthless, bark-covered pinewood planks that were saved from year to year. Unsecured pine branches

* Hut.

served as a roof, but in retrospect, Al sees that *succah* as the first of his many attempts to build a home away from home.

Al's favorite holidays were Purim, Passover, and Chanukah, which were summed up by the old Jewish expression, "They tried to kill us, they didn't, let's eat." But what Al cared about were the gifts of food—nuts and hard candies. On one night of Chanukah, Al's mother gave each of her four children a single but memorable grape.

"Conversations about God and the role he played in our lives were a constant." Children as young as Al and Harry engaged in Talmudic-like discussions—How did Moses part the Red Sea? Why did God turn Lot's wife into salt? And how come God made Job suffer so? Although Al wasn't convinced there was a God, he nevertheless worried that there might be, especially in view of his fondness for stealing. "There was one wonderful moment—the conversation was about sin—when an older boy explained to us that we shouldn't worry about sin because we were too young. 'Until you're older,' he assured us, 'all your sins go onto your father.'" Al was thrilled with the news. "I was so angry at my father for letting my mother take us to this Siberia for a second time that I said, 'Okay, Dad. My sins are coming your way to wherever you are, and I hope you enjoy them.'"

In spite of Al's aversion to religion, Bible stories inspired his artistic creativity almost as much as the comics. He drew Daniel in the lion's den, Hagar at the well, and the parting of the Red Sea. But it was his elaborate drawing of Moses standing on the top of Mount Sinai, holding the Ten Commandments, that Al would never forget. "I couldn't have been more than eight years old. I was fascinated by the story of Moses and the Jews escaping the pharaoh.

"How would an eight-year-old make a drawing of a mountain? It would be a triangle, and Moses would be standing on the point, teetering. I colored the picture with watercolors, but then this older kid showed me that if you rubbed the watercolors with a candle, the picture got this nice, satiny sheen to it. My three younger brothers were watching me do this magic. When I was finished, David, the youngest—he must have been around three—rubbed his hand along the picture and said, 'It's so slippery. Won't Moses slide down

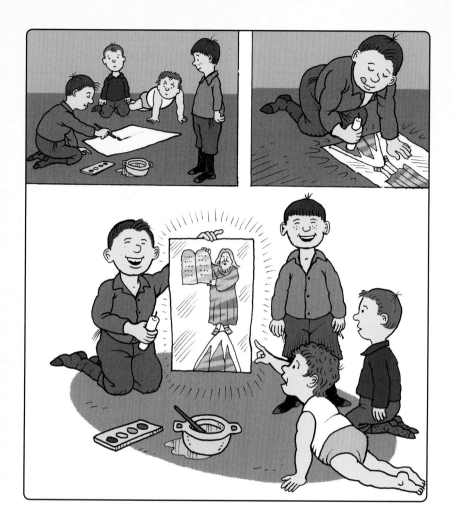

the mountain?'" By putting Moses teetering on top of this pointy, shiny mountain, Al had made it plausible that Moses might slide down. Al identifies David's inadvertent joke as "the first thing that ever struck me funny. At that moment I understood the difference between the slapstick I had seen in the funny papers, and this other, deeper dimension." He recognized this same dimension just four years later while watching his favorite cartoon, *Betty Boop*, at his Uncle Moise's movie theater in Kaunas. Betty Boop was in danger, and in order to save her, Felix the Cat needed a ladder. No problem. He pulled off his tail, spread it apart, turned it into a ladder, and rescued her.

Sometime during this first year back in Zarasai, three-year-old Bernard contracted spinal meningitis. He received medical care, which is probably why he survived, but the ordeal left him deaf and mute. This lively little boy, the prodigious talker and mimic who, just a year earlier, had amused and amazed everyone at Grandfather Gordon's table by asking Irinka for *chai* in Russian, could now neither speak nor hear. "At first we were totally unaware of what had happened. We would stand next to him and we would say, 'Bernard, move over,' and there would be absolutely no response. Finally we started clapping our hands. Still no response. Over time we developed our own crude sign language so we could communicate with him, but it was tedious going. Bernard was a happy child, in spite of his physical problems. He'd been butchered by a mohel in Savannah. He was blind in one eye, due to a botched effort to straighten his crossed eyes. He'd taken a lot of punishment in his young life."

Al's schooling remained episodic. During his first stay he had been obliged by edict to study the Lithuanian language. This time, although there was a cheder in town, his mother hired a tutor. In spite of the fact that Morris Jaffee's part-time job as a standby postal carrier paid him a pittance, he continued to send money to Mildred on a regular basis. It's possible that Grandfather Gordon also continued to pitch in. "We didn't have to be poor, but we were, because my mother was giving most of the money away."

Japan's defeat of the czar's army was a big subject around town. "Danke was obsessed by Japan's defeat of the czar's army even though it had happened in 1905, long before he was born. He enjoyed the fact that the Japanese kicked the shit out of the Russians. There wasn't a Jew anywhere in the world who wasn't thrilled to see this anti-Semite get his just deserts because he sent many a Jew to a horrible death. The fact that the Japanese defeated the czar's army and paved the way for the Russian Revolution was good for the Jews, for a little while anyway, because now everybody had a chance to be somebody. Harry loved to illustrate the battle scenes—right down to the Japanese gun emplacements—and Al's tutor loved to teach it. To this day, Al enjoys reciting the mellifluous names of the four main islands of the Japanese archipelago: "Hokkaido, Honshu, Shikoku, Kyushu."

Month by month, year by year, Al became more and more caught up in shtetl life. He accepted as normal what he had once rejected as the primitive hardships and indignities of life in Zarasai. "I got into the adventure. In many respects I had a happy Huck Finn–ish childhood in Zarasai because all the things of childhood were available to me. My world, in whatever way it is connected with art, is just an extension of childhood playtime, only now I need to get paid."

Although their father was missing from their lives, he kept the promise he'd made years before and continued to send the funnies to Zarasai. Al and Harry read the first installment of *Dick Tracy* curled up on the *pripichuk*. "Cartoons consumed our days and constituted an intense sense of play. We spent whole days cutting out cartoon panels, assembling them in sequence, and sewing them into bindings." The brothers may have invented the Big Little Book in Zarasai before 1932, when the debut cartoon book, devoted to the new pulp-inspired comics hero Dick Tracy, was produced in the United States. Harry and Al read their home-sewn books to each other over and over again. Then they translated them into Yiddish and read them to their friends, who by now were hooked on American cartoons.

The entire town was their playground. Zarasai's location on top of a hill from which pathways radiated downward to the lakes provided year-round opportunities for fun. In the winter, sledding would become Al's main preoccupation. "If you shoved off at the top of the hill, you'd pick up so much speed that you'd spin out nearly half a kilometer on the frozen lake and sail almost clear across to the mainland. Then you'd have to trudge forever to get back up the hill."

There was not much to do around Karolka's compound. Al's pet chicken, named Hun (chicken), didn't offer much in the way of entertainment, so the boys trekked five kilometers daily in order to meet up with their friends, all of whom lived in town. If the weather was warm, the brothers and their friends might race barefoot to the lake, gaining speed until they lost control just in time to splash headlong into the water. "I loved being in the water, even more than I cared about eating."

Two years before, the boys had only dared to wade, but now they were ready to learn to swim. To that end, they invented water wings. Al and Harry picked and chose among the spongy reeds that grew by the water's edge, gathered them in a bundle, and tied them tight in the middle with a piece of rope. Later they made boats out of reeds. The boys also had fun with a sturdy, bamboo-like vegetation that grew near the lake. If you broke the sticks apart into segments, you could blow bubbles in the water. The boys had heard their grandfather talk about the time during World War I when he, Lifa, Moise, and some other Jews from town had hidden from a murderous Bolshevik rampage by submerging themselves entirely in the lake, breathing through these reedy straws. Al and Harry tried this technique out for fun.

To put a finishing indoor touch to an outdoor day, the brothers

might take in a free movie at their Uncle Moise's oddly named Bango Theater. No one knows how the theater got its name, but Al thinks it might reflect the frequent subtitle "Bang Bang" (as in "Bang! Bang! You're dead") that appeared at the bottom of the screen during gangster and cowboy movies. However, those Lithuanians in the audience who could read pronounced the English word *bang* as "bong," so that although the theater was named the Bango it was pronounced "Bongo," as in "Bong! Bong! You're dead."

If landing in Zarasai from Savannah was a moon shot for Al, a night at the movies was at least as disorienting and unnerving for the rustic peasants who made up the majority of the audience, since the short silent films were especially chosen for their capacity to engender shock and awe. A moviemaker would set up a camera on a railroad track and film an oncoming locomotive that, when shown,

would seem to be rushing headlong into the audience, most of whom had never seen a train. Another terrifying short subject featured a mastiff lunging repeatedly at the camera, drool dripping from its bared fangs. Children cried. Sometimes the peasants fled the theater. One man threw his cane at the dog. All of this mayhem was going on to the inappropriate accompaniment of schmaltzy Russian songs played on a scratchy gramophone. Meanwhile Al sat back and enjoyed the show. "It's hard to believe that anyone would not know this was just a picture, but they didn't." The Bango was a

place where the nineteenth and twentieth centuries clashed with a vengeance.

One night, a clip of a film featuring a Moscow Cossack choir would, like the plausible impossibility of Moses sliding off Mount Sinai, open Al's mind up to a whole new world of the ridiculous that years later he would bring to artistic realization in the pages of *MAD*.

"First, the choir members marched in and lined up in three or four rows. Then the guy with the baton began to conduct and the choir started singing, except that while their mouths were moving, no sounds were coming out. Finally the guy who was manning the gramophone got the thing going, but by then they were totally out of sync. When they had finished singing, the choir marched off. Only this time their mouths were closed, but they were still singing. That absurdity of timing struck me as the funniest comedy I'd ever seen."

Sleds and skates dominated play during the long winters. Wooden skates were made locally. Al never managed to get a pair, but he did get a sled. In the winter, when the peasants couldn't grow crops, they'd try to earn some money making many items, among them sleds. They'd take a piece of oak, steam it, and bend it around to form a little platform on which to mount the runners. Then a smith would fashion bent steel runners and attach them to the sled. There were no nails. Everything was wound and secured with local reeds and rope.

"Once a peddler came down the road with five or six of these sleds on his shoulder. I had never had my own sled, even though I'd been begging for one. This time my mother went out and bought one. Every once in a while she came through." Al had been hoping for one of the beautifully handcrafted ones made by the local peasants and decorated in the centuries-old European tradition, a sled like the one that Berke Lintup's mother had bought him. "Instead, she fell for one that looked like a Flexible Flyer. Maybe it was imported. Maybe part of her was still attached to buying American."

Typically, Al, already the mad inventor, couldn't leave well enough alone. He knew how fast these sleds could go, especially if you headed them downhill in the direction of the lake. He nailed four poles to a

plywood base, added a piece of plywood on top for liftoff, and launched himself down the hill. "I figured I'd go flying, and I did. Partway down the hill, the sled hit an obstruction and the nails holding the plywood base came loose. I almost chopped off the end of my middle finger, which was caught between the base and the sled. I wrapped a rag around the injury and ignored it." So did his mother, assuming she ever even noticed. Nor, it seems, did anyone notice the pre-gangrenous odor that increased daily. "About a week later I was visiting my crippled cousin, Chaya. She unwrapped the rag, and the

nail fell off. She tended to my finger and bandaged it properly. My mother didn't notice that either."

When they weren't sledding or swimming, the brothers and their friends found plenty to engage their interest just hanging around the town square. They'd stop at the Musil family grocery store, where Mr. Musil would invariably offer them a piece of candy. Better yet, he would climb down the wooden ladder that led to his cold cellar and emerge with a crystallized apple or pear. Even though the grocery store, like all the stores in town, was unlit and therefore always gloomy, for the boys it was a cheerful place. Mr. Musil would watch with satisfaction while Al and Harry sucked greedily at the delicious fruit. "Good?" he'd ask rhetorically. "Good like wine?"

Like kids everywhere, Al and Harry and their friends were drawn to the thrill of danger. During the day, if they were feeling brave enough, they played hide-and-go-seek in what Al and his friends called the *moyershe krumin,* the "scary stores," a large building that housed small shops that had been gutted during World War I. Nighttime offered even more terrifying possibilities. The gang didn't dare approach the cemetery from which, it was believed, the dead rose, walked among the trees, and went to the synagogue to pray. But they did summon the courage to hide out in the high balcony of the main shul looking for and hoping not to see *shaydem*** that were rumored to float around haunting the place.

Playing amateur archaeologist was another source of fun and giddy terror. The skeletons that had been unearthed in front of Moshe Jaffee's record store two years earlier only whetted their appetites for further exploration. The boys walked about, their eyes trained on the ground, looking for clues—sometimes a bit of paper or a coin—that suggested a promising excavation site. Digging with sticks and their bare hands, they unearthed boxes full of worthless treasure—badly deteriorated paper money and czarist rubles that had probably been buried as the German soldiers advanced in 1917. They made their most spectacular find when they were digging

* Demons.

right next to Berke Lintup's house. "We came upon old circular medallions that said GOTT MIT UNS,* and I remember thinking, 'Oh my God, the Germans spoke Yiddish.' I told my friends and they all agreed. We didn't realize that Yiddish is based on German, not the other way around. Then we started to find machine-gun bullets—lots of them. The number eighty-six sticks in my head.

"What to do with the bullets? I got a great idea to knock off all the bullet heads by banging the tops off with rocks and then emptying the powder into an earthenware flower pot. We all could have

* God with us.

78

been blown to kingdom come. Then I initiated a discussion about all kinds of devastating things we might do with the gunpowder.

"Everybody hated the rebbe at the cheder because he used to hit. He had a cane, and if you didn't do your lesson properly, he hit you across the hand, like to break your fingers. We made up a song about the rebbe, whose name was Yosche, the slang word for 'defecate.' Whenever he would stagger into the outhouse, we kids would start singing, '*Yesh-che, drish-che, shmear die vent,*' suggesting that the rabbi was going to defecate and afterward he was going to wipe his behind with his hands, and then smear his hands on the outhouse walls, the evidence of which was always there. Most people wiped themselves with their own hands. There was no toilet paper or newspapers. There were no Montgomery Ward catalogs either. I didn't go to the cheder, but I suggested to my friends who did that when the rebbe went to the outhouse for his daily crap, we could put a fuse in the flower pot, light it, and throw it under the outhouse. Little did I realize that if that thing blew up, this guy would fly about a thousand feet in the air. We threw our bottle bomb and ran. Luckily for us and the rebbe, our bomb didn't go off. I still get these crazy ideas. People should be very careful about following them. *I* should be very careful about following them."

Toys were scarce in Zarasai, and what few showed up in the marketplace were made of straw. But that didn't mean that Al and his friends felt deprived. "There was something appealing and exciting about making your own toys. At the same time that parents were buying hoops and jacks for their children at the five-and-ten-cent stores in the United States, the shtetl kids were begging hoops from the local barrel makers and ironmongers and making jacks out of clay. With a spool, a stick, some string, and a propeller cut from tin, aerodynamically shaped for maximum liftoff, Al and Harry amazed their friends by pulling stoutly on the string and launching the propeller fifty feet in the air. "We even made our own fishing line out of hairs we'd yank from the tails of white horses. One of my friends showed me how to braid three hairs together by knotting them at one end and rolling the hairs between my thumb and index finger. I was extremely skeptical at first—I thought the whole thing would come

apart—but it didn't. We made the bobbers from discarded wine-bottle corks. The only manufactured part we needed was the hook."

This childhood pleasure of making things from virtually nothing would turn Al into a lifelong scavenger and inventor who prefers homemade to store-bought. He would forever covet garbage. The sight of four metal tubes protruding out of a trash bin would beckon to be turned into the legs of a coffee table. While other artists dipped their brushes into pots of paint, Al would use the tops of spent seltzer

FISHING EQUIPMENT ZARASAI-STYLE

Supplies needed: Goose quill, cork, sapling, white horsetail hairs, fish-hook, worm.

1. Remove feathers and cut quill into sections slightly longer than cork.
2. Drill hole in cork, insert largest quill section.
3. Braid horsetail hairs and tie together to form fishing line.
4. Push line through quill in cork and insert a thin section to hold line.
5. Attach line to pole, hook to line, and worm to hook. Go fish.

bottles. When his tennis partners threw their tennis cans into the trash, Al would retrieve them and make vases, sconces, and bird feeders. In his adult life, Harry would carry this tendency to extremes, cutting the cuffs off of worn-out pants to make himself hats and filling his apartment with furniture he constructed entirely of cardboard.

Unlike their American counterparts who drove their hoops with sticks, Harry and Al navigated theirs by means of a wire they'd bend into a U shape. "The challenge was to keep the hoop going. We wandered everywhere, steering our hoops up and down hills and around corners that required expert maneuvering." So did a local variant of the hoop, a kind of crude push toy, a wheel on a wire. "You looked for a round log, and you had someone cut off a two-inch-thick piece. Then you drilled a hole and put a wire through it and you pushed it around."

One day when Al was rolling his hoop through town, he encountered trouble in the form of Simeonka's *Shaygetz* (Simon's gentile son), a Lithuanian bully, navigating his wheel on a wire. "The mere mention of Simeonka's Shaygetz's name struck terror into all the little Jewish kids. It was like *High Noon* whenever this kid, this *bulvan*,[*] came down the street. Everybody would be jumping into windows, over fences, running all over the place. This time I decided to stay put. I just felt that a tough guy from America doesn't go running like that, so I stayed put, provoking Simeonka's Shaygetz to spit out the Russian equivalent of 'Go to the devil, you filthy Jew.'"[†]

Still undeterred, Al stepped fearlessly into his path. "I believe I called out to him in Russian, '*Ya, Amerikansky!* I'm American! I am not afraid.' Something like that. My Russian wasn't very good at the time. The next thing I know I'm being awakened across the street at Berke Lintup's house, where they're putting cold compresses on my head."

* Man built like an ox; coarse, rude person.
† *"Idik chertu, zhid."*

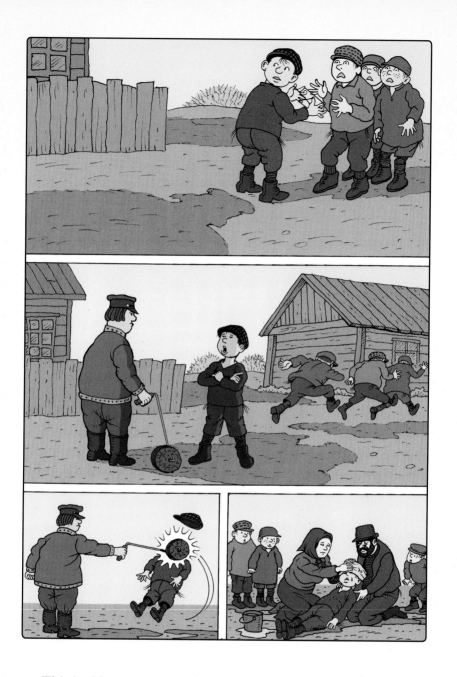

This incident permanently extinguished in Al what had been a childhood passion for confrontation. "I suffered an abrupt personality change after being hit by a log. Ever since then, even when I'm completely in the right, I back down from confrontations. I ask myself, 'What would John Wayne do?' And then I do the opposite. I'm afraid of becoming a babbling idiot. Anger overwhelms me.

Maybe it's the anger of wanting to get back and kill that son of a bitch who hit me over the head with a log, and I know I never can. This fear of confrontation pisses off my wife, Joyce. It bothered my first wife, Ruth, too. My women have never been too happy about my cowardice. They want the warrior."

At one point during their career in Zarasai, Al's and Harry's passion for innovation took a turn toward alchemy and the boys became preoccupied with the idea of making ink out of horse chestnuts. "I loved the chestnuts. They grew inside of a prickly shell, the size of a peach. When they were ripe, one of the favorite pastimes for kids was to knock them down with a rock or stick and crack open the shell. You'd get this beautiful chestnut. No one would eat them, but we collected a wagonload of them. We tried cooking them for days, but all we got were charcoal chestnuts."

When the ink caper failed, Al and Harry switched their attention to the making and selling of penholders. "We were pretending to be little shopkeepers, like the grown-ups. Entrepreneurship was in the air. We were doing the equivalent of an American kid's lemonade stand. What Lithuanians called *le Crise,* the impending Depression, was being felt in Zarasai, and everyone was trying to make some extra centimes. Penholders may seem an esoteric product, but in Zarasai, where everyone used pens, we were dealing in a basic necessity. We

carved the penholders out of wood, colored them, waxed them, and tried to sell them to the other kids, but they, like most of the adults we were imitating, didn't have any money."

Mostly, when it came to ingenuity, Al and Harry led the pack, but it was the native shtetl kids who showed the boys how to make balls out of the hair from molting cattle. Karolka's cow was a major donor. "By rubbing her flanks, you could grab a fistful of hair, which was

usually wet with perspiration. We would mold it into a ball until it got dense enough to bounce off the side of a barn. I suppose this is how people made balls for their children to play with going way back into history. It's curious to me that I lived in such a backward country that we made balls out of cow hair, whereas at the same time in Germany and the U.S., they were manufacturing rubber balls and baseballs."

Although some aspects of primitive life appealed to Al's and Harry's sense of adventure, nothing—not the outhouses, not the wolves—had prepared them for the horror they felt one day when they saw a peasant woman sawing the head off Karolka's cow. "The cow was our friend. We loved her. We had just come back home from downtown. We noticed the cow was not in her usual place, between our cottage and the barn. We found her in a little clearing very near the sauna. We snuck up and hid behind some bushes. The cow was standing but too sick to try to get away. This woman was dressed in an abbreviated babushka and a typical peasant dress. She was a *shtarker,** a farm lady, a slaughterer for all I know. She held the poor cow's horn and was slicing away at its neck from beneath. A big pool of blood was forming at her feet. We must have made some noise because suddenly she's brandishing

* Powerful person.

this big knife at us—it was like a scimitar—and she's yelling, *'Ve kroyh yite-ze.'** We ran out of there. Talk about traumatic sexual experiences!

"Later I was talking to Karolka about how sad I was. He showed me a piece of wire about four inches long, wire that in all probability was snipped off from some fencing around the tomatoes and must have flown into the haystack. It was in the cow's internal organs, but it didn't kill the cow immediately. For weeks and weeks she stopped eating and giving milk. She was dying, he said, so it was better to slaughter her before she suffered any more. The meat was okay to eat, he said, because she hadn't died of poisoning. I had dinner at Karolka's a lot. I hope I never ate her."

Their friends introduced Al and Harry to their favorite games—*lapta* ("lap-*ta*") and soccer. *Lapta*, similar to baseball, was the gang's favorite pastime. They played it as it had been played centuries earlier. "At first it appeared to be a simple game requiring only a big stick and a little stick. But once you got into it—think of American baseball—the game could get very complicated, with techniques, scores, and statistics. The little stick was carved and tapered to a point at each end. You would put it on the ground and hit it, and

* "I'm going to cut your balls off."

because it was tapered, it would fly up into the air and then you would hit it with the big stick and try to run to the base and back. Someone out there would try to catch the little stick and run after you and tag you. I was amused about fifty or so years ago when I heard that the Russians claimed they had invented baseball in the fourteenth century. Thinking back to *lapta,* maybe they did."

Al longed for a soccer ball. He was eager to show his pals that they didn't have to kick around a crude ball made of sweaty cow hair. Al's mother was always encouraging him to write to his father asking for things. "We are hungry," she coached him to say. "We are cold. We need books to read." Into one of these letters, Al slipped a request for a soccer ball. "Next to *lapta,* soccer was the most popular sport in Zarasai. I wanted to make a huge impression on my friends by having my father send a real soccer ball. I bragged to all of them that my rich

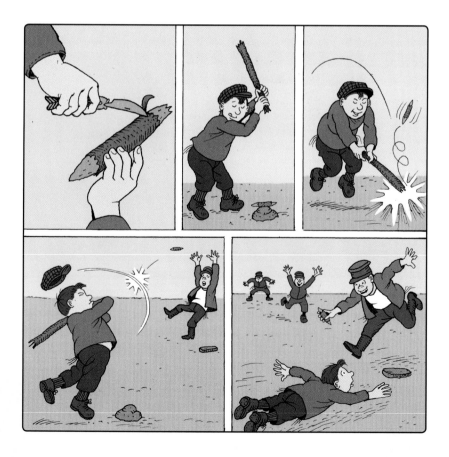

American father was sending a football. This is a *foot*ball, after all, I reasoned. You kick it with your foot. The language difference never entered my mind. I wrote a pleading letter and waited for months and months. Finally, this misshapen ball arrives. An American football to those kids is a totally bungled soccer ball. Can you imagine if you've never in your life before heard of anything but a round ball, and someone sends a magnificently made leather ball that's shaped like a cigar? My ego was on the line. I would have been a laughing-stock. The amount of disappointment I felt could not be measured. I don't think I showed it to anybody. I think I buried the thing.

"I was trying to keep a bridge between me and my father, but I couldn't bring America to Lithuania, and we, in Lithuania, could not get to America." Although their father would continue to send the funnies, money orders, letters, and gifts, with each passing year even this minimal contact dwindled to the point where Al lost all hope of ever seeing him again. Morris became more and more out of touch with how old his children were. "By now I was almost eleven years old and Harry was nearly nine. Time froze for my father. When

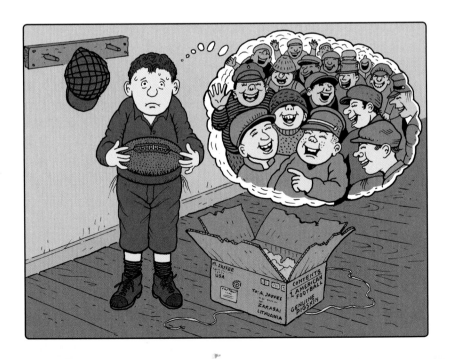

we asked for books, he would send us kindergarten books—*Sean of Ireland* or *Tom Sawyer*—with one line per page. 'Tom is painting the fence.' He would write us these very simple short notes. 'I miss you. Someday we'll all be together.' I learned later that he had gone into a big decline and was very seriously depressed. He simply stopped knowing what to do. I think that he, too, was giving up hope."

THE MONTHS PASSED; it was 1931. Al was ten; Harry, eight and a half. By now they felt quite at home, although "home" often meant somebody else's house. At the cottage they usually ate standing up and at different times. At their grandfather's, Karolka's, or Chaya's, or at Chaimke Musil's, everyone ate together around a table, like a family.

"We loved going into Chaimke's house. It had dirt floors and lots of little warrenlike rooms to play in." Mrs. Musil excelled in treats for hungry boys. At harvesttime, she would cut the sweet-tasting cores out of cabbages from the large garden in back of the house and offer them to Al and Harry. In the backyard, next to the *succah,* the Musils had a huge earthenware oven. Mrs. Musil baked once a week. Most of the bread was meant to be sold at their store in town, but she'd set aside one loaf for Chaimke and his pals. "We'd hang around and play there all day, and when the loaves came out, Chaimke's mother would divide one down the middle, cut out slices, smear them with butter, sprinkle them with honey or sugar, and give one to each of us. She'd send us off to sit on the front porch. 'Wait until they cool off or you'll get a stomachache,' she would call after us. That bread was like eating watermelon—you'd have this big warm slice covered with goodies. It was heavenly." At the Musils', food was love.

"Chaimke Musil's house was a warm place for us. They were family. We were invited for dinner very often. We enjoyed ourselves so much that we would stay until it was dark. 'Don't you think you should go home?' Mrs. Musil would remind us; she was concerned that we wouldn't be able to find our way in the dark. But we'd always say, 'Sure, we'll go home soon.' We never wanted to leave. We sat at a huge table, and whatever they had they shared with us. We would bask in this warmth."

One night around the dinner table Mr. and Mrs. Musil and some guests were talking with great animation about something that had taken place that afternoon in the square. It didn't take long for Al to realize that he had witnessed that mysterious something. "I was hanging out around the town square when a cowering woman was let out of jail. A mob gathered and followed her screaming a Russian word, *blyad*, over and over and louder and louder. The poor woman was sobbing hysterically. Since I did not know the word's meaning, I didn't know if I should feel sorry for her or join the crowd and yell."

Al listened to the grown-ups as their voices rose in excitement and fell in secrecy. When there was a pause in the conversation Al seized the opportunity to get his question answered. "What is a *blyad*?" His words met with total silence. "You would have thought I'd farted. Everyone dug into their soup. I later learned that the word was Russian for 'whore.' To break the embarrassing silence, Mrs. Musil made a big deal out of noticing how dark it was getting outside. 'Don't you think you boys should go home soon?' I felt for this poor, sobbing woman. After all, my mother was called names, too, just because we lived in Karolka's compound without my mother's husband."

Al and Harry left the Musils' promptly and soon found them-
selves in the middle of nowhere. "It was pitch black. The moon
wasn't out, so we couldn't see a foot in front of ourselves, and we
had a five-kilometer walk in the snow back to Karolka's cottage. We
heard wolves howling in the distance, and all we could figure was
that the wolves were coming in a pack and they were going to get us
any moment."

Al could not help but be affected by the seminal Eastern Euro-
pean folktales that seized the imaginations of adults and children
he lived among. He did, in fact, live in that cautionary world of snow
maidens, wolves, woodsmen, and wicked witches such as Baba Yaga

who ate orphan children lost in the forests. "By the last couple of kilometers I was in a terrible panic—but not Harry.

"From now on," Al told Harry, "I'm not going to stay out so late. I'm scared of the wolves."

"I'm not," Harry answered, pulling out a gun he had carved out of wood. "If the wolves come, I'll point my gun at them."

"So I said, 'Harry, we know this is a gun, but the wolf doesn't know this is a gun. Besides, it's not a real gun. You can't shoot him with it. This isn't going to do us any good at all.' "

Some, who didn't know better, might view Harry as merely a bit naïve for his age, but, even at the time, Al was beginning to think that maybe his brother and dearest friend was more strange than naïve. "In a primitive society that doesn't have eight psychiatrists to every square foot, and fourteen teachers who think they're psychiatrists, and parents who read all the health columns in the *New York Times* and *Good Housekeeping*—in a country that has none of that, how do you know what unusual behavior is? There were no diagnoses in Zarasai, only nicknames: Yudel *'der knacker,* Avrom *der putz,†* Moshe *der gonif,‡* or Lifka *die meshuggeneh,§* a sixteen-year-old young woman who flung her used menstrual rags on her front lawn." Al and his friends thought she was dying.

Al has no idea why, in 1932, his mother moved the family from Zarasai to the heavily Jewish Slobodka district in the capital city of Kaunas. Perhaps he never knew. What he does remember is how intensely he hated the place, much as he had despised the hellish interregnum year he spent in Far Rockaway between the two trips to Zarasai. "I may be mentally blocking memories of Kaunas because in retrospect, Kaunas made Zarasai look good."

Once again he was called upon to adapt, and once again he did, but not without paying a price. To this day Al gets terrible stomachaches whenever he has to change places, no doubt an intestinal homage to the perils of traveling with Mildred Jaffee.

* Big shot.
† Jerk.
‡ Thief.
§ Crazy woman.

About the time that the Jaffees arrived in Kaunas, Lithuania's golden age was coming to an end. Anti-Semitism was taking hold. In 1930, on the economic front, an organization of Lithuanian workers and traders whose slogan was "Lithuania for the Lithuanians" had made it increasingly difficult for Jews to compete with Lithuanian cooperatives that enjoyed tax privileges. On the political front, President Antanas Smetona was preparing the way for Hitler by suppressing parliament and assuming authoritative powers. Al paid no attention to politics, but he knew that Smetona was "bad for the Jews." What most intrigued him, though, was that Smetona's name sounded like *smetana,* which is Russian for "sour cream." "We all had closeted laughs about this tyrant."

Kaunas had become the de facto center of Lithuanian Jewry and culture after Vilnius was incorporated into Poland in 1922. There were three Yiddish daily papers in Kaunas, assorted journals, a Hebrew theater, sports clubs, Hebrew banks, and youth organizations. One-third of the population was Jewish. Slobodka, though not yet a ghetto—it would become one in 1941 when the Nazis herded Kaunas's Jews into the already crowded district—was a well-known center of orthodoxy and learning. Large, the size of the Warsaw Ghetto, Slobodka was a place where Jews could keep completely to themselves, practice their traditions, and rely exclusively upon Jewish doctors, lawyers, and other professionals without ever having to come into contact with the outside world. Maybe that's why Mildred moved to Slobodka—to burrow even more deeply and completely into Jewishness. To do so she gave up the comfortable familiarity of her hometown, her shul, and her relatives. For their part, Al and Harry had to give up their unfettered freedom, their playmates, their friends and relatives, the beauty and bounty of the woods and countryside of a place they had come to call home, and, most critically, Karolka, their friend and protector.

Even though Kaunas was a twentieth-century European city, Al wasn't impressed. The tall buildings, cars, trains, and buses of his earliest childhood days in Savannah left him cold. "I know I played in the street with other kids—we built snow houses and had snow fights—but I don't remember a friend, I don't remember a name. And to make matters worse, the cartoons stopped coming. We knew

nothing of my father anymore. We didn't think we'd ever go back to America."

Mildred Jaffee took this opportunity, however belated, to enroll both Al and Harry in yeshiva (an even more religious school than the cheder), where they became the hapless victims of its cheerless rigors and rote demands. "The yeshiva we attended was in Kaunas, even though Slobodka had shuls on every corner. We lived on the top floor of a three-story wooden house on a small mercantile street. If you looked out the window in one direction there was a shul and a store. Look out in the other direction? Another shul, another store. My mother was surrounded by *Yiddishkeit.** She loved it."

Al went to the yeshiva every day, but once there he adhered to a policy of passive resistance. Although he was obliged to dress "like a bellhop" in his itchy yeshiva uniform, he drew the line at further conformity. "I refused to learn the prayers." While other children *shuckled*† and *dovaned,*‡ Al refused. "I never said a word of Hebrew. I faked it. Essentially, I think it was my American background saying, 'What am I doing standing here with all these people shaking back and forth?'"

Only ambivalence can define why many years later, while working at *MAD,* Al would cheerfully agree to contribute original cartoons for practically no money to the *Moshiach* (Messiah) *Times,* a completely religious magazine, generated in New York and published by the Lubavitcher sect for Orthodox Jewish children who *shuckled* and *dovaned.* To this day he continues to draw cartoons for them, doing his Talmudic best to draw only kosher animals, those with cloven hooves, and to avoid depicting mice, which are also not kosher. The assignment of a barnyard scene posed a particular challenge. Pigs, of course, were out. So were horses, cats, dogs, and any other creature that was without cloven hooves and did not chew its cud. When Al got done with it, Old MacDonald's kosher farm included a cow, some deer, a moose, and an antelope.

* Jewishness.
† Swayed while praying.
‡ Prayed.

"I have a warm relationship with my editor, Dovid Sholom Pape. Even though I abandoned all of the religious zealotry years ago in Lithuania, I like the kind and gentle souls of the people of Orthodoxy. Or maybe I'm doing penance for my mother. I keep asking Dovid, 'Where was our God while they were roasting our people?' I know it's an elementary question, but I still haven't gotten an elementary answer."

THE TRIP ACROSS THE RIVER, which they made daily to attend yeshiva, was almost as fearsome in its urban way as the walk through the woods from the Musils' to Karolka's had been in the outskirts of Zarasai. The houses reminded Al of a scene from a silent movie, *The Cabinet of Dr. Caligari,* where the stark, angular buildings that lined the road seemed to lean menacingly toward one another. Still, it was worth the scary journey, especially when their destination was Uncle Moise's Bango movie theater.

It was through the movies that twelve-year-old Al began to develop an adult emotional repertoire. He fell deeply in love with Clara Bow. He envied the handsome Gustav Frölich, who always got the girl. In a world of beautiful people, Al, so sure he was ugly, wondered if he'd ever succeed with women. *Uncle Tom's Cabin* elicited his first feelings of compassion. "I felt so bad for this poor slave woman, holding her baby, jumping from ice floe to ice floe." Another silent film, *Taras Bulba,* about the medieval conflict between the Lithuanians and the Poles, suffused him with passionate pro-Lithuanian patriotism. He was growing into a man. Even so, Al never outgrew his adolescent enthusiasm for slapstick. "To this day, my favorite comedians are one of the world's first film comedy duos, the tall and short slapstick Danish team of Pat and Patachon, the models for Laurel and Hardy, and Abbott and Costello."

Their only Jaffee relatives in Kaunas were two brothers, Naftolka and Fishke Simetz, who were probably related to the Gordons. Like the relatives in Zarasai, they moved in to fill the emotional and nutritional void and inadvertently provided Al with yet another father substitute. "The older brother, Naftolka, was a big, powerful, virile guy. His brother was very effeminate. Ironically, Fishke was

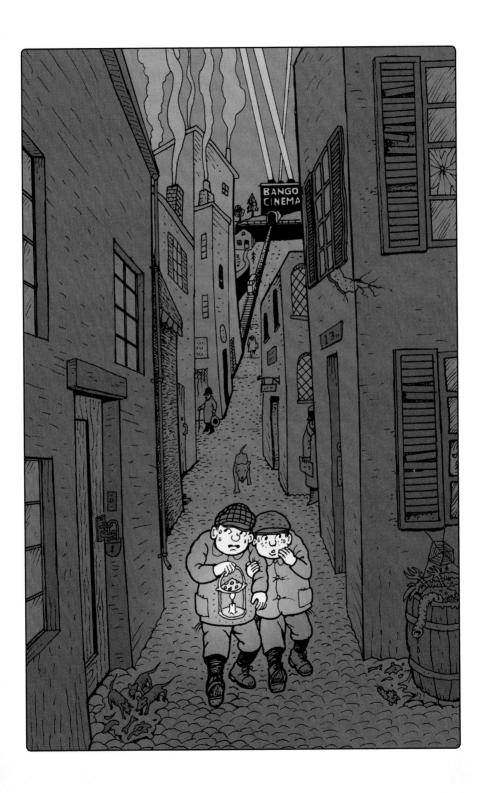

the only one who survived and got to this country. I should go find him, but I hate to retrace those terrible years.

"Once a week, Harry and I would visit the Simetzes for a meal of sprat sandwiches and a glass of milk. Harry loved the sardine-like sandwiches so much that even back in America, when he was fifty years old, he kept trying to replicate that meal, but he could never find the Russian soldier's bread (*soldatskee khleb*) he enjoyed in Lithuania. The sandwiches must have given Harry such a great lift. He considered them a delicacy. I ate because I was hungry."

Mildred continued to be far more involved in her religious life than she was in the lives of her children. "Some of the time we were locked in. We were on the third floor and there weren't any fire escapes, so we just did whatever we could. She left us some food—butter mashed with cheese—and a pail for our bathroom needs. Once we were locked in for two days, but a bag full of defective wooden yo-yos—maybe my mother got them somewhere—kept us amused. We built buses and cars. We used whatever we had— cardboard, wood, pieces of string. From these basic materials, we were able to rig the front wheels with string so that we could steer the vehicles from behind by pushing them with our thumbs. My mother wasn't home, so we moved all the furniture around and set the whole apartment up as a racecourse. Making things was every bit as important as drawing.

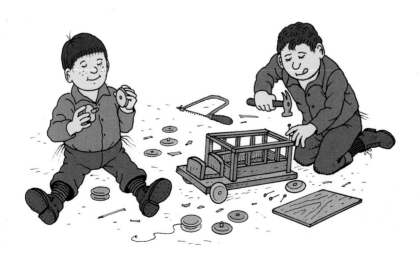

"I don't remember thinking I had a special talent, but Harry amazed me. Harry was the brilliant inventor and engineer. In Kaunas, Harry built a remarkable toy fire engine that actually squirted water. He spent weeks making little ladders out of matchsticks. He could have built the Taj Mahal out of matchsticks. I would have stopped after the fifth matchstick. My talent is creative, more in the humorous, fantasy realm. That's my biggest problem. If I'm going to satirize something, it has to have some semblance of accuracy, so I have to do research. It slows me down and I hate it."

January 21, 1933, marked a turning point in Al's life, although he didn't know it at the time. It was a bright sunny day in Slobodka. "I went outdoors. There was no one on the street. It wasn't a Jewish holiday, which could have accounted for why the streets were deserted. I tiptoed around. It occurred to me to go to the nearby grocery store, where Harry and I bought candy whenever we had a couple of centimes. I walked inside. The store was filled with people. Many of them were crying. I asked the proprietor what was happening. She told me that Hitler had taken over Germany. I didn't know what Hitler was. I wasn't very concerned about it."

On one of the brothers' weekly visits to the Simetzes, a smiling Naftolka met them at the door. With a grand gesture he waved us in, saying "Come in, come in, I've got a big surprise for you today."

The surprise was Morris Jaffee. "After four years, there was my father. He was smoking a Lucky Strike. He reached his arms out. I moved reluctantly toward him. I knew who he was, but I wasn't all that comfortable about being embraced. I remember having very funny feelings. All these American things were coming at me: my father, Lucky Strikes, the way he was dressed. 'Go tell your mother that I'm here and I'm going to take everyone back to America,' he said.

"I didn't think that this was going to be a particularly good turning point in my life either. What did begin to seem okay was that if I went to America, I could get out of this ridiculous yeshiva; I wouldn't have to dress like a bellhop and *dovan*."

Morris could not have afforded passage for himself, his wife, and his children on his meager earnings as a part-time letter carrier. Al learned later that Morris Jaffee had appealed to his relatively wealthy brother, Harry, for money to make this second rescue mission to Lithuania. Harry, in turn, appealed to Morris's other siblings and relatives to pitch in, and they did.

Al's parents had not seen each other in four years. Nevertheless, Mildred Jaffee refused to meet face-to-face with her husband. Instead Al was tapped to act as envoy between the two, carrying back and forth across the bridge Morris's pleadings to come to America and Mildred's refusals to leave Kaunas. "Ultimately an agreement was reached. My mother said she couldn't come with us, but it would be all right with her if our father took me, Harry, and Bernard, but not her favorite, David. She said she needed a little more time—six months—to put her affairs in order and then she'd join us.

"I asked my mother if she would come to the train station the next day to say good-bye to us, and she answered, 'Yes, my darlings.' We loved it when she called us 'darlings' and 'sweethearts.' I was tremendously anxious about what my mother was going to do. Would she come to the station, or wouldn't she? I thought I had become inured to the fact that what she said and what she did were seldom the same, but I got a stomachache anyway.

"So the next morning we're at the Kaunas railroad station. We wait on the platform. No Mother. Ultimately the conductor tells us that the train is about to leave and we must get on board; reluctantly we do. So now you've got one of those tearjerker scenes. Three little

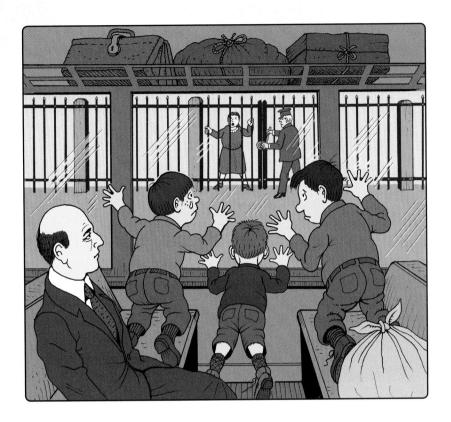

kids—Bernard is nine, Harry is ten, and I'm twelve—and our faces are pressed against the train window and our eyes are glued to the gate, which is right in front of us. Slowly a guy comes over and starts to close the iron gates that shut off access to the platform. No sign of our mother. When the gate is closed and the chain is locked, she shows up. She's got both hands on the bars, shaking them violently, trying to break them open. She really didn't recognize the formality of schedules. I think maybe departure and arrival times seem flexible when you grew up in the last century in small villages. You talk to somebody and ask him to open or close the gate. That would explain it. So there she is, trying to break the gate down. The train starts to pull out, and that was the end of that. The scene is etched in my mind forever. That was the last time I ever saw my mother."

The train took Al, his father, Harry, and Bernard to Memel, where they boarded a ferry that would take them across the notoriously rough Baltic Sea to Göteborg, Sweden. Morris had purposely

chosen to depart from Sweden rather than sail from Germany. Before the ferry embarked, the ever-curious Al toured the ship and behind a glass wall saw an oval table heaped with delicacies—meats, fish, pastries, and cakes—a spread the likes of which this dirt-poor boy had never seen or imagined. Perhaps he had been wrong. Perhaps this bounty—so soon to be his—was a promising sign that going back to America was a good idea.

The passengers were not allowed to pass through the glass enclosure until the ferry was under way. Al waited impatiently to gain entry to this extravaganza of a feast, but the moment the doors were opened the ferry started bucking and pitching, and Al spent the rest of the journey hanging over the railing. "I was so seasick, I never got to eat. I dreamed about that smorgasbord for many days afterward." On May 16, 1933, a depleted Al, his father, Harry, and Bernard boarded the *Gripsholm,* a Swedish boat sailing from Göteborg, bound for the Port of New York.

It was only the day before, when the brothers met their father at the Kaunas railroad station, that Morris Jaffee learned that Bernard was deaf and mute, something that Mildred had never mentioned in her letters.

"My father was traumatized by the news. As soon as we got settled on the *Gripsholm,* he took Bernard down to the engine room, thinking that maybe the terrible noises made by the spinning propellers, the pumps, and the generators would penetrate and somehow miraculously bring his hearing back. As it turned out, Bernard didn't hear a thing and was having a wonderful time examining the machinery. It was my father who was going deaf."

Although Al was only twelve, he was sought out by the purser as the only other passenger on the ship who might be able to communicate with a Lithuanian woman who was crying hysterically and incomprehensibly in the captain's quarters. "She was central casting's version of a Lithuanian peasant woman. She had braided, flaxen hair and wore typical peasant clothes. I managed to elicit from her the fact that she had suddenly realized that she would arrive in the big city of New York and not know how to get to Chicago, where she was to meet her husband, who had left Lithuania some years before and had finally saved enough money to send for her." She told Al that he took care of

a big building. "I didn't know what that meant at the time, but all too soon I would be living in a tenement myself and would understand that Lithuanians, Poles, and Czechs often took janitorial jobs because they got a free apartment and didn't have to speak English."

Al translated her fears to the captain, who assured her that she would be met at the dock by someone who would see to it that she got on a train to Chicago. The young woman was so grateful to Al for his help that she invited him to her cabin to show him the present she was bringing to her husband—a beautiful, lovingly hand-crafted sickle. "My notion of humor and satire and the ridiculousness of life in general must have started at an early age. A sickle was a great present in the hinterlands of Lithuania, but what was a janitor in Chicago going to do with it? In my crazy head, I saw the scenario in terms of a cartoon sequence. She hands him the sickle, her eyes bright with anticipation. I picture him looking at it, his eyes rolling."

Strange as it may seem, during their ten-day journey on the *Gripsholm,* Al never asked his father where they were going to live once they landed in New York. He didn't even wonder to himself. "What was the point of asking, 'Where in America are you taking us?'" Wherever his mother had taken him, he had gone. Wherever his father was taking him, he would go there too. "I had gotten to the point in my life where I just let things happen. I kind of shut off."

4

SLEEP FASTER,
WE NEED THE PILLOWS

"I am a reverse
immigrant."

AL'S PREMONITION THAT coming back to America might not be
"a particularly good turning point" was immediately realized. He
learned that for the first time in his life he would be separated from
his brothers, and they from one another. This second rescue had
depleted his father financially and psychologically. Instead of a
family life, Al would embark on a lonely Bronx odyssey that would
take him to at least eight different households—none of them his
own—over a period of three years. (Frequent moves were common
during the Depression years, motivated by the inducement of two
months' free rent, a bonus Al's father couldn't afford to turn down.)
Some of the places Al would remember by their addresses only:
Kelly Street, Saint Paul's Place, Daly Avenue. Other households in
which he boarded were made memorable by the people he met and
the challenges he encountered as he continued to be moved about
by forces over which he had no control, living sometimes with rela-
tives, sometimes with strangers.

Uncle Harry met Morris and the three boys at the Port of New
York and drove them to the tenement apartment of his and Morris's
sister, Anna, in the Bronx. Uncle Harry, who had raised the money
to help Morris rescue his family from Kaunas, now took on the job

of presiding over their well-being in New York. Harry was the only relative who had the wherewithal to care for the impoverished Jaffee clan—a good job with the IRS, a car, and a kind heart. While Harry drove through New York with his human burden, Al took the measure of the city.

"What has our father brought us into? This place called New York is a slum. It's one hundred times worse than Lithuania," he thought as he looked out the car window at the dreary apartments and the cars, streetcars, and pushcarts competing for space with screaming kids, hustlers, and beggars. "There was noise and confusion everywhere. It was just so overwhelming I went into some kind of shock." That initial jolt was followed by the all-too-familiar experience of the immigrant sleepover—too many people, not enough beds—a situation that inspired the Yiddish saying "Sleep faster, we need the pillows."

The Jaffee boys arrived with not much more than their Eastern European clothes on their backs. "We were like hobos with our few possessions tied up in a cloth *bindle*."* They hung their coats on wooden pegs and endured the hugs and kisses of aunts with bad breath and prickly chin hairs. When it was bedtime, Al and Harry shared what Aunt Anna called the "lunge." They slept with their heads on the seat of the lounge and their torsos and legs resting on two kitchen chairs pulled up for that purpose. Harry cried himself to sleep. Al fought to keep himself calm, even though he was terrified. "I never knew what was coming next, and even if I did, there was nothing I could do about it." He never considered the possibility that what was coming next might be good.

In the morning the relatives gathered to participate in a cruel triage: What are we going to do with the *kinder*?† It was a given that nobody wanted or could afford to take all three kids; the Depression had affected them all. For the first time in their lives, the Jaffee boys would be split up. Harry responded with a tantrum. What would he do without Al? Bernard cried and frantically signed his grief to a father who didn't yet understand the crude sign language

* Bundle.
† Children.

the Jaffee boys had invented to communicate among themselves in Zarasai. Al was stoic, passive. "I learned not to question anything." The fact that he had lived with his brothers his whole life and now was about to be separated from them didn't enter into his conscious thoughts. "I was completely focused on surviving these new surroundings.

"Had I become totally unfeeling? I know that's not true. I don't think my feelings were distorted—they were rearranged a bit, that's for sure—but for me to get excited and agitated about being separated from Harry or Bernard would have led to an argument, and I had learned somewhere way back that carrying on got you nowhere or it got you punished. I don't remember complaining, 'Why can't you keep us all together? Why do you have to separate us?' I had learned to submit."

Harry would live in relative luxury with Uncle Harry and Aunt Pauline in Brooklyn, where he began a long career of aggressive behavior, upsetting the household by persistently picking on his cousin Bernice. Bernard would go to the New York School for the Deaf in Manhattan, where his immigrant status gave him one more handicap. To add to his misery, he had no home to go to when the other children went home for the weekends. Al, it was decided, would be sent to South Fallsburg in Sullivan County to live with the Cohen brothers. He'd overheard his fate while huddled with his father in a phone booth outside Aunt Anna's apartment. "We'll keep the kid for the summer, Morris, but in the fall he goes back to you."

If there had been television sitcoms in 1933, the Cohen brothers' domestic arrangement would have qualified for prime time. The brothers, Joseph and Morris, had married two Jaffee sisters, Sarah and Dora. Between them they had three children, Florence, Bernie, and Seymour. The brothers were partners in Cohen Brothers Printing Company, which produced brochures promoting Borscht Belt hotels. Both families lived over the printing shop in mirror-image railroad flats, joined by a connecting door. Even though their apartments were identical, they were always grousing about who had the better place. From May through August, Al would move from one apartment to the other, living alternate

months with alternate Cohens, sleeping in their alternate sun-porches. "In either case, someone was stuck with me."

Not much of the school year remained when Al arrived in South Fallsburg, and truancy was no longer an option. "I couldn't believe what was happening to me. I was a big, husky twelve-year-old. The teachers put me in the third grade. I couldn't fit into the seats. The first day we're all shlepped outside, where there's a big pole in the ground. Each one of us was given a ribbon to hold. We were going to dance around something called the Maypole. I felt like eight feet tall, running around this pole with these little farts, singing a song about two lips, 'Tiptoe through the Tulips.' I'm prancing around this thing thinking, 'How can you tiptoe through somebody's lips?' I thought they were crazy. I wished I was back in Europe with sane people." With the exception of the miserable months he had spent

in Far Rockaway, Al had lived the last six years of his childhood in Lithuania. Be it ever so awful, Lithuania was home.

Culture shock caused Al to inadvertently insult his aunt Dora, who set out to please this poor, deprived little shtetl boy by saving her pennies and serving him a piece of cantaloupe, a rare and expensive treat in those Depression days. Al, who had never seen a cantaloupe, refused to eat it. Stunned and hurt, Aunt Dora said, "And what do you expect me to do with it?" Al responded by adding insult to injury. "Give it to the beggars," he said, drawing upon his experiences in Zarasai, where there were beggars on every corner eager to snap up his mother's table scraps or potato peelings. "I was on Dora's shit list from then on."

Repatriation did not come easily. It didn't help that Al had returned to his native land a reverse immigrant, wearing cobbled boots and speaking English with a Yiddish accent. "The kids called me 'greenhorn.'" As always, when confronted with a strange new scene, Al literally drew himself into the picture and began to make himself at home. He ingratiated himself with the other kids by drawing popular cartoon characters—this time in chalk on sidewalks. "I was very good at Popeye. I also found out that I could get laughs by making witty observations, or by drawing cartoons and having the characters say something funny. At first I used cartooning as a crutch, but soon it took on a life of its own."

Al enjoyed living in largely Jewish South Fallsburg. "It was like being in a modern American shtetl—but with bathrooms. The town even had an Orthodox shul nearby, one little movie theater, and one little school. It was small town, USA. It was to my scale. I liked to go down to the old railroad station to watch the huge locomotives come in and the happy passengers get off. I loved it there."

It was his twelve-year-old cousin Seymour who smoothed Al's transition to South Fallsburg, just as his Lithuanian cousin Danke had done during Al's first stay in Zarasai. "Seymour was such a wise kid. Everyone looked up to him. He was my mentor. He convinced me that not wearing a hat on my head all the time was not a sin. He got me to read my first English book—*Gulliver's Travels.* I labored over that. He introduced me to all his friends. He took me to the Neversink River to go fishing. We dived off the bridge, over the Old

Falls, and plunged into the swimming hole. He took me to my first backyard baseball game at the Levines' and bought me my first Tootsie Roll at Weinstein's candy store. Seymour taught me how to be an American. I had it all—well, almost all. It wasn't mine and it wouldn't last. I would always be an intruder."

In return, Al introduced Seymour to his world of mad inventions. The town was treating itself to a big Fourth of July celebration. One of the events was a downhill wagon race through town. He immediately enlisted Seymour in his project to design a wagon that would knock the citizenry's socks off. "Seymour and I found a rickety old wagon and fixed it up with an elaborate display. I put sparklers and firecrackers from Weinstein's on the wheels. Come that evening, we hauled this crazy wagon to the top of a big hill, lit the explosives, got in it, pushed off, and began our triumphant descent. We drew quite a crowd as this flaming wagon was going downhill, shooting off sparklers and fireworks in all directions. We were the talk of the town. We could have burned ourselves alive."

It was in the candy store, which sold a great deal more than ice cream and firecrackers, that Al discovered the comic book. It was called *Famous Funnies*, and it is generally credited as the first comic book ever. Al swooned with delight. "*Famous Funnies* was like taking the love of my life—the comic strip—and multiplying it to thirty-six pages. For ten cents you could buy an anthology of the most popular comics from the best syndicates. It blew me away." The next year Al thought he'd died and gone to comic heaven; *Famous Funnies* had almost doubled in size, to sixty-eight pages.

The publisher of *Famous Funnies* was pioneering Max Gaines, a printing salesman, who would later go on to publish Educational Comics (EC). After his father's death in a boating accident in 1947, William "Bill" Gaines, inherited EC and changed the editorial direction of the company toward horror, science fiction, and satire—and the name of the company to Entertaining Comics. His most successful satiric publication would be *MAD* magazine. (Not blessed with the gift of prophecy, young Al could not appreciate the power of this moment at the time, although as an adult he enjoyed wondering about whether to credit coincidence or fate.)

"The Depression was solid. Printing presses were idle. Max Gaines went to the syndicates that were publishing newspaper comic strips like *Hairbreadth Harry* and *Boob McNutt* and asked them what they did with the plates after the comic strips appeared in the funnies. "Nothing," was the answer. "Go ahead, take whatever you want." Max put his presses back to work and hit the road, stopping at every candy store along the way. The deal was, "If you sell some, fine; if not, I'll pick them up later."

"In a few days, when Max came back, they were all gone. An industry was born. Originally, he had planned only one edition, but Max rushed to do a second 'collected works.' At some point the syndicates realized that they were giving away gold. They could do the same thing, after all."

Al spent a happy summer with the Cohens, and Seymour in particular, in South Fallsburg. He had everything a kid could want, including the strategic advantage of living over a candy store. But he didn't have the company of his own family, about which he could do nothing. Nor did he have the comfort of his own home. It didn't matter that the Cohens were nice to him. No matter where he would live in the next few years, no matter how well he was treated, the feeling that he was "a homeless, unwanted intruder" never left him, which is one reason why he built a clubhouse in South Fallsburg.

Seymour and Al had all the kids in the neighborhood rounding up pieces of wood. Al designed the clubhouse so that it had a gabled roof, like the houses in Zarasai. "It was a great feeling when there were six or seven kids keeping nice and warm and dry in something I'd built. Never mind that it was a ramshackle little clubhouse ham-

mered together by twelve-year-olds. The thing is that it kept out the rain. The house gave me a feeling of safety and protection. Every other place I lived in belonged to someone else. Nobody could march in and say, 'What are you doing here?' Nobody could push me around. This was my home, at last, a place I couldn't get kicked out of."

As the summer was coming to an end, Al began to receive letters from his father, reminding him that it would soon be time to return to New York and start school. He recalled the words spoken on his arrival in South Fallsburg. "Oh, I remember being so depressed by those letters." Al responded by writing an impassioned letter of his own, begging his father to allow him to stay in South Fallsburg. "If you need me to come to New York and go to work and bring money into the family, maybe I can do that here. I'll send you the money, but leave me here," he wrote. Al never mailed the letter. "I reread it. It sounded like such a sob-sister letter, or worse—like the way the

beggars in Zarasai tried to crawl into your sympathy. I faced the music. I knew what my fate was. It's like accepting the diagnosis of a terminal illness. First you rage, then you accept. I'm going to have to go back to this filthy city to a school I don't know, with kids I don't know, and it scares me to death."

This time Al's worst fears were realized. In September 1933 Al and his father boarded with Aunt Frieda's relatives. He thinks he was placed in the fourth grade at a school in the East Bronx near Saint Paul's Place and Crotona Park. From now on father and son would share single rooms and sleep together in a single bed. Their room was not much larger than a closet. In subsequent rentals there might be room enough for a little bureau or sometimes a chair.

The fact that Al was reunited with his father did not add to his sense of well-being. His once attentive, indulgent father, who had worked so hard for so many years to bring his boys home, was, for the one or two hours that he wasn't at work or asleep, angry, critical, and remote. "By this time I distrusted both my parents."

In the summer of 1934, after a dismal school year, Al once again found himself boarding in the Borscht Belt, just a few miles north of South Fallsburg on Route 42 near the town of Woodbourne. Perhaps the Cohen brothers would have taken him again for the summer, but this time Harry and Bernard needed summer lodgings as well, and the Cohens didn't have room for three boarders. Instead, there being no shortage of unrelated people named Cohen in the Catskills, the boys lived in the servants' quarters at Cohen's Villa, a hotel that had thrived before the Depression but was now carrying on with a reduced clientele and fewer servants. The boys took their meals in the servants' quarters, in a separate building that, with its generous rooms, may at one time have been the owner's home. "We shared one large room and one big bed and played hide-and-seek in the living room. We didn't get to participate in any of the shows, dances, or parties that were going on in the hotel, but we didn't mind. We were happy just to get into a bed that was big enough for all three of us and play gin rummy." It was while living in the servants' quarters that Harry once again displayed the hostile behavior that had begun when he was living with his uncle. He persistently tormented one of the servants' little

girls, reducing her to tears. He didn't stop until the child's father threatened to "knock his head off."

"Basically, we were contented because the place was bucolic, peaceful, and quiet like Lithuania and the grounds were simple and pretty." The hotel was large. A staircase led to a wide veranda that ran the length of the hotel where the guests would gather on rocking chairs to read their newspapers and chat. Al and his brothers weren't allowed in the hotel. Neither was the black troubadour who showed up one afternoon in his tin lizzie and sat on the porch entertaining the guests. "His shtick was singing Yiddish songs about *Mameleh** and songs I remembered from Lithuania like 'Vein Mein Shtetele Vein.'[†] I was absolutely flabbergasted. He had a good accent

* Mother.
† "Cry, my little town, cry."

for a greenhorn. Or a blackhorn. He might have gotten dinner, but he would have had to eat it on the steps of the hotel. There was a strict racial code at the time. Jews might have been liberal, but they weren't that liberal."

The summer before in South Fallsburg there had been a parade with a brass band featuring a monkey riding on a greyhound's back while a man with a megaphone shouted, "Come to the dog track." Al had never seen anything like that before; nor had he ever heard a black man singing in Yiddish. "There was very little that was surprising in Lithuania." By contrast, America kept presenting Al with fascinating, peculiar events.

The boys had little to do during the day. They weren't allowed off the hotel grounds, so they couldn't walk into town. This left them with the option of netting fish in a small pond on the property, until Mr. Cohen informed Al that they'd been fishing in a cesspool. "Thank God we didn't have access to the cooking facilities."

The summer took on purpose and excitement when the boys discovered a cache of lumber, a pail of nails, and a hammer in the crawlspace under the hotel. Al immediately envisioned another clubhouse, another home away from home. "Harry and I were both natural builders, but Harry was better than I. He had much more patience for infinite planning." They looked around the property for a place where no one would be likely to discover their construction site and decided to build behind the chicken coop. "We'd wait until no one was around, and we'd sneak over to the hotel, grab a board, and run like crazy behind the coop. We were always terrified that the Cohens would find out we'd been stealing and we'd be thrown out of the place, but they never did. Later, when Uncle Harry took us to visit Seymour and the Cohen brothers, Harry and I bragged to them about how we built an entire clubhouse on the hotel property and didn't get caught. And one of my uncles said, 'They knew about it while you were building it, but they were so pleased with the way it was turning out that they didn't want to stop you. They loved it. They turned it into another chicken coop.'"

In September of 1934, the Woodbourne summer idyll came to an end. Bernard returned to the New York School for the Deaf, Harry went back to live with Uncle Harry, and Al and his father

moved to another rented furnished room in an apartment at 2117 Vyse Avenue in the East Bronx. Their new landlord was a man redundantly named Pinchas Pincus. "Mr. Pincus, who must have been around sixty, was a spunky, dandy man with snow-white hair and a perfectly groomed white handlebar mustache that extended beyond his face. Mrs. Pincus—I never knew her first name. Even Mr. Pincus seemed not to know her name. He'd say, 'Mrs. Pincus, I think it's time for lunch now.' She was a squat, slow-moving, cheerful, voluble *balabusta.* She had dark hair tied in a bun. She looked like a grandma."

Like many adults of the time, Mr. and Mrs. Pincus were crazy about the comics, so much so that they had named their dog Sandy after Little Orphan Annie's. The whole country was fascinated by the Gumps, rich Uncle Bim and chinless Andy. *Blondie,* one of the hottest movies of the time, came out first as a comic strip in 1930 and then went on to inspire a movie series in 1938 and a radio show in 1939.

At midnight on Saturdays, grown-ups lined up at the newsstands waiting for the Sunday paper to be delivered. They were more interested in getting a jump on the funnies than they were in reading the front page. Monday mornings Al would go down to the basement where the super piled up the Sunday newspapers and swipe the comics.

The Pincuses weren't even "sort of relatives," but they eagerly welcomed Al and his father into their home, perhaps because they had lost a child in the influenza epidemic and saw in Al an opportunity to care for a motherless and nearly fatherless child. "Mrs. Pincus kept trying to feed me. Mr. Pincus wanted me to take walks with him and Sandy. They wanted to bring me into their bosom, they wanted to adopt me and turn me into an ideal American boy, and all I had to do was listen to them and be a nice, cooperative, docile kid. But I wasn't that kid; it was too late for me. I was almost thirteen years old, mixed up and independent. The more they tried to be nice to me, the worse I was to them. They wanted me to go into the living room with them and listen to radio shows like *Bobby Benson* and *The Lone*

* Homemaker.

Ranger. They were shocked that I didn't love *Little Orphan Annie.* It disgusted me that Pincus treated his dog like it was a human being. Why are they slobbering over this dog? Why are they letting this dog lick their faces? It's a dog—a fucking dog.

"I don't want people to turn me into something else, no matter how nice they are. The surest way to capture a slave is to offer him something. I'd gone through Europe with all kinds of religious people wanting to turn me into a yeshiva *bucher.** I didn't want to be somebody's surrogate son. Perhaps I felt so strongly about that because deep down I resented my parents' not being together, not being available, and not being my parents. If I can't have what's due me, I won't have anything."

One spring day, as Al and his father were returning to the Pincuses' from an outing at the Bronx Zoo, Morris collided with another man near Vyse Avenue. "My father, who had a very hot temper, said, 'Why the hell don't you watch where you're going?' and this giant turned around, grabbed my father, picked him up by his lapels, and said, 'Ya wanna fight?' My father kind of weaseled his way out of that predicament and walked away shaken. The guy called after him, 'I'll let you go this time, but next time I won't let you off so easy.' I felt a sickening mixture of fear and humiliation. The scales were falling from my eyes. I realized that my father was just a little, hardworking man. What I had been relying on was the protection of a big man, not a person who was shrinking before my eyes. What if I'm waiting someday and he never shows up? I couldn't see that there was anywhere to go from there."

Whether he liked it or not, Al, recently separated from his mother and his brothers, was now completely dependent upon his

* Student.

115

father. "For a number of days after that incident, I would wait for him to return from work. I knew approximately what time he was going to get off the 180th Street subway, so I would go to the corner of Vyse Avenue and look downhill toward the subway exit until he appeared. I felt great relief whenever I saw his gray fedora in the distance. This went on for a while until I felt reassured. My father was a small man, but he was the only protection I had."

It was after Al and his father were settled at the Pincuses' that Morris sent for his belongings, which had been stored at Aunt Anna's apartment. Among them was a cheap, battered, cardboard valise, barely held together by its metal fittings. "I clearly remember my father saying to me, 'You know the letters your mother had you send me, telling me you were starving?'" Morris put the bag on top of the bed and insisted that Al watch him open it. Inside, filling the trunk from top to bottom, was a sea of pink receipts—proof that Al's father had been sending money to his wife for years. "I remember my mother receiving pieces of paper like that enclosed in letters from my father. We had been starving, and she was giving money to the rebbe and the poor. He needed to prove to me that he hadn't abandoned us. Then he threw the trunk and its contents away; he no longer needed it. Finally he had a witness."

While Al lived with the Pincuses, he attended PS 6, where the art teachers took note of his prodigious talent. Given his immigrant background, he astounded his teachers and fellow students by winning most of the spelling bees. Because of his success in spelling and his dazzling artistic talents, his teachers advanced him rapidly—Al finished what should have been a two-year course in a year and a half and graduated in January 1935.

Even though Al was by now allergic to the kindness of strangers, he sought friendship from kids and found a real pal in Hilton Spikony, a boy his age who lived in the same building. "He was a very American boy; he had roller skates and a hockey stick. I pestered my father, who was at that point the lowest of the low in the post office, and somehow I got him to buy me a pair of roller skates and a hockey stick. I knew they would make me feel more American. Hilton took me to the top of the hill at Bronx Park South. The street went downhill for several blocks and ended abruptly at a waterfall at the Bronx River. I hadn't been on skates before, except for one time in Zarasai, with disastrous results." Al had dared to skate on Zarasai's only sidewalk, whose owner threatened to beat him if he ever showed up again. "I laboriously worked my way six blocks up to the top of the Bronx Park South. Hilton warned me that we were out of the Jewish neighborhood and that if we encountered roving gangs of Italian kids they might take away my roller skates and my hockey stick. I remember the fear of Zarasai coming back. This is America? This isn't supposed to happen here."

As they flew down the hill, the boys ran into trouble. "Out of nowhere about twenty-five kids of all sizes came after us. Hilton, who was very good on skates, turned, jumped the curb, and found sanctuary by parking himself behind a pregnant woman with a baby carriage. Today, of course, these kids would simply knock over the baby carriage and punch the pregnant lady to get at Hilton. But that was then. So now all twenty-five of them are racing after me and I'm going down the hill out of control. I have no idea of how to stop on roller skates. I'm picking up speed, but they're gaining on me. I hear the big boys egging on a little guy who was maybe nine or ten. 'He's yours, Rocco!' they're yelling. 'Get him!'

"The goyim were after me again. I swung around and hit him in the face as hard as I could with my hockey stick. I must have split his head open. The last thing I saw as I flew by was this circle of kids around somebody lying in the middle of the street. To this day, of course, I wonder if there's some kind of a zombie wandering around named Rocco. I can't say I felt good about it. My heart was beating a million miles a minute because I still faced the Bronx River. I'm still heading downhill, picking up speed, and cars are coming in all directions. I'm looking at the cement fence and the river and the falls on one side and the elevated subway on the other. Somehow I managed to make a right turn, zoomed in between two cars, and tumbled down in front of a store.

"I was afraid I'd killed this guy, but nothing ever came of it. I didn't go skating after that. It's not my sport. Either you get killed or you kill someone. In the war between the Jews and the anti-Semites, the anti-Semites win in Zarasai and the Jew wins in the Bronx. I thought about Simeonka's Shaygetz. I got a blow to the head, and now I gave a blow to the head. So I figure we're even. Closure, they call it."

By January 1935, after a year of living uneasily, the situation at the Pincus household had so deteriorated that Mr. and Mrs. Pincus gave up on their mission of saving Al and threw out both father and son. Al and Morris moved to another furnished room, on Daly Avenue in the East Bronx, where they boarded with the Morrisons. If Al wanted to be completely left alone, he got his wish. There the "room" of "room and board" meant a bedroom so small that it barely held a single bed, never mind a bureau or chair. As for "board," there was none. "The Morrisons' son was a happy-go-lucky kid who ran to the refrigerator whenever he wanted something to eat." The Jaffees weren't even allowed in the kitchen. Al rarely saw the Morrisons or his father. At about 8 PM, after yet another day of trying to eke out a living by hanging around the post office, Al's father would return to their tiny room with dinner—two sandwiches—which they would eat sitting on the edge of the bed. Then Morris, exhausted, would fall asleep. After finishing his homework, Al would get into bed and settle in against his father's back.

It must have been about 1935 when Al entered Herman Ridder Junior High School, a newly constructed, turreted, Art Deco castle

on Boston Road. Herman Ridder, named after an editor and publisher who had been prominent in New York political and civic affairs, was a "rapid advancement" school, open to children who occupied the tenements near Crotona Park. At some point during his year at Herman Ridder, Al and his father moved to within walking distance of the school, from Daly Avenue to Kelly Street. On his walks to and from school, Al made sure his route included a stop in front of an art store that displayed in its window a pencil sketch of a nude woman. "I was probably fourteen by now, and oh, how I stopped and stared at that! I could hardly wait to get through school so I could come back and see it again. I think I was in some kind of puberty stage." Even though he was more than capable of drawing this, or any other nude woman, Al refrained. "My father was so straightlaced. If he saw me looking at a nude, he'd cuff me. He didn't even like dirty words. I waited until I went to art school to draw naked ladies."

One of Al's favorite classes at Herman Ridder was shop. There he spent the entire term designing and constructing a book rack, which would hold books in a freestanding V-shaped cradle that

could be placed at the back of a desk. "I carved elaborate end pieces with intricate, flowery designs that I then painted. I was very proud of it." Al anticipated an A+ in woodworking. Then along came a fellow student and thug named Sandowsky. "He looked to be about eighteen—he'd probably been held back for years. This brute was accompanied by two other bullies, the kind who threaten you for your lunch money. He just came over, took my shelf, and declared it his own. He literally stole my work, and he got away with it." Al, who had long since had his taste for confrontation beaten out of him, retreated. Taking his lumps without protesting was becoming a lifelong habit. "I certainly wasn't going to go to the teacher. That would have been a death sentence."

As had been the case at PS 6, Al continued to amaze students and teachers at Herman Ridder with his superior artistic talents. He had one close competitor, a friendly rival named Herbert. Even though the students had their lunch in the school cafeteria, they sometimes skipped out and went to the local diner, where invariably Herbert and Al would argue about who was the better artist. "Herbert would bring pictures he'd drawn the night before and say things like, 'I'm going to show you that I'm a better artist than you are.' I really wasn't as intense about it as he was. I could draw what I could draw, and I wasn't thinking in terms of being a better artist than somebody else. But Herbert felt a strong need to show me up.

"Then came the *moment critique*—the annual talent show. Anyone who could sing, dance, draw, or recite was invited to participate. I was asked to do something, but I turned down the invitation. I didn't think drawing was a performance. The auditorium was filled with students. I was surprised to see two people lug a large easel out onto the stage and place a big drawing pad on it. One of the easel bearers announced that Herbert would appear onstage and give a drawing demonstration.

"Herbert marches out, takes his place in front of the easel, and addresses all assembled. 'I will now take suggestions from the audience. If somebody will make a request, I will be happy to draw it.' Somebody shouted out, 'Draw a tiger,' to which Herbert responded calmly, 'I'm not going to draw that. I'll draw a football player instead.' With a flourish, Herbert applied pencil to pad and quickly

produced a perfect rendering of a football player. He'd probably sketched on the pad beforehand. Everybody applauded wildly. Nobody seemed to mind being duped. I was had again."

But Al was not "had" for long. A month or so before he was to graduate from Herman Ridder, one of the school monitors came into class, read out his name, and said that he was to report to the art room. There Al found himself in the company of about fifty kids, Herbert among them. The students were instructed to come up one at a time, take a sheet of drawing paper and a pencil, go back to their seats, and draw something. "Nothing came to me except to draw the village square in Zarasai. As I was finishing my picture, something in front of me caught my eye; it was a drawing being executed by the tiny, skinny little freckled boy seated in front of me. I'd been in the school for at least a year, but I didn't know this kid. I thought the picture was of an old rabbi, but he told me it was a peasant. How he knew from an old peasant I don't know; *I* should have been drawing old peasants. I thought to myself, 'If everybody in this room is drawing as well as this twerp, then what am I doing here?' It was the most beautiful portrait I had ever seen.

"A monitor came by, collected all the drawings, and took them up front to the teacher, who took a few minutes to examine each picture and then announced, 'Everybody is excused except Abraham Jaffee and Wolf Eisenberg.' Then the monitor came over and said he was going to take us to the principal's office." Those two words, spoken in conjunction, caused Al considerable worry. His recent misdemeanors flashed before his eyes, filling him with dread. "I had obviously done something terrible, but what about this other kid?"

While Al was sweating it out on the bench outside the principal's office, Wolf Eisenberg turned to Al and said in a thick Bronx accent, "I tink dere gunna send us to art school."

Wolf was right. "The principal gave us the whole spiel. 'You are two very lucky boys,'" he said. "Mayor La Guardia is creating a brand-new music and art high school. Kids from all over the city are taking the test. You two have qualified to take the final test." Herbert had not.

Al and Willie* had each been agonizing about which one of three unappealing career paths to pursue after they graduated from Herman Ridder: vocational, academic, or industrial. Neither of them had imagined a fourth alternative—a high school devoted to music and art.

In September of 1935 Will Elder and Al, along with about 300 other contestants, took a test to compete for about 140 places in the Fiorello H. La Guardia High School of Music and Art, a massive building located at Convent Avenue and 135th Street. The multiple-choice test involved many pages. "I clearly remember one question: 'Here are two lamps; which do you think is the better designed?' One of the lamps had a very clean Art Deco design. The other was too

* Throughout his school years, Wolf's friends called him "Wolfie." Years later, after he left the army, he adopted the name Will Elder. Al's references to "Wolfie" as "Will" or "Willie" reflect this later circumstance.

fussy, too full of curlicues. I chose the simpler design, hoping that I wasn't going to be judged by some old-fashioned lady with a passion for the *ongepotchket.** We must have picked the right answers. Willie and I won. We started school in January 1936." Three years later, when Al and Willie were seniors, Harvey Kurtzman would win a place in the freshman class, setting the scene for a cartooning collaboration that thirteen years later would be *MAD* magazine.

After a life overburdened with impermanence and dismal turning points, Al's prospects changed dramatically for the better. For the next four years, Music and Art, "the Castle on the Hill," would offer Al not only stability but also the kind of versatile artistic training that would beckon to and develop his already impressive talents, talents that would eventually drive Al and his friend Willie Elder to *MAD*. Perhaps just as significant, at least at the time, January 1936 was also the date that the Jaffee family would finally move to a rental apartment of their own, a place they could call home.

Acting off a tip from one of his fellow postal workers, Al's father had found a one-bedroom apartment on Marcy Place in the West Bronx, a classier neighborhood than the East Bronx. There, where everyone had his own bed and access to a kitchen, they languished in the lap of tenement luxury. Morris slept in the bedroom—by himself. Harry and Al set up two beds in the living room. When Bernard visited on the weekends, he would sleep with one of his brothers. Even Morris emerged from his depression long enough to engage in some home decorating. He was amused by a cartoon he'd come across of Sir Otto Jaffe, a Jew who had been the mayor of Belfast at the turn of the century. He deemed it suitable for framing. Even though Sir Otto only had one *e* at the end of his name, he

* Excessively and unaesthetically decorated; overdone.

might have been a relative. You never knew. Anyway, he was good for a laugh. "I can still see my father proudly hanging it over our little kitchen table."

The rent was thirty-five dollars, probably more than Morris could afford. It is likely that Uncle Harry pitched in. After three years of living apart, the Jaffees were a family again, but Al found the reunion anticlimactic. The family had gone their separate ways for too long. There was no picking up where they left off.

"We were as much a family as we were ever going to be during the time I was at Music and Art, but we were teenagers. Each of us moved in his own space, off on our own. Dad read the newspaper and listened to the radio."

It fell to Al, the eldest, to pick up Bernard at the New York School for the Deaf on Fridays and to return him on Sundays, a job he resented. The trip to the school involved multiple lengthy subway rides that meant he sometimes had to miss class activities and after-school basketball and baseball games. But most of all and much to his chagrin, he resented Bernard's poignant neediness. "Bernard waited eagerly for me at the school gate, glued to the iron fence. He had been thrust into this strange place, separated from me and Harry, the only people he could talk to. He was a puny kid.

He was way behind in school. I'm sure he was bullied." Al's anguished and complicated feelings of compassion, resentment, and shame only increased on the subway rides home. Bernard, in his enthusiasm to transmit to Al all that had transpired during the past week, made funny grunting noises and gestured wildly in his crude, homemade sign language, which sometimes involved jumping up and down or hitting himself on the head. Soon the entire subway car was galvanized, staring at Bernard. "I kept shushing him. Here I am in a strange land, trying to fit in. And I was a teenager, ashamed of everything that teenagers are ashamed of—their parents, their grandparents. I was embarrassed to have the whole world see our peculiar problems."

Years of living apart had weakened Al and Harry's intense bond, but in 1936, the year when the family came together, however tentatively, under one roof, Harry abruptly turned against Al. Even when Harry entered Music and Art six months later—he breezed through the exams—Harry would have nothing to do with the older brother from whom he had once been inseparable. "Harry regarded me as a philistine. I wanted to be part of the excitement of society—parties, dates, girlfriends. Harry looked down on me. Harry was into intellectual pursuits. He was listening to classical music while I had the radio on to *Make Believe Ballroom*. He was reading Kahlil Gibran and Blake. He became a real artsy-fartsy Greenwich Village culture vulture. 'What do *you* know?' he'd say to me. 'You're into this low-class popular stuff.' He put me down."

Only when it came to building projects, like making an entire model train, a movie projector, or a miniature iron lung out of flattened Del Monte peach cans, did Al and Harry collaborate as a duo. "Harry and I made use of all kinds of throwaway stuff. For us, coming from Zarasai, making things was easy.

"We didn't know how these things worked. We guessed. We found a piece of film on the street and decided to make a projector. It turned out it was a night scene from a silent film. We only got the projector to show movement, but it worked."

The model train took months to make. Sitting at the kitchen table on Marcy Place, with a pattern from *Popular Mechanics* at his elbow,

Harry cut out the pieces of tin with scissors. They didn't have a soldering iron, but improvisation was their forte. Instead, Harry used pliers to hold a heavy nail over the flame on the gas range. Al and Harry mined telephone

lines for the copper wire necessary to make the impossibly tiny chains that steered the cars. Al was very proud of their creation. "The degree of authenticity we achieved was astounding. We entered the train into the science contest, where it was stolen. We suspected the teacher."

Harry did his work and got good grades, but outside of the classroom he started to behave erratically—a continuation and intensification of the nasty teasing he had directed at Uncle Harry's daughter, Bernice, and at the little girl at Cohen's Villa. He challenged people to fights without apparent cause or regard to his potential for success. Invariably, he was beaten and came home crying.

Domestic life at Marcy Place got off to a shaky start. "We are now in our apartment and it's the first dinnertime. My father gave us money to go to the market on 170th Street. Somehow we decided we

would have salami and eggs because Harry, who had eaten a lot of salami and eggs when he had lived with Uncle Harry and his wife, Pauline, knew how to make them." They also agreed upon baked beans, a family favorite.

When they got home, Harry found a frying pan and a pot among their rudimentary kitchen supplies. The directions on the can of beans read: "Place contents in pot." They paused to consider the meaning of *contents*. They lingered for a moment in front of the sink, standing on the spot where the linoleum had worn to the wood, and discussed whether or not they should add water to the pot. They decided against it. Then they put the can in the pot, turned up the

flame, and went to work on the salami omelet. The beans exploded, sending up a gooey gusher that hit the ceiling, hung there briefly, and then yielded to the laws of gravity, plopping down in disgusting clots.

The great bean explosion and other domestic disasters that followed made Morris Jaffee, hardly a cutting-edge feminist, wish he'd had at least one daughter. "I was always amused by my father's rants. He'd say, 'Why couldn't one of you have been a girl so we'd have somebody to keep this place in order and cook for us?' At first I'd commiserate with my father. To have one girl to be the mommy like in *Peter Pan* and see to it that everybody had their lunches and stuff was a very appealing idea to me at the time. It wasn't until I got a little older that I finally said, 'You know, Pop, if you had a daughter and we had a sister, I don't think she'd want to take over this hellish job of scullery maid any more than I do.'"

It was Aunt Frieda, Mildred Jaffee's sister, who came to the all-male household's culinary rescue with her personalized catering service. Every Friday she'd cook up a storm, both for her own family, her husband, Charlie, and their two daughters, Nancy and Sonie, and for the Jaffee gang as well—a huge pot of stew, a whole chicken, chicken livers, chicken soup, and gefilte fish—enough to last well into the week.

The problem was how to transport this twenty-five-pound load of takeout from Aunt Frieda's place on the Grand Concourse to the Jaffees' on Marcy Place, a hernia-inducing shlep of about six blocks and three flights of stairs. The answer was a cardboard satchel from Woolworth's. The next problem was who would perform the onerous task. Al and Harry would play rock, paper, scissors to determine who would be the unlucky shlepper. Then they realized that they could tie the suitcase to the handlebars of Bernard's scooter. It didn't take but one round trip for Al to realize that "cardboard suitcases, chicken soup, and gravy don't go together too well. As we passed by the alleys between tenements, dripping gravy and chicken soup, we'd be pursued by cats and dogs with their tongues hanging out. We were never attacked. They just followed us, stopping and licking their way to Marcy Place." This became a four-year ritual for

man and beast, except for the summers when Aunt Frieda and her family went to the Rockaways, at which time the Jaffees reverted to beans—out of the can—and salami omelets.

As far as Al was concerned, the problem with the School of Music and Art was that it was a school. "The academics were the only fly in the ointment. When you're a kid, what you're looking for is the ice cream, not the spinach." Al was force-fed plenty of spinach. In retrospect, though, he acknowledges that it was good for him. "Music and Art saved my life."

In addition to the usual high school curriculum, Music and Art required its students to be fluent in two languages besides English. English had been an interrupted language for Al, so he struggled with rules of grammar in that class. French came pretty easily—he had his parents' flair for foreign languages—and because of Yiddish, he was a whiz in German. But he flunked algebra. When he took a make-up class with a teacher who spoke Al's intellectual language—

logic—he got the second-highest grade in the class. "Logic appeals to me. I thrived on algebra; it's pure logic. It's one step at a time. It's just common sense." Nevertheless, not looking forward to trigonometry, calculus, and Pythagorean theorems, Al told the teacher that he was going to drop math.

"Why is it," the teacher asked, "that when I get a really gifted student he quits?"

"You mean I'm gifted?" Al replied, always the last to know anything good about himself.

Although it was his goal to be well liked, Al failed to appreciate the fact that he had achieved the popularity he sought. Harvey Kurtzman looked up to Al. "Al was the BMOC. I used to worship him from afar." Harvey's opinion is borne out by the couplet that accompanies Al's 1940 yearbook photo.

We like his art, his music, sport, et cetera,
In fact, there's nobody M & A likes bettera.

Music and Art was strictly devoted to the fine arts and frowned upon cartooning and satiric art. Nevertheless, Al found an outlet in doodling for his not-so-fine artistic urges. While studying Charles Dickens in Miss Hollander's English literature class, Al couldn't resist doodling an avaricious Tiny Tim tucking into an entire turkey. "To doodle or not to doodle" was not the question when the class studied *Hamlet*. Al drew Laertes staggering around, blood gushing from his gut, declaiming, "Forsooth! Is this a dagger that I see inside me?"

"Miss Hollander always waited until the end of the class, and then she'd march right over to my chair and confiscate my doodling. 'How dare you do this while the class is going on? Don't you ever let me see you doing that again.' Of course I paid no attention to her. I kept on doodling, and she kept on confiscating. The day that I graduated she presented me with a loose-leaf album that contained about sixty of my doodles. 'This is a collector's item. Someday this is going to be worth a fortune, and that'll teach you not to draw in my class.' "

Miss Riley, Al's art teacher in his sophomore year, was another fan. In fact, she had far more confidence in Al than he had in him-

Al's Borscht Belt crowd scene, circa 1939.

self. She was amazed by his talent for composition. She'd make a point of looking over his shoulder while he indulged in his favorite subject, the mob scene. "I just want to see where you start," she'd say. "Go ahead. Start."

"So I'd put the pencil down in one place, and I'd start. And she'd say, 'I'll come back later to see what you've done.' I had fallen in love with Milton Caniff's *Terry and the Pirates*, which all took place

in China, and I stole plenty from him. I filled the paper with about three hundred Chinese people. By the time Miss Riley came back, I had completed an entire street scene in what I thought might be Shanghai. Rickshaws were going hither and yon; people in pointy hats from the movie *The Good Earth* were bustling about all over the place. The signs on the ramshackle tumble of Chinese stores were meaningless; they might have been in Yiddish for all I know."

Miss Riley was stunned. "It's hard to believe. How can you know you'll end up with a viable composition if you start in the middle of nowhere?"

Al didn't know how to answer the question. He just knew he could, but he didn't know how he could. "I can see it," he told Miss Riley. "I may not see all the detail, but I know what's going to flow out wherever I start. All I have to do is draw it in." What, after all, he wondered, was the big deal? The "big deal," according to Miss Riley, was that not many people could do it.

"Oh, Al, you're so blasé," said Miss Riley.

"Thank you, Miss Riley," Al replied.

"Now I had to find out what *blasé* meant." Al headed off in the direction of the French department to ask Miss Judels, who told him the word meant "world-weary."

That winter, Morris, still a substitute mail carrier, suddenly lost the use of his legs. He was taken to the Veterans Hospital, where the diagnosis was hysterical paralysis.

During the two weeks that Morris spent in the hospital regaining his mobility, Al traveled by trolley to visit him, a journey that would have a serendipitous effect on his career as a cartoonist. As the trolley rattled along, Al's attention was drawn to the advertisements for a bug spray called Flit. Unlike the public ads Al was used to seeing, these were cartoon ads drawn by Theodor Seuss Geisel, who would later become famous as Dr. Seuss, the writer and illustrator of children's books. Each ad bore the caption: "Quick, Henry, the Flit!" "I loved those cartoons. They strengthened my resolve to be a cartoonist. For some reason I thought that the Sunday funnies were all sewn up, but these ads made me realize that there were other areas for cartooning. To be on a trolley car and see this ad with a cartoon lent a new legitimacy to the kind of work I might do someday."

After the paralysis incident, Morris made one last attempt to lift himself and his family out of abject poverty, from substitute letter carrier to permanent mail sorter. In order to do so he had to pass a test demonstrating how quickly he could throw so many letters into so many cubbies without making any mistakes. He sent away for a cardboard box with cubbyholes that Al helped him assemble. Al would write addresses from his father's Grand Central Terminal territory on cards and place the cards in a pile at his father's right hand. Then his father would draw from the pile and throw the cards as fast as he could into the appropriate cubbies—a section of Madison Avenue into one slot, a section of Lexington into another. "My father practiced every waking moment throwing these cards into the practice bin while I timed him. It was pretty boring for me, but I knew it was important to him. He was elated when he was finally accurate and fast enough to make clerk. Still, he could never shake the feeling that life was hopeless."

Even as a regular with an eight-hour workday, the post office turned out to be difficult and degrading for Morris. He had to work three different shifts. Al used to watch him get dressed at midnight to go out into a snowstorm to spend eight hours throwing letters into boxes. This man, his father, who had once ruled Blumenthal's department store in his glory days in Savannah, had to be accompanied to the bathroom by the foreman to make sure he wasn't taking a cigarette break.

"When I'd ask my father if he wanted to do something entertaining, like go to the movies, he'd say, 'Movies? Is a movie going to buy you a piece of bread?' He was so depressed I was surprised he could function. He was sure that there was no way out of the post office for him, and that none of us were going to amount to anything, that we were all destined to be the poor slobs that we are. I don't fault him for his attitude, but at the same time, he failed to transmit any optimism to me. He got so little out of life that these piddling things didn't mean anything to him. As a consequence, they didn't mean anything to me, either. My father didn't even come to my graduation. My Uncle Harry and Aunt Pauline did. I couldn't believe it when my Uncle Harry once said to me, 'You know, your father's very proud of you. Every time he

Al and Willie cutting up in the High School of Music and Art cafeteria.

visits when you're not with him, he raves about all that you and your brother Harry are accomplishing.'"

Wild Willie Elder was the perfect antidote to morbid Morris. He and Al were the class cutups. "I was a physical comedian," Will Elder said. "Al was more mental. We made a great pair. We worked off each other. Al gave sophistication to my zaniness."

Willie was the master of the spontaneous. "Will and I would be walking toward the subway, about to descend the stairs, along with a lot of other people. Just when we'd get to the top step, Willie would all of a sudden turn to me and say, 'All right now, Al, here's the way you do it. You put one foot—that's it, pick up your foot—good, good—and then you put it down on the next step—that's it, good, very good—and then you bring the other foot over.' He would walk me down the stairs like I was a moron."

Will pulled the same kind of stunt at the Horn & Hardart cafeteria. "We'd put our dollar down, and the cashier would slide us twenty nickels. We'd head toward the wall with the glass windows, usually to get a piece of pie. One time, without any warning, Willie goes into his shtick. 'All right, Al. Take the nickel—see—this is a nickel—Al—listen to me—take the nickel and you put it in the little slot—that's it—Don't rush it! Don't rush it!—and then you turn the handle—good, good—and then you get your pie.' And all the while Willie is slapping me on the face to make sure I'm paying attention."

Al and Willie's work dominated the bulletin boards at the annual art shows. Al, in particular, was an artist for all seasons. "I loved doing everything and I did everything well. I wasn't the best oil painter, but I was good; there's always somebody better than you in one thing—but I did pastel, oil, woodcuts, puppetry, everything.

"The first time I heard the name Harvey Kurtzman was when someone came up to me and said, 'Watch out, Jaffee. There's a young kid that just came in who did a drawing that'll amaze you. It's on a bulletin board near the gym.' I went and looked, and I was very, very impressed. It was a drawing of the class boat ride. Now, *I* was known for mob scenes. I'd even done one of the class boat ride, and here I was looking at another guy who kind of did what I was doing—his was more artsy and mine was more earthy—but he was good, very good. I knew he had a great talent."

Kurtzman and Jaffee held each other in mutual esteem. Harvey saw Al as "a natural-born satirist and humorist and a good storyteller. I always had the feeling I was nothing alongside of Al. I was in awe of him."

Because Al and Will Elder were well-known seniors and Kurtzman a mere freshman, their friendship was limited to the school lunchroom, where it didn't take long for the three boys to recognize their shared talent for clowning around. Al remembers Harvey as "a shy boy who absorbed everything," but every once in a while, Harvey would join in the fun, spoofing the films and comic-book stories of the day.

When he was a small child Harvey had written and illustrated papers filled with news and jokes and distributed them to his

friends and neighbors. By the time he entered high school, Harvey knew that he wanted to produce humor magazines. At Music and Art he was already on the lookout for artists who could further his dream.

Years after their graduation from high school, when Harvey and Al drifted together again at Timely Comics, Harvey told Al that "when he saw Willie's and my work at Music and Art he determined that someday he was going to create a humorous magazine and include us in it." But Harvey's high school dream would not be realized until fifteen years later when he edited the first issue of *MAD* magazine.

5

THE RISE
OF INFERIOR MAN

"I very often see myself
as a ridiculous person."

NO ONE HAD EVER ASKED AL what he wanted to be or do, and as a consequence, he had almost ceased to want. For the next few years, Al would play an essentially passive, reactive role in the progress of his own career as he went from job to job, moved by the vagaries of chance and the interventions of others. He had been at everybody's mercy for his entire life, taken, always against his will, from Savannah to Zarasai to Far Rockaway, back again to Zarasai, then on to Kaunas, South Fallsburg, Woodbourne, and finally to the tenements of the Bronx, the move that Al believes crushed his spirit.

"I rarely did anything to advance myself in my career. It's like the story of my life. Just one thing after another would happen to me. I was amiable, nonthreatening, and funny, and people gravitated toward me. I was a 'go with the flow' guy. I'm not a pioneer. I respond to someone who says, 'Here's what we do.'" Al likes to say he was only following the aphorism he invented at the time to apply to his own reluctance to seize control of his life: To ensure success, aim low.

"I'm not aggressive. There's this old joke about the guy who walks up to a girl and says, 'Do you want to go to bed with me?' and

she slaps his face. Someone asks him, 'Why do you keep doing that?' and he says, 'Well, I get my face slapped a lot, but I also go to bed a lot.' Aggressiveness pays off. However, it's not part of my character. I'm a wuss.

"I have a built-in bullshit meter that I apply to myself as I do to others. I wasn't going to bullshit myself into thinking I'm the greatest artist to come down the pike and that all I have to do is graduate from art school and go out and conquer the world. I very often see myself as a ridiculous person. I hear the expression 'Don't beat up on yourself,' and I think to myself, 'Why not? I'm handy. I *do* beat myself up.'

"I never had the technical, sparkling skills that many people had. They wind up being recognized. When I went to school I was good at many things but not spectacular at any of them. I shot in all directions. There wasn't one quality in me that was screaming, 'Develop me!' I was searching for something that would give me uniqueness. That's what held me back." That very same quality that Al so disparaged, his ability to do so much so well, to write as well as to draw, would eventually work to his advantage in the world of cartooning.

In spite of his intransigence, Al's teachers took the measure of his talent and were aggressive on his behalf. One of them persuaded him to take the entrance exam for Cooper Union; he got in and quit after a week. Without Al's knowledge, another art teacher had submitted his portfolio to the Art Students League, which offered him a full scholarship. He left Cooper Union and turned down the scholarship partly because he realized he didn't want to go to school anymore and partly because of the impending war. He saw no point in initiating anything—hardly Al's specialty anyway—when he was probably about to be drafted. Undeterred, one of Al's English teachers used her influence to get Al a series of short-lived, dead-end jobs designing Ex Libris cards and, when that enterprise failed, stenciling letters for advertising signs. He and Dave Gantz—who would later go on to create the cartoon strip *Don Q.*—developed a nonconfrontational cartoon character named Chiquillo inspired by Ferdinand the Bull. It went nowhere. Al hit bottom when, following up on a tip from one of Harry's friends, he tried out for but failed to

get a job assisting a superhero cartoonist who was going blind. "Apparently," said the ever self-deprecating Al, "his eyesight was good enough to see no promise in my work."

While Al struggled to find his place in the world of cartooning, Morris Jaffee, deeply concerned about the Nazi threat and convinced that his wife would never leave Lithuania, was determined at least to save David. On August 23, 1939, just days before Germany entered Poland, the Russians signed the secret Molotov-Ribbentrop pact, which ultimately relegated Lithuania to the Soviet sphere of influence. In response to increasingly urgent appeals from her husband to return to the United States with David, Mildred wrote back, "I've lived with Russians before, I can live with them again."

No one knows for sure how or by whom David was saved. Israel David Jaffee (his given name), aged thirteen, is listed on the ship *Westernland*'s manifest, along with four adult American citizens. The *Westernland* departed Antwerp on April 13, 1940, went on to Southampton, England, left Southampton on April 17, and arrived at the Port of New York on April 25. David's destination in the United States is listed as 38 Marcy Place, Bronx, NY.

Morris's brother Harry probably financed the trip. He might also have arranged the rescue, since it seems unlikely that a thirteen-year-old boy could have made his way alone from Zarasai to Antwerp, especially against what might be assumed were his mother's wishes. One of the four other American citizens listed on the manifest, Joseph Walicky, age twenty-one, of Polish extraction, might have been his "kidnapper" and his escort. Walicky is now deceased, but his nephew, Krist Joseph Walicky, confirms that his uncle, an adventurer and a member of the merchant marine whose mission it was to assist travelers and matériel across the oceans, was living in Vilnius at the time of David's rescue.

While the most important aspects of David's return elude verification, David did share some of the details of his escape with Al. "During the train trip to Antwerp, David yakked with German soldiers in Yiddish. They understood each other perfectly. The Nazis even shared their lunch with him. David had a great time with the Wehrmacht." David also bragged about how delicious the food was

on the *Westernland*. He retained the lavish menus, which he showed to Al. The culinary bounty that so delighted David might have had something to do with the fact that a group of chefs and waiters were aboard, on their way to work at the Belgian pavilion at the 1939 New York World's Fair, which opened its second season that month.

David rarely spoke about the seven years he spent, from 1933 to 1940, with his mother in Lithuania, except to say that they moved back to Zarasai, perhaps to settle her father's estate. The formidable Chaim Gordon had passed away on December 9, 1933, at the age of seventy-two. David also reported that his mother made a living in Zarasai teaching English, no doubt to Jews trying to emmigrate to America. "I wish I had asked David what life was like for him and my mother during those seven years when the rest of us were in New York, but I never did. We're a strange family. We're not curious or communicative. My mother became a taboo subject."

Sixteen months after David was rescued, Mildred Jaffee was most likely murdered. There is no record of how individual Zarasai Jews met their deaths. Two fates are most likely. One possibility is that Mildred Jaffee was shot on June 26, 1941, by Lithuanian partisans who colluded enthusiastically with the Nazis against their Jewish neighbors by blocking all the roads that led out of town and shooting every fleeing Jew on the spot. The other is that she died in an *aktion* (a Nazi euphemism for "mass murder") on August 26, 1941. Men and women, as well as children and the old and feeble from Zarasai and surrounding towns and villages were forced to march to the Daugutzi Forest where the *aktion* took place. A total of 2,569 Jews were shot that day. A Nazi with a Teutonic fondness for statistics must have stood by with a clipboard, recording each murder. His report reads: "767 Jews, 1,113 Jewesses, 1 Lithuanian Communist, 687 Jewish children, and 1 female Russian Communist." It is likely that Mildred Gordon, who believed until the end that God would save her, was one of the 1,113 Jewesses. One woman, the mother of two children, had overheard two Lithuanian guards talking about how the Nazis were planning to kill all the Jews the next day. She, along with her

children, managed to escape to Kaunas through the woods. They were shot later that year, however, in the "Great *Aktion* of October 28 and 29" in Kaunas, thus rendering the little town of Zarasai 100 percent *Judenrein.*

There is at least one bright light in this otherwise dark and brutal story of how the Nazis slaughtered the Jews of Zarasai. A Holocaust record housed at the YIVO Institute for Jewish Research mentions a Karolka Mikutovistsch who tried unsuccessfully to save a Jewish family by hiding them in his house. That must have been the same Karolka who befriended Al and Harry when he was their landlord.

"After the war my father suggested that I try to find out what happened to my mother. I remember not wanting to. What if she survived? What if we found her? What if we brought her here? What would we do with her? I didn't want to look at the sad part. I was married. I had children and a home. I had left her a long time ago, and I didn't want her back in my life. I didn't want the madness. Once I came back to America I expunged her. She had no place in my world. I was only twelve when I did that.

"Decades later, when I was working for *MAD*, I had a chance to return to Lithuania. Bill Gaines was planning a *MAD* trip to Russia and asked me if I'd like to take a side trip to Lithuania to visit Zarasai. I thought about it. Berke Lintup, Chaimke Musil, and Itzke Schmidt and their families had been murdered. Danke, I'd learned, had died in the Battle of Stalingrad. What am I going to see? I'm going to see Lithuanians living in the homes of my friends. Who am I going to talk to? The people who killed my friends and my mother? Karolka and his siblings would have died by then. I decided not to go.

"I dreamed about my mother for the first time a couple of years ago. In my dream I am trying desperately to rescue her before it was too late. The only comfort I could get out of the dream was that they didn't have the Jews to kick around anymore. That's not terribly comforting either.

"Sometimes I think I'm hard-hearted, as if I didn't care what happened. But I did care. When the selection was made in the con-

centration camps, some people chose to go to the left, to stay and die with the people they loved. When the selection was made in Lithuania, I didn't stay with my mother; I went to the right."

As a result of David's rescue, all the Jaffees, except Mildred, were living under the same roof for the first time since 1933. "David took to America and everything American better than the rest of us. He became a fashion plate, an athlete, a typical, happy-go-lucky American teenager. It was as if David had never left America. Harry and I couldn't figure out how the hell he had integrated so well."

It was Harry, not Al, who scored the first artistic success. While strolling down Madison Avenue, Harry paused in front of the display window of a print shop to admire models of antique boats and sailing ships. Among them was a painting of this new rage, the airplane, soon to be a massive tool of the looming war. He assessed the quality of the sky-blue paper on which the plane was painted. He noted that the artist must be French, since his signature ended with an acute accent. The price tag on the painting read five dollars. Harry carefully examined the glittering airplane set against a pale blue sky and thought to himself, "I can do that." Then he sought out and found the same sky-blue, handmade paper, complete with French watermark.

Harry signed his first airplane portrait "Jaffée." The *J* was large and loopy. The rest of the signature was more modest in size and style, except for the French acute accent over the first *e,* which went shooting off like a comet into the blue.

Harry's first Jah-fey, taken on consignment, sold the next day for five dollars, big money in the Jaffee family. The store ordered more. Al took a portfolio of five of Harry's airplanes to the art buyer at Macy's. Tucked under his arm were a TWA Clipper, a B-17, a Vickers Vanguard, a Mariner B-26 Marauder, and a Curtiss Tomahawk. "The art buyer took one look and said, 'I'll take them all.' She bought me out. Airplanes were in the air, so to speak." Harry scored a similar success at Brentano's and at Abercrombie and Fitch. He even picked up some private commissions from rich plane owners who wanted portraits of their Piper Cubs.

Orders were pouring in faster than Harry could fill them. In

response, the Jaffee boys set up an assembly line in the living room on Marcy Place. Unable to work comfortably in such cramped quarters, Harry found the family a two-bedroom apartment in a fifth-floor walk-up a few blocks away on Townsend Avenue. One of the bedrooms was an ample sixteen by ten feet. They moved the beds into the living room, brought the table and chairs in from the kitchen, and went to work. The room comfortably held five young men and their drawing boards. Harry, of course, did the original drawing. Bernard, who, like his younger brother, David, had no artistic talent, did the simplest part. Using translucent tracing sheets and carbon paper, Bernard transferred Harry's drawing onto the blue paper. Then he'd pass the drawing along to Will Elder, who'd add the first color and hand it along to Joel Epstein, a Music and Art graduate, who'd fill in another color and pass the page over to David Gantz, also from Music and Art, who'd add the third color and give the nearly complete drawing to Al. Al would finish up with the fourth color and hand the drawing along to Harry, *le vrai artiste,* who would add the speed lines

and other finishing touches that gave the plane its sparkling, aluminum, three-dimensional look. Even when they split the profits five ways, Al and his friends were making ten bucks a week. "We just kept churning these things out until we were overtaken by silkscreen."

The man who would ultimately put an end to the lucrative production line was Rudolf Lesch of Fine Arts, Inc., a national art-print distributor. His representative took one look at Harry's plane paintings in Brentano's and placed a huge order, so huge that the Jah-fey team, even working at Chaplinesque speed, could not keep pace with demand. That was when Lesch realized that he didn't have to sell originals; he could do just as well—maybe better—selling prints. Harry would sign and number the prints and then sit back and collect royalties, two dollars for every five-dollar print. "Harry was ecstatic. He went out and bought a maple living room set for our new apartment, the kind with cushions and wooden arms. Today Harry's planes sell for as much as eight thousand dollars on eBay."

After a year of trying to find himself in all the wrong places, Al began taking his portfolio around to comic-book publishers' offices. The day he got an appointment with Will Eisner—best known at the time for his crime-fighting comic hero, *The Spirit*—Al arrived at the beginning of his cartoon career. Eisner flipped quickly through Al's drawings but stopped when he got to *Inferior Man,* Al's satiric response to the wildly popular Superman.

"When you do satire, you have to have a jumping-off point. With *Inferior Man* I felt I was on solid ground." Inferior Man, a.k.a. Courtney Fudd, was an accountant by day and an anti-superhero by night. His outfit included dingy underwear emblazoned with the letter *I,* garters to hold up his droopy socks, and, of course, a cape. He had no muscles and he didn't fly—he flitted. "Inferior Man would prance around looking for crimes, but if the crime was more than he could handle, he would step into a phone booth, change into street clothes, and blend into the crowd." Al, a self-confessed loser, claims a very personal relationship to Inferior Man. "When you have people who are oppressed, whether it's Jews living in places where

people don't want them, like Jews in Zarasai, or slaves living for masters in Savannah, about the only amusement you have is to see your oppressor from a satirical point of view. You make fun of him. You make yourself feel superior by pretending to be them and exposing their excesses. Inferior Man is my alter ego."

Eisner rejected Al's idea that Inferior Man should be an accountant with delusions of grandeur. Not surprisingly, Eisner, who was packaging Military Comics, preferred that Inferior Man be somebody with a lowly job in the army, a quartermaster, perhaps, who handed out uniforms. Since Will was paying ten dollars a week, and

since the ingratiating pleaser in Al found it almost impossible to say no, Al tried to breathe life into Eisner's idea. He failed, and by failing, found out that his learned passivity had its limits. Whenever he found himself in creative bondage, Al's inner wild Indian, the kid who lit fires and stole fruit, rebelled. "I'm not comfortable having somebody tell me what to do. It's not difficult to do a one-shot of somebody's idea, but if that idea is not alive in you, how do you do the second shot? The worst bind I can find myself in is when somebody says, 'Okay. Now I want your script to show fifteen dancing Cossacks over here, and I want girls, lots of girls, over there; now go ahead and write it.'"

He found himself in a different kind of bind when he took a job penciling for cartoonist Chad Grothkopf. Grothkopf was drawing *The Imp,* which was written by the eighteen-year-old wunderkind of Timely Comics, Stan Lee. After several boring, underpaid, repetitive months of penciling *The Imp,* Al found the courage to quit. "I can't do rote. I have to break away." It took a while, but it finally dawned on Al that he was being exploited by Grothkopf. "Why couldn't I go to Stan Lee directly?" It was a good move. From now on, in spite of his passive nature, and because of his impressive talents and Stan Lee's imprimatur, opportunity would come to him.

Stan Lee made short work of his first encounter with Al. "He picked up a script from his desk, tossed it at me, and said, 'If you can do this, you can work for me.'" "This" was a dull script for a comic book about two bumbling cops called *Squat Car Squad.* Stan Lee tossed Al what he needed most, a chance to cut loose, draw comic figures, and express his nonconformist zaniness. Al inserted a caricature of himself into the story. There was Al, pratfalling *SPLAT* on the sidewalk. Then he pushed further. He blamed his own characters for ad-libbing the lines he'd written for them, and in turn, he let his characters blame him for not following Stan Lee's direction. "It's as if we were all alive—the cops, the artist, the editor—all of us. We could wander in and out of the panels at will, *my* will. Stan loved it, and I had a wonderful time. Stan never edited me. He never told me what to write."

Anthropomorphic animals were big in this, the Golden Age of Comics. Stan and Al brainstormed their way into a story line for a children's comic about Silly Seal, an innocent living at the North Pole, and, after a few issues, gave him a companion, a porcine sophisticate named Ziggy Pig to keep Silly Seal from catastrophe. Given a free hand, Al seized the opportunity to indulge his penchant for engineering and mad inventions. Al had Silly Seal build a cannon out of ice that launched snowballs at enemy submarines.

The war interrupted Al's career at Timely Comics. "I was 1-A, prime meat." Harry, who also volunteered, was designated 4-F for psychological reasons. The incurious Jaffee family already knew that Harry was "odd," but they characteristically looked the other way. "We all denied that there was anything wrong with Harry.

"I don't have a clear picture of what Harry was doing while I was in the military—probably hanging out with his Village buddies who were similarly undraftable. The Jaffee airplane business was winding down, but Harry continued to get some royalties, so I guess that's what he lived on."

Al's father refused to see him off to war. "He said good-bye to me as I left the Townsend Avenue tenement. After he rescued me from Hitler in 1933, here I am, ten years later, heading off to who knows what. Perhaps my leaving brought back memories of his time as a prisoner of war. Perhaps he feared I might never come back." Whatever the reason, it was Uncle Harry, the family's surrogate father, who met Al at the Forty-second Street subway station to wish him well. "He gave me a Longines wristwatch, a coveted gift in those times. I wore it throughout the war."

Al, who figured he had a better chance of staying alive as a pilot, expressed his preference, took a cram course, and was sent to flight school at Maxwell Field, Alabama, where he developed a serious case of motion sickness. "We tried to throw everything we could at the Nazis, but they didn't regard my parabolic vomit as an effective weapon." He flunked flying, which he didn't much mind. It was the fear of losing his new buddies that upset him. When Al entered psychoanalysis in the 1960s, his shrink would give this, his worst fear, an official name—separation anxiety.

Grounded, Al was transferred to a replacement center in Greensboro, North Carolina. Up to his old ingratiating ways, Al was making friends and influencing people by drawing funny cartoons on the envelopes his new army buddies sent home to their families. Among others, Al befriended Melvyn Maybe, who, tentative in name only, had relatives in high places, and thought the army should take advantage of Al's artistic talents. He recommended Al to his brother-in-law, Captain Grow at the Pentagon, who reassigned Al to the luxurious Miami Biltmore in Coral Gables, which had been converted into an army hospital.

Grow and Maybe were Mormons from Salt Lake City. "They lit a warm fire in my heart for the Mormons. They may also have saved me from getting killed." It was Al's job to create and lead art-therapy programs for shell-shocked soldiers. One such program involved recruiting coeds from a nearby college to pose in bathing suits on the Biltmore's golf course. "Once I stopped throwing up, the air force turned out to be a good thing."

After that idyllic stint, Captain Grow intervened again and sent Al to work at the Pentagon, where a Colonel Howard Rusk needed an artist to create and illustrate pamphlets for his convalescent rehabilitation program. Rusk asked Al to do a floor plan, a kind of flow chart, for what, in 1948, would be realized, much as Al designed it, as the Rusk Institute.

Throughout his life thus far his name, Abraham, had brought him so much grief that little by little he had transformed himself into Al. He signed his work A. Alan Jaffee. His friends called him Al. "When jokes about Abie and Sadie and their efforts to get extra ration tickets started to go through the army ranks, I cringed. The jokes were created to feed upon the resentful soldiers who believed they were in this war because Roosevelt was trying to save the Jews from Hitler." He learned from a fellow soldier named Lipton (né Lifschitz) that he could change his name for free at the Judge Advocate General's Corps.

"What the hell. I'm tired of dodging my real name. And I wasn't very crazy about it either—it didn't sound very American, and professionally I thought it would be better to be an Al than an Abraham. So I filled out the forms and had my name changed. But they

changed it all wrong—Alvin instead of Alan—and then they'd spelled Jaffee with one *e* instead of two. What had I gotten myself into? So I went back and had it changed again so that now I'm a two-*l* Allan and a two-*e* Jaffee."

Irony was working overtime when Al met Ruth Ahlquist, a WAC and California beauty queen who was obsessed with the idea that she must marry a Jewish man. Ruth had been raised a Christian but had recently learned that her mother's side of the family was Jewish.

Uneasy about her identity, she responded by determining to resolve her discomfort by declaring herself Jewish and by dating Jewish soldiers. Al, who had never had a serious girlfriend before, was dazzled by Ruth's good looks. "They validated my masculinity. I could give up the notion that I was totally undesirable." But there was more to their relationship than his Jewishness and her beauty. He also enjoyed her sweet, shy personality. For her part, Ruth liked the fact that Al was a big man on the Pentagon campus. "I was popular. I think she thought I was fun to be with." They married while Al was working at the Pentagon, after knowing each other for less than a year. Both were twenty-four years old.

It wasn't until after they were married that Ruth would come to resent the fact that her shul-averse husband was not nearly Jewish enough. "She wanted me to join a temple. I wouldn't give a penny to those fund-raisers," said Al, sounding just like his father.

In 1946, after serving for three and a half years in the military, Al went back to work for Stan Lee, this time as an artist-writer and later as an associate editor in charge of teenage and humor comic books at Timely. As associate editor, he was responsible for translating writers' scripts—usually written with little regard to artistic layout—into a logical sequence, a process called storyboarding. Since Al was a writer, an artist, and a wannabe engineer, he rose to the challenge and loved the job almost as much as he loved the security of a good steady income.

On weekends he would write the script for *Super Rabbit,* about a quasi-satirical, Nazi-fighting screwup cut from the same comic mold as Inferior Man, thereby augmenting his seventy-five-dollar-a-week salary by eighty dollars.

In response to his new middle-class status, Al Jaffee, up-and-coming married man, enthusiastically embraced the conformist postwar suburban life. He bought a house in a development in Floral Park, Long Island, as near to the water as he could get, and fathered the requisite two children: Richard and, three years later, Debbie. He dug a garden in the backyard, installed a plastic swimming pool for his kids, finished his basement, maintained his lawn at regulation crew-cut height, and bought himself a golden Hudson convertible with red leather seats and "Envy me" written all over it.

"Later, I traded the Hudson for a Buick Roadmaster that was only a half step down from a Cadillac. But I got all that out of my system when we moved to Babylon, Long Island—even closer to the water—except for a short affair with a Chris-Craft cruiser and a small sailboat."

Still, you can't take the shtetl out of the kid. "That first spring at Floral Park I went out and bought every packet of flowers and vegetables I could think of. I planted cucumbers against the back fence. I wanted to get back to that agrarian society that I liked so much. But the cucumbers that emerged were diseased and puny, totally unlike the big, luscious ones in Zarasai. Turns out I liked stealing cucumbers. I didn't like taking care of them." A few years later, when he moved to Babylon, where he had a larger backyard, he planted a grape arbor and an orchard of apple and pear trees. "Oh, how I loved that orchard! That's what I missed most—the orchard and my workshop—when I eventually moved into Manhattan."

His passion for designing and engineering traveled better. "I went to Macy's and bought a brand-new tool I'd been salivating over, called a Shopsmith. It was a power drill, a saw, a shaper, and a sander all in one—brilliantly conceived. I became obsessive." Only instead of building clubhouses, boats, and sleds, Al finished his basement so elaborately that he made his neighbors gasp. When it came to woodworking, there was no keeping up with the Jaffees. Then he turned the porch into an all-season room by enclosing it with twenty windows, making the wood frames, inserting the glass, and attaching the hardware. Next he moved on to the kitchen, where he overengineered a foldaway table. "If I hadn't been able to draw, I would have been a cabinetmaker. I would have loved it."

By his own admission, Al was not an attentive father. He enjoyed the idea but not the reality of having a family. He traces his relative indifference to his children back to when he was a mere eighteen months old. As the eldest, he found the glory of his primacy taken away after eighteen months by Harry and thereafter, at eighteen-month intervals, by the births of two more brothers. "I was inundated by brothers. I wanted to get away from it all, and the next thing I knew I had children."

Ruth would encourage Al to pay more attention to his son, and Al would try. When Richard outgrew his tricycle, Al retrofitted the pedals with paddles and a float so that Richard could ride his bike in the pool, but it was the inventive engineering that appealed to Al more than the opportunity to delight his son. "It was me reliving my youth."

When Richard's Boy Scout project was to carve a totem pole out of a piece of balsa wood, Al meant to use the opportunity for father-son bonding. "I forgot myself. I forgot that I was supposed to be a father. I got so into it that when I'd finished mine I realized that Richard was just sitting there, forlorn, holding an untouched stick of balsa wood. We had some good moments, too, but I wasn't a doting father. I didn't get down on the floor and play with them. I just took them for granted.

"Ruth would say to me, 'Richard has me as a friend, why don't you be a friend to Debbie?'" Al tried. He sometimes played Chutes and Ladders with her. He built furniture for her dollhouse. He would cuddle up to Debbie when they watched television. But as Al sees it now, what was enough for Al wasn't enough for Debbie.

"If I had it to do over again, if I knew then what I know now, I would have made more of an effort and everyone would have benefitted. I was a prominent part of the equation, and different behavior on my part—screw the garden, screw the woodworking—might have made a difference. But I had to have a garden. I had to do my woodworking. I did neglect Ruth and the kids."

For a long time, well after the war years, the public's appetite for comic books seemed insatiable. Al could work as much as he wanted and he wanted to work a lot. Timely was publishing up to fifty comic books every month and Al was writing, drawing, and editing as fast as he could. "My first year out of the army I made fifteen thousand dollars. That was a lot of money. If I'd had my way, I would have stayed on salary forever and never would have worked for *MAD*." But the law of supply and demand deemed otherwise. By 1949, the bottom dropped out of the comic-book business. GIs, who had been comic books' greatest fans, returned to civilian life as did a glut of cartoonists and writers. Martin Goodman, the publisher of Timely, who had filled numerous offices in the Empire State Building with a staff of forty to fifty salaried artists and writers, let them all go, including Al. The staff was told that when Timely reestablished itself, certain people might be coming back.

For a few months in the fall of 1949 a depressed Al floundered, picking up an occasional freelance assignment and worrying about how he was going to afford the mortgage on his Floral Park home. In January of 1950, Al got a call from Stan Lee, asking him if he wanted to take over the comic book *Patsy Walker,* a popular teenage idol and a takeoff of the popular Broadway show *Junior Miss.* Al had drawn *Patsy Walker* as part of his editorial job at Timely. It was freelance work, but he couldn't afford to say no. Al and this vapid teenager would go together—one might say they were pinned—for five long years.

Al Jaffee and *Patsy Walker* were hardly a perfect fit, as Al was quick to bring to Stan Lee's attention when Stan offered him the job. "I don't do teenage girls; I do funny stuff," Al reminded Stan. "Try," Stan answered. "It won't kill you." Lee, at least, was not worried. "Maybe Al was better at writing humor, but really talented people can't be typecast. Al could do anything well." Patsy's trivial,

high school concerns—would she or her raven-haired rival Hedy get to go to the prom with Buzz?—could not have been less related to Al's satiric wit, except as an object of it. Al forced himself to read *Seventeen* magazine to learn about teenage fashion. In spite of these problems, Al found a way to loosen the ties that bound him and his paper-doll characters. He animated the petty plots that had previously moved his characters from panel to panel and instead made them react to more serious social issues in their limited world—meanness, gossip, poverty, and cliques. Even so, the job exhausted him. He had to produce two entire magazines in a four-week period, which kept him working long after midnight, seven days a week.

Help came in the form of the highly esteemed cartoonist Frank Fogarty, a retired old-timer who had prospered in the 1940s with *Clarence* and *Mr. and Mrs.* He didn't need the money, but he was desperate to get back to work—retirement at age sixty-five didn't suit him any more than retirement at eighty-nine would suit Al—and Fogarty didn't mind taking the meager five dollars a page that was all Al could afford to pay him.

"Frank Fogarty was an idol of mine, and now he was doing piecework for me. I felt uncomfortable about that. His job was to fill in the backgrounds of each frame of *Patsy Walker*—the trees, the high school, the sky. I told him not to work too hard. The backgrounds didn't really matter." But nothing would satisfy Fogarty except to do his best, whether the job merited it or not. Fogarty didn't drive, so every week Al would zoom off in his golden Hudson to pick up Fogarty's drawings, and every week Al was stunned by the quality of Frank's work. "The backgrounds were a labor of love. He drew every blade of grass. The pictures that hung on the walls of Patsy Walker's house were little Rembrandts."

Al's odd-couple professional relationship with Frank lasted four happy years. (By then, Al had made the upscale move to a house in Babylon, too great a distance to drive to Fogarty's home in Manhasset.) The men had developed a warm friendship in spite of the fact that Al was a lapsed Jew and Fogarty a devout Catholic, just the kind of believer whom Al and his agnostic father would have made fun of. And yet when Al mentioned to Frank that his father's doctors

were worried that Morris might have throat cancer (he didn't), Frank said to Al, "I know you're Jewish and I'm Catholic, but do you mind if I say a prayer for your father?"

"His compassion really got to me. It brought back memories of religious conflict and turned them upside down: a devout Christian offering to pray for a Jew's welfare just wasn't in the playbook I'd brought back from Lithuania. Some kind of circle got rounded."

It was Fogarty who made sure that Al was invited to join the National Cartoonists Society, where he met all his childhood heroes— Rube Goldberg, Otto Soglow (*The Little King*), Milton Caniff (*Terry and the Pirates* and *Steve Canyon*), and Walt Kelly (*Pogo*). "I was one of the younger members, and there I was, rubbing elbows with the crème de la crème." In 2008 this same society honored Al with its cartoonist-of-the-year award, the Reuben. "When he got nominated," says cartoonist Sergio Aragones, "everybody knew he was going to win, everybody knew he was the best. That kind of unanimity never happens. Other candidates didn't even bother to show up."

While Al was earning his stripes at Timely, Harry was impressing everyone at Benton and Bowles, a top-notch advertising agency, with his extraordinary talents. Unfortunately, it wasn't long before his mental problems, which included delusions of grandeur, reasserted themselves. Harry felt he should have his boss's job. His boss, predictably, did not agree, and Harry was fired.

In 1954, while Al was still lashed to *Patsy Walker*, Harry suffered a complete mental breakdown. By this time he had married and fathered a daughter, Marilyn, with Lenore, a talented Greenwich Village artist who shared his bohemian lifestyle. Lenore had been handling Harry's volatile moods and behavior for years, but this time she knew the situation was much more serious. She called Al to report that Harry wouldn't get out of bed, talk, or go to work. By the time Al got to their apartment, Harry was gone. After several panicked hours, during which Al filed a missing-persons report with the police, Harry returned home, but he remained mute until Al asked him where he had gone.

"I go out to eat," Harry answered. "I just stop at whatever place has food and I get something to eat."

"Why do you do that?" Al asked.

"When Irish people are in trouble, they drink. When Jews are in trouble, they get something to eat."

"It made a kind of weird sense," Al thought, "even in the midst of his catatonia." Then Harry shut down all conversation and reverted to gibberish.

Al remembered that his doctor, with whom he played poker and bowled, had a brother who was a psychiatrist. The psychiatrist examined Harry and diagnosed him as being in a catatonic state. A call to Bellevue, the nearest mental hospital, brought an ambulance, medical attendants, and two policemen who stood by with their guns drawn while Harry got dressed.

"You don't need a gun," Al pleaded with the officers. "My brother is as gentle as a lamb."

But guns were standard operating procedure in such situations. Al stood helplessly by while the police escorted Harry into the ambulance. "They took him away. I drove home. As I was telling Ruth about Harry, I collapsed in tears." Al wasn't crying for the Harry who had turned his back on Al in high school or the Harry who continued to disdain his older brother for being a bourgeois philistine. "I was mourning my little kid brother, the five-, six-, and seven-year-old Harry, my childhood companion in Zarasai with whom I'd hung out for so many years. My job was not yet finished.

"Harry's condition did not improve at Bellevue. He was given shock treatments, after which he talked a blue streak and then relapsed into catatonia." Once again Al called the psychiatrist. Harry was transferred to Hillside Hospital, now a part of Long Island Jewish Medical Center, which had a good reputation for dealing with mental patients. Al convinced them to take Harry temporarily, even though Harry had no insurance and Al and his father could not afford private care. Later, at about the same time that Al, Ruth, and the children moved from Floral Park to Babylon, Harry was transferred once again, this time to Pilgrim State Hospital in Brentwood on Long Island, where a lobotomy was recommended. Lenore responded with an emphatic no.

Morris had no car. This meant that he was dependent upon Al to take him to his frequent doctor appointments and, on Sundays, to whatever institution in which Harry was confined. Once there,

Morris would insist upon sitting in silence with an utterly uncommunicative Harry for three to four hours, while Al grew increasingly impatient to leave a situation that seemed doubly insane and emotionally anguishing. Besides, these visits kept him from his family and social life. "One Sunday I begged off. My father was so angry with me he didn't speak to me for months."

Ultimately, with the advent of psychotropic drugs, a more compliant and complacent Harry was deemed well enough to leave Pilgrim State and Morris took Harry to live with him in Rego Park. There Harry resumed his passion for building. Morris feared that Harry's nonstop sawing and hammering would provoke the landlord to throw him out of his apartment and suggested that Harry move back to the Village.

Lenore had separated from Harry after he was institutionalized, but she never divorced him. For the rest of Harry's life, Lenore, their daughter, Marilyn, and the man who had by then replaced Harry as Lenore's lifetime partner remained concerned about his well-being and involved in his life. He sometimes lived with them in an odd foursome, but when Harry's paranoia strained that situation to the breaking point, he would move in with his father or with Al, or take a room in a cheap hotel.

Harry, having worn out his welcome with his father and with Lenore, went to live with Ruth and Al in Babylon. There he did household chores, mowed the lawn, engaged happily with Richard and Debbie, and found security, comfort, and significant relief from his demons. Once a dapper dresser when he worked in advertising, Harry now wore ragged clothing and bathed infrequently. "It was as if he had adopted a Zarasai life. He idolized our mother. He missed her and wanted to be back with her. He identified with the beggars of Zarasai; they were his mother's favorites. Harry saw himself as the recipient of *tzedakeh*. He loved to be taken care of, and Ruth catered to him."

Little by little, crisis by crisis, Al's weary, broken father shifted the role of paterfamilias to a very reluctant Al, who was frequently called upon to bail out his three younger brothers when they found themselves in desperate straits and in need of financial help. "Now *I* was Uncle Harry." Morris would bring his concerns about his children to Al, as if he were not one of them, as if he and Al were coparents.

"My father talked to me about his will. He told me that he was leaving what little money he had to my three brothers because they needed it more than me. All the childhood affection he'd shown me in Savannah was lost.

"'I don't think that's fair. I want to be one of the sons. I want some kind of demonstration that I'm part of the family and that I'm going to be treated equally. Each one of us should get one-quarter. I guarantee you that not one penny of it will go to me, but I want to be in the position of giving my brothers what you left to me.' My father agreed. And, as I predicted, it all went to my brothers. Not one penny of it did I spend on myself."

By 1955, Al was working eighteen-hour days grinding out *Patsy Walker*. "Once I got an idea for a *Patsy Walker* story, I would write it out and add my quick sketches; I'd feel as if I'd done the whole thing. But then I'd have the drudgery of turning the idea into a cartoon, and by then the only inspirational voice I'm hearing is 'I've got to finish this; the mortgage is due.' It was hard labor to work up the enthusiasm to put myself into her milieu, but I probably would have gone on forever if nothing else showed up."

But something did. Earlier that year, Bill Gaines had agreed to turn the *MAD* comic book into a magazine under Harvey Kurtzman's editorship, never imagining that Kurtzman would quit after two years. This meant that Harvey was free to offer Al his first opportunity to write for *MAD* magazine.

"I'm a fan of yours going way back to high school," Kurtzman told Al, "but I don't think you've ever reached your real potential. I'd like to give you a chance to do that." Between 1955 and 1957 he assigned Al a number of articles. The subject of the first was champion golfer Ben Hogan, whose technique had been celebrated on the August 1955 cover of *Life* magazine. Even nongolfers were caught up in the Hogan craze. What was the secret of his amazing swing? Sportswriters had concluded that the magic was in his grip, but what, they all wondered, was so special about his grip? Was it supination, pronation, the way he held his thumbs? At last, here was something seriously preposterous that Al could reduce to ridicule with a thrust of his satiric pen. He would reveal the secret of Hogan's grip. He would show what actually happens when the great man swings.

"Nowhere is it better to look for funny stuff than in a slow-motion sequence. We all know the beginning and we all know the end, but we don't know what's in between. Hogan starts out with the normal ten fingers. Then, in each subsequent panel, he keeps growing fingers. By the middle of the two-page spread, fingers are sprouting out of Hogan's wrists—but by the time he finishes his swing, he's back to five-fingered normalcy." Harvey loved it. So did Bill Gaines.

Shortly thereafter, Harvey called again, this time to offer Al a job working for *MAD*. By then Harvey was a legend in the comics industry. Al was thrilled at the prospect of getting what he'd always wanted—the opportunity to let his crazy, arrested-adolescent self run wild. Joining creative forces with some of the most innovative cartoonists of the time—Harvey Kurtzman, Jack Davis, and his old pal Willie Elder—was a dream he'd never dared to dream. "I was part of the philistine group. They were the elite group. I never considered approaching them. They were doing the kind of work I would kill for." Perhaps best of all, Al saw them as a family. He anticipated a convivial band of cartoon brothers presided over by the paternalistic Bill Gaines.

Then reality intruded. Al realized that he couldn't afford to take his dream job. The pay—Kurtzman estimated that Al could make about ten thousand dollars freelancing for *MAD*—was half of what he was making with Stan Lee.

"I've got to make a living," he told Harvey. "I can't just throw over *Patsy Walker* and go to *MAD* on a freelance basis with no guarantee." A disappointed, cautious Al said no. He might have been expressing his financial reality or his shtetl fears of once again finding himself poor and starving. Harvey had once described Al as "close with the buck."

Just days after he'd received and turned down the offer to join *MAD*, Al made his monthly visit to New York to deliver yet another *Patsy Walker* to Stan Lee. Instead of engaging in their usual banter—"Hi, Al, what garbage have you brought me today?" "Well, Stan, you're going to love this garbage; it's perfumed"—Stan held up a page of *Patsy Walker* panels, submitted by a cartoonist who was campaigning for Al's job. "Look at what came in over the transom, Jaffee. You'd better look to your laurels."

MY SECRET

Benn Ogen reveals mystery gimmick that made him rich and famous

WITHOUT SECRET Ogen's conventional grip is exactly the same one he has used for years with unspectacular results.

WITH SECRET Ogen shifts his fingers ever so slightly which is the main reason why his opponents could not detect it.

by BENN OGEN

PICTURES BY AL JAFFEE

"Tricky lil' Devil, ain't I?"

The better golfer you become the more trouble you'll have with the hook. A hook is the natural outgrowth of a more powerful swing. It'd be almost funny if it weren't so pathetic to see the ridiculous lengths that some famous tournament players have gone to to get rid of this terrible problem. Take the case of my old friend Sam Snood. Sam approached the problem with calm logic. He figured that since a hook veers off to the left he could solve it by standing a little further over to the right. Little by little he edged further and further over to the right and when the ball was almost landing just right he suddenly developed a terrible slice. Since a slice veers off in the opposite direction of a hook, poor old Sam could do nothing else but start working his way back in the other direction. Just as the slice was about to disappear guess what? . . . that's right . . . the hook returned and with calm logic Sam proceeded to smash every club over his caddie's head. Mang Lloydrum tried various methods of licking the demon hook including a special set of anti-hook clubs with built in battery-operated swivel heads. A mid-game short circuit ended that idea. Alfred E. Neuman tried the most audacious experiment of all . . . he gave up golf. Oh these poor, poor deluded boys. I just couldn't help chuckling to myself as I watched their pitiful efforts when all the while (chuckle chuckle) I had the *real* secret. Boy, I just hated myself for laughing at their (HA, HA) expense, but with my secret I was (HO, HO) beating the pants off 'em. They were (HOO, HAH-HA) starving. But now that I'm load—er—now that I've decided to retire I'd like to share my secret with them.

What makes the whole thing so very interesting is the utter simplicity of my secret. I can't understand why no one ever noticed it. You start by simply gripping your club in the usual manner . . . then with a simple motion you start to pronate the right hand till a small "V" is formed between the wrists. Apply the rule about isosceles triangles to this "V" then go on to figure out the distance from angle "A" to angle "B." If it exceeds 11½ degrees, compensate with a simple reverse pronation until left thumb comes right under the middle knuckle of left forefinger. Simple, hey? But wait—that's not the secret yet. You will notice that after all this maneuvering that there's no place to put the right pinky. Well, just point it towards where you'd like the ball to go, then try to hit the ball there. If it happens—man! *You've* got the *secret!*

you read it in **MAD**

THE SECRET BEGINS when Ogen goes into his backswing. He starts his

loosening up as shown in picture 2 and continues until he reaches critical moment. (3)

Whereupon his left hand pronates downwards (4) with great speed (5)

SECRET CONCLUDES with reverse pronation upwards (see 6) and a firm

tightening grip (7) Downswing continues till the moment of contact (as in 8) resulting in

follow-thru 'and right pinky pointing to spot ball should light (9)

Al was in a no-kidding mood. "Stan, I haven't had any sleep in three days. I don't want to look to my laurels. I'm too tired. And maybe I'm tired of *Patsy Walker*. I think you should give the job to this guy." And he walked out. "This was totally abnormal behavior for me, especially toward Stan, who had been my friend and mentor for years."

By the time Al got home, Ruth was waiting on the front lawn. Stan had been phoning nonstop. "Stan said he was only kidding. He said you can keep on doing *Patsy Walker*."

But Al had made up his mind during the hour-and-a-half trip home from the city. He called Stan back. "I just can't do it anymore."

Al might never have found the courage to leave *Patsy Walker*—given his fear of change and separation—but he had an ace up his sleeve. "I couldn't wait to get to the phone to call Harvey. 'Okay, Harvey. I'm burning my bridges. I quit *Patsy Walker*. I'm coming to *MAD* to work with you.'"

"Oh, Al, I forgot to tell you," Harvey responded in the slow, measured way he had of speaking, "I quit *MAD*. But don't despair, Al. I think I have something in the works. Everything is going to be all right." Once again, Al hung suspended.

In spite of the fact that almost everything in his life thus far seemed calculated to demonstrate that everything would not be all right, he believed Harvey. Al, who even now torments himself nonstop with scenarios of unpaid mortgages, life insurance policies, and credit card bills, never looked down. "I'm out of work. I've got a couple of thousand dollars in the bank. My faith in Harvey was like the faith I might have felt for a parent, the kind of parent I never had. When I would express doubt about my ability to do something, for instance, a superhero parody, I would say, 'I don't know if I can do that, Harvey. I don't know anatomy,' and Harvey would answer, 'I don't want somebody who knows anatomy, I want Jaffee. I know what you can do.' He always reassured me that he had made the right choice when he chose me. He was 'Father Knows Best.' My teacher at Music and Art, Miss Riley, had been like that, too. If I ever said I didn't know how to do something, she would wink at me and say, 'Oh, yes you do.'" In a lifetime of surrogate parents, Miss Riley and Harvey Kurtzman stood out. So Al waited and did not despair.

Sure enough, about a week later Harvey called to offer Al a guaranteed ten-thousand-dollar salary and a position as associate editor of *Trump,* a start-up satirical magazine intended to compete with *MAD* and bankrolled by the hottest entrepreneur in the magazine business, *Playboy*'s Hugh Hefner. Al was so relieved that he forgot about the ten-thousand-dollar salary cut that had kept him from accepting Harvey's original offer. "How could I argue with this guy Hefner, this genius entrepreneur with the golden touch? I was putting my future in Harvey's hands, and Harvey was putting his in Hefner's hands."

The Bill Gaines–Harvey Kurtzman split is legendary in the annals of cartoon history and reaches back to 1949, when Al Feldstein and Kurtzman were both working for Bill Gaines at EC Comics, which Gaines had renamed Entertaining Comics and which published horror, crime, science-fiction, and war comic books. In 1956, when Kurtzman quit *MAD* to edit *Trump,* Gaines would choose Al Feldstein to replace Kurtzman. The two men had been rivals ever since Kurtzman came to EC Comics in 1949. Kurtzman was annoyed that Feldstein was making more money than he was, even though he worked as hard as Feldstein. Nevertheless, as Gaines pointed out to Kurtzman, Feldstein was outproducing the slower, more meticulous Kurtzman and making more money for the company. Gaines suggested that Kurtzman make up the difference by starting a humorous comic book, which would use his talents well and release him from the time-consuming research that, as a perfectionist, he had been lavishing on EC's war comics, thereby allowing him to make more money. In 1952, Kurtzman responded with *MAD,* a comic book that would lampoon the comics themselves. It got off to a slow start, but the fourth issue, which contained a wickedly dark parody of Superman, entitled *Superduperman,* flew off the stands.

In 1954, at the height of the anti-Soviet madness, Fredric Wertham, a distinguished psychoanalyst, published *Seduction of the Innocent,* in which he argued that crime and horror comics were contributing to juvenile delinquency, that popular culture, including the movies, was part of a capitalist dumbing down of the culture, and implied that Wonder Woman was a lesbian role model and that Batman and Robin were homosexuals. (Wertham was a politi-

cal liberal and civil libertarian. He ran free, low-cost psychiatric clinics in Harlem and testified for the integrationists in *Brown* v. *Board of Education*, but he made a prudish exception to the First Amendment when it came to severed heads, melting flesh, and sex.) The Senate Subcommittee on Juvenile Delinquency, led by Estes Kefauver, conducted what, in retrospect, was as much an inquisition as the McCarthy witch hunt. By 1954, the Comics Code, the spawn of that commission, had, in addition to demanding that teenage heroines like Patsy and Hedy wear looser blouses, banned torture, the walking dead, and all depictions "lurid, unsavory, and gruesome." J. Edgar Hoover, often the butt of *MAD* satires, kept a file on *MAD*.

The code effectively put the EC horror empire out of business, leaving Gaines with the *MAD* comic book and a pile of debt. Gaines was on the brink of closing down EC, at least temporarily. Reluctantly, he laid off Feldstein and was about to stop publication of *MAD* as well, when Kurtzman, taking advantage of Gaines's weakened condition and emboldened by a job offer from *Pageant* magazine, encouraged Gaines to borrow money to keep *MAD* afloat—not as a ten-cent comic book but as a publication more in keeping with the fulfillment of Kurtzman's high school dream—a classier, more expensive, and more successful twenty-five-cent bimonthy, satiric magazine. Gaines acceded.

First Harvey turned his satiric lance on EC's own defunct horror comics and made mincemeat out of such sophisticated publications as *Life* and *National Geographic*. Ironically, by slamming the door shut on horror, crime, and sex, Wertham and the Kefauver investigation had inadvertently opened the door to the magazine most responsible for putting an end to American childhood innocence. Hypocrisy, revealed and soured by satire, was mother's milk to *MAD*.

Even so, Al believes that Gaines's experience with the Kefauver committee forever had a chilling effect on *MAD* magazine's content. "After that," says Al, "*MAD* never went to the printer without Gaines poring over it with great care. He read every single word. He didn't fact-check or critique the humor. He was looking to make sure it was safe—safe from copyright infringements and safe from

vulgarity. He'd been burned. Gaines wanted good, clean fun." *Super-duperman* had incurred the wrath of the owners of *Superman,* National Periodicals, who threatened to sue for infringement but ultimately did not. *MAD* wasn't as lucky with *Sing Along with MAD,* a collection of parody lyrics that provoked the lawsuit *Irving Berlin et al.* v. *E.C. Publications.* Ultimately, after an appeal that went to the Supreme Court, *MAD*'s rights to parody and satire prevailed. In 1966, the ownership of *MAD*'s mascot, Alfred E. Neuman, was contested and affirmed in *MAD*'s favor. In spite of Gaines's best efforts to avoid vulgarity, *MAD* managed to provoke angry letters from readers—most likely the parents of readers. A deer dressed as a hunter and carrying a gun brought down the wrath of the National Rifle Association. One of Al's fold-ins—the theme of which was immorality—depicted a sex shop that included an inflatable nude. When folded in, the picture morphed into the likenesses of notorious evangelicals who had recently been in the news for their sexual improprieties. Gaines got hit with angry mail from both sides—the fervent evangelicals and those who were offended by the naked dolls. The protests were so significant that *MAD* lost a chunk of sales from some supermarkets who banished that issue from their racks.

Feeling proud and vindicated about *MAD* magazine's phenomenally successful launch—the first issue sold out and had to go back to press—Kurtzman asked for a personal stake in his baby. The accepted version of the percentage story is that Gaines offered Kurtzman 10 percent. Kurtzman, who was more interested in control than money, countered with a demand for 51 percent. Gaines refused and Kurtzman left *MAD,* taking most of the staff with him. Gaines immediately rehired Al Feldstein to replace Kurtzman as editor.

"Harvey was naïve," says Denis Kitchen, coauthor, along with Paul Buhle, of *The Art of Harvey Kurtzman.* "Harvey didn't understand how offensive his fifty-one percent demand was to the patriarchal Gaines." Kitchen believes that if Kurtzman had had any business sense, or if he'd had better advice, he would have dropped his demand for 51 percent and negotiated for and gotten editorial control.

"Three years later," Al recalls, "when I started freelancing officially for *MAD*, Bill Gaines asked me, 'What is it about Harvey that people will follow him to the ends of the earth?' I didn't know how to answer him. Harvey said to the people at *MAD*, 'I'm leaving *MAD*. Who wants to come with me?' and nearly everybody went with him. He was like the Pied Piper."

Al believes that Kurtzman found the courage to leave *MAD* because of Hefner's offer. He further believes that Kurtzman didn't want Bill Gaines supervising his satirical work. "While he felt that Bill Gaines was very capable and successful with his horror magazines, Harvey didn't think Bill had much of a feel for satire. Harvey had used up the comic format. He wanted more text, more illustrations, and more non-cartoon stuff. Bill Gaines, who had more of a comic-book mentality, had given in to Harvey's demands, but Harvey still wasn't satisfied."

Denis Kitchen thinks that Hefner seduced Kurtzman. Kurtzman couldn't resist the fact that the charismatic Hefner, who represented "class" to Kurtzman, had come to him, flattered him, called him a "genius." Moreover, Hefner promised him slick paper rather than newsprint, placement on newsstands with "smart" magazines such as *Look*, and, more important, total editorial control and unlimited funds.

Al has his own version about the percentage face-off between Kurtzman and Gaines. "Harvey might have made millions if he had been willing to cede control and accept forty-nine percent, but that's assuming Harvey could have done with *MAD* what Al Feldstein, who inherited the editorship, was able to do—make money. I think Gaines was willing to give Harvey forty-nine percent of *MAD*. He may not have been able to give Harvey the fifty-one percent he wanted because Gaines's mother, Jessie, a hard-nosed businesswoman, held a controlling interest in *MAD* and refused to yield control to Harvey. If Harvey had taken the forty-nine percent, he would have been two percentage points less rich than Bill Gaines— that's many, many millions of dollars. Harvey missed the boat on that. The thing that killed it for Harvey was that his eye was on the art, not the bank account. I respect him for that."

Denis Kitchen agrees that Kurtzman blew a golden opportunity when he turned down 49 percent but thinks he could have had his 49 percent *and* editorial control.

Feldstein, who was the editor at *MAD* for nearly thirty years, is miffed that Kurtzman, who died in 1993 and edited the magazine for a mere two years, continues to get more credit for its success than he does. "Harvey didn't have the guts to announce that he was leaving *MAD*. Instead he manufactured a reason for Bill to fire him. I took over *MAD* in 1956 when it was selling about 350,000 issues as a 'quarterly'—if Harvey could make the deadlines. I assembled an entirely new and talented staff of writers and artists and increased its sales to almost three million, eight times a year, with two hundred fifty original and reprint paperback titles, eleven foreign editions, and four special annual editions. And yet almost all of the articles written about *MAD* attribute its creation to Harvey (and deservedly so) but then to go on to describe the magazine's popularity, its influence, and its originality through the late fifties, sixties, seventies, and early eighties when I was *MAD*'s editor and *never even mention me*! You bet it's annoying."

Al was happy to follow Harvey Kurtzman to *Trump*. "I had a tiger by the tail. I was working for Hugh Hefner of *Playboy* fame, the biggest magazine around. I was going to the Playboy Club and being invited to Hefner's Christmas party. It was celebrity time." *Trump* was going to compete and overwhelm *MAD* with superior production. *MAD* was all black and white, except for the front and back covers. *Trump* was going to have color throughout. Backed by Hefner's money, driven by Kurtzman's boundless creativity, staffed by the most talented satirists in the industry—Arnold Roth, Jack Davis, Will Elder, and Al Jaffee—how could *Trump* fail?

Easily, as it turned out. After two issues *Trump* crashed and burned like a third world missile launch. "The story that Hefner gave us was that his bank said that unless he cut his expenses, they wouldn't continue to finance *Playboy*. Since *Playboy* was the flagship, his explanation was plausible and we all accepted it. *Collier's* and *Liberty* magazines had folded because they, too, couldn't get bank loans." In retrospect, Al wonders if maybe *Trump*'s price—fifty cents—and

elegant look turned off the rebellious kids who were well content with the scruffier, cheaper twenty-five-cent *MAD*.

Years after *Trump* failed, Al ran into Hefner's financial CFO, Bob Preuss, who told him that *Trump*, supposedly a monthly, had been folded because Harvey Kurtzman, a perfectionist, and Willie Elder, a slow, methodical artist, could not be relied upon to put the monthly magazine out on time, as evidenced by the fact that the first issue came out in January of 1957 and the second in March. Advertisers tore their hair, and Hefner got stuck paying for days of reserved but unused press time. "I gave Harvey Kurtzman an unlimited budget," Hefner is reported to have said, "and he exceeded it."

Al was now completely unemployed and without income. He was thinking about what to do next when, within two weeks of *Trump*'s demise, Kurtzman called Al with another "do not despair" message. He had a plan to start another monthly satirical magazine, *Humbug*. *Humbug*'s targets would be more topical, more sophisticated and literate, than those of either *MAD* or *Trump*. *Humbug* would be a communal endeavor, owned by the artists and writers who invested in it and contributed to it. Kurtzman, Will Elder, Arnold Roth, and Al would be their own bosses and stockholders, unrestrained by anyone but Kurtzman, the creator and editor. Hefner, feeling contrite about the failure of *Trump*, offered the collaboration free office space.

In spite of *Trump*'s failure, Al's faith in Kurtzman held firm. What was peculiar was not that Kurtzman risked walking off another cliff but that Al, given his cautious nature, so readily followed him. "It was a blow when *Trump* folded, but even then, when it seemed that the whole world was falling apart, I felt safe with Harvey." Al invested all of his savings in *Humbug;* he even borrowed on his life insurance. He held back just enough money to cover the barest expenses, since *Humbug* was unlikely to pay anyone a salary for the first few issues. Money was tight, tight enough to limit the magazine to black and white on pulpy paper and to keep Harvey disciplined about deadlines. Even with all the staff's savings invested, the Charlton Press of Derby, Connecticut, *Humbug*'s printer and distributor, would have to advance all costs.

The atmosphere at *Humbug* was freewheeling and wacky. Al was on fire with creativity. "*Humbug* offered the opportunity to go on with what we had started at *Trump* in the same wonderful atmosphere. It was cartoon Camelot." It was at *Humbug* that Al got the chance to use the unique engineering skills that would later dominate his work at *MAD,* particularly the fold-in. He drew a hyperwordy cereal box that made fun of the then-recent tendency of containers to read like publications. The text-laden box itself made for hilarious reading, but Jaffee offered more. When cut out and assembled according to instructions on the opened and flattened box, it perfectly replicated a Kellogg's cornflakes box. "Al's way of drawing is distinctive," says Arnold Roth, who worked with Al on *Trump* and *Humbug.* "He has a natural legibility. He uses language and art beautifully, and you always know it's him talking. His graphic concept caters to the idea. You're giving information when you draw. His idea of construction is always in character."

Before they were officially known as "Al Jaffee's Mad Inventions," his comical constructions first saw print in *Humbug.* In a satiric response to the tedious, intricate, balsa-wood model-airplane kits that consumed hours of hobbyists' time in the 1950s and gave glue sniffing a bad name, Al designed a variety of prefabricated model-making kits that, with a single yank of a string, would instantly transform themselves into the Taj Mahal, the Statue of Liberty, or the Sphinx. He might as well have been back in Zarasai with Harry, designing and flying sleds and whirling propellers.

"I was at a neighborhood cocktail party in Babylon when one of my neighbors asked me how long I'd been working on the magazine without a salary. I realized it had been four or five months. Then he asked me, 'Don't you feel nervous?' I remember that moment because I realized, much to my own surprise, that I wasn't nervous. I couldn't understand it. This was the happiest and most peaceful time of my professional life. I was enjoying what I was doing so much I must have decided to transfer all of my anxieties to Harvey, who I somehow believed would pull us through one way or another. He came up with *MAD.* He came up with *Trump.* He came up with *Humbug.* We were all still alive. What, *me* worry? Let *him* worry. Psychologically, it

MODEL MAKING

Today, all parts are perfectly fabricated.

Just out on the market, the ultimate in model making pleasure, is the ingenious "YANK-IT" kit pictured above

COMPLETED model is perfect and professional looking. Also, the young craftsman does not suffer from overwork this way. He can easily make several in one evening without missing anything on TV except perhaps a few commercials.

With this cleverly consructed kit the young craftsman need only give one good yank and all parts fly into place.

was my Scarlett O'Hara *Gone with the Wind* moment. If it didn't work, I'd think about it tomorrow."

It didn't work. *Humbug* failed for a number of reasons. Underfunding was certainly one of them. Another was that Kurtzman fell prey to his own irrepressible urge to innovate. By choosing to create a uniquely sized magazine—one that was smaller than a comic book—he doomed *Humbug* to insignificance or invisibility on newsstands, where it was either dwarfed by or hidden behind larger magazines. Al identified the problem in retrospect. "Looking to be innovative doesn't always pay off unless you solve all the problems you create. A house on top of a telephone pole is very innovative, but who's going to move in?"

When after the eleventh issue *Humbug* was still not making a profit, the Charlton Press made a demand: either we take over the magazine or we'll pull the plug. Without consulting anyone beforehand, Kurtzman told Charlton Press he would not be owned, and so the magazine failed.

Al had no regrets. "Going broke working with Harvey was the best experience of my life." He took his stock certificate, folded it into a paper airplane, and sailed it out Hefner's rent-free-office window.

Actually, *Humbug* died twice. Shortly after Kurtzman turned down Charlton Press's offer to take it over, Al got a phone call from Al Feldstein, who by then had replaced Kurtzman as the editor of *MAD*. "Al and Bill Gaines had come up with an idea. They knew they couldn't negotiate with Harvey. Either they had tried or they figured he was unapproachable. They asked me if the *Humbug* staff would be interested in being a sister magazine to *MAD*, alternating publication months. *MAD* was published eight times a year, and even that was a strain for them. They were willing to keep *Humbug* alive, at what price I do not know. I told them I didn't have any control over Harvey. The feeling I had at the time was that Harvey should have called us together to discuss the plan to save *Humbug*. If Gaines wanted to own it, we could always have said no. But suppose he would have been willing to give us stock?" In effect, Al refused the role of intermediary, and so the plan died aborning. "There never was a meeting with Gaines. Harvey refused to negotiate with them. I was

disappointed because at that moment I was without a job or any prospects, but I wouldn't do it without Harvey being involved."

After the financial losing streak of *Trump* and *Humbug*, Kurtzman and Will Elder teamed up to create *Help!*, a magazine similar to *MAD*, and Arnold Roth and Jack Davis returned to their freelance careers as illustrators. After an uncharacteristically perilous couple of years, Al reverted to form. He wanted steady, lucrative work, the kind of sinecure that a syndicated feature could provide. "If I could sell a syndicated column, I could live a life of ease, but the odds of success, even for a pro like me, were terrible." The competition for space on the funny pages was Darwinian. "I was told that you couldn't sell a new strip without knocking out an old one." Al's chances for displacing the likes of Harold Gray's *Little Orphan Annie*, Chester Gould's *Dick Tracy*, or Milton Caniff's *Steve Canyon* were just about nil.

How, he wondered, could he occupy space that wouldn't challenge an old strip. He opened the newspaper and stared at the familiar layout of the funny pages until the obvious—yet something no one seemed to have noticed before—dawned on him. All the cartoons were horizontal; therefore, Al would go vertical. He employed the same kind of slightly perverse oppositional thinking that he used as a child to defend himself from his mother. "My thought process has always been to look at how it's always been done and then turn it upside down. I thrive on change and novelty. It's just a natural part of me. I love the challenge."

Al immediately started thinking vertical—flagpoles, trees, staircases, ladders, ski slopes, skyscrapers, trampolines, and snails that unfurl when they sneeze. "I doubt," said Al, "that the people who do horizontal cartoons ever bother to think, 'Now I have to draw snakes, clotheslines, garden hoses, and anything else that lies flat on the ground.'"

What Al likes best about what became *Tall Tales* is that the height of the panel allowed him to elicit double takes from his readers. "One of my first *Tall Tales* was a roofer who had dropped his hammer on the lawn and was reaching for it two stories down through the drainpipe." Al has intentionally dressed the roofer in a black shirt and executed the rest of the cartoon in minimal lines against a

white background, thereby making him the focal point. Then, after having had a moment to take in the strained look of the roofer's face, the reader follows the drainpipe downward and is rewarded with the double take of a pantomime punch line—the roofer's hand impossibly poking out of the end of the drainpipe, attempting to grasp the fallen hammer. Although he sometimes had to rely on a word or two—in one instance to send a bank robber from the deposit to the withdrawal window—Al loved being able to tell a tale without the help of words and to have his creativity be literally hemmed into a tight vertical space.

The feature sold immediately to the Herald Tribune Syndicate, but, like Harvey Kurtzman's uniquely small *Humbug* format that contributed to its undoing, the fact that *Tall Tales* could be placed anywhere in the paper doomed it to obscurity. By going vertical Al had avoided competing for space on the comic pages. "Unfortunately, because the column could be put anywhere in the newspaper—from the editorial page to the classifieds—fans of the feature got sick of trying to find it. I had out-created myself." Even so, the feature appeared for six years and at the height of its popularity ran in about one hundred papers, thirty-five of them foreign. The coup de grâce was delivered by an editor who insisted that Al add text to *Tall Tales,* thereby killing one of its unique features and destroying its considerable foreign market. "My doom was sealed. I'm a visual humorist, not a gag writer. The feature lost its raison d'être."

Although Al's writing is as well regarded as his drawing, he is prouder of his wordless cartoons. "If you can turn the action into a story where words are superfluous, it's a complete art form. Sergio Aragones is the master of pantomime art. He could tell a two-hundred-fifty-page story without a single word in it, and you would be able to read it."

Aragones and Al belong to a mutual admiration society. "I grew up in Mexico," says Aragones, "and I knew his work from *MAD,* but I never saw *Tall Tales.* I was so proud of my pantomime cartoons, and then, ten years later, I saw *Tall Tales* and I thought, 'Oh my God, he must think I'm a plagiarist.' He is a master cartoonist. I am in awe of that man. He's the best cartoonist ever."

Al feels the same way about Aragones. "Everything he does I wish I had thought of. Sergio is the epitome of what I admire in cartooning, and I like to believe I can do it, too." Antonio Prohias, originator of the supremely popular and silent *Spy vs. Spy,* joined *MAD* in 1961. Aragones would follow in 1962, giving *MAD* a trio of wordless cartoonists—a quartet if one counts Don Martin, the master of sound effects.

Al set his sights on *MAD* at about the same time he embarked upon *Tall Tales.* Ever since he'd done the Ben Hogan parody, he knew that *MAD* was "home." However, he lacked the nerve to knock

on the front door. What stopped him was that he feared guilt by association with Kurtzman.

"There was bad blood between Harvey and the *MAD* staff. I knew I had to be persona non grata at *MAD*. Even though I was an innocent bystander—I wasn't even a regular when Harvey left—I felt that I was being tarred with the same brush." Then there was the added taint that Al had worked for Kurtzman on both *Trump* and *Humbug,* two publications that had declared war on *MAD*. Nor could Al forget the time he, along with Kurtzman and Arnold Roth, had promoted *Humbug* on the popular Long John Nebel talk radio show. On that acrimonious occasion, *MAD* staffers phoned in to the show to excoriate Kurtzman for leaving the magazine in the lurch. Even though none of this hostility had been directed at Al, the mere possibility of an angry confrontation was enough to make an ingratiating man cringe.

He screwed up his courage and made the call. "I don't know if I'm a pariah because of my association with Harvey," he told Al Feldstein, but before he could say another word, Feldstein said, "C'mon down."

Al brought with him an armload of scripts left over from *Trump* and *Humbug* that had never seen print. Feldstein looked them over and handed them to Bill Gaines.

"A couple of days later, Gaines calls me into his office and greets me warmly. 'So you're the guy Harvey's been raving about all these years,' he tells me. Then he asks me if I'd mind going through the old issues of *Humbug* and pointing out which of the stories were mine. We rarely signed our work in those days. It wasn't unusual for multiple artists to work on a single project.

"So we sat on a couch in Gaines's office, and as Bill turned over each page I would identify my work—this is mine, this is mine, this is mine. After Gaines had paged through all eleven issues, we went to Al Feldstein's office and Gaines said, 'Hire this guy.' "

6

MAD DAYS

"Every once in a while
I tell myself, 'Live it up,
you're an American.'"

IN SPITE OF THE FACT that his work for *Humbug* and *Trump* made
it evident to Gaines that Al could draw as well as write, Al began his
official association with *MAD* in 1958 as a writer, because *MAD*
needed writers more than it needed artists. Al accepted the limita-
tion with grace. "The magazine was voracious. It would eat scripts up
as fast as they could be produced. Artists like George Woodbridge,
Bob Clarke, and Jack Rickard needed to be fed."

During his first year at the magazine Al flooded the *MAD*
machine with ideas, and because he couldn't resist, he also offered
accompanying cartoon sketches. "I was a hybrid." Alone in his office,
Nick Meglin, *MAD*'s associate editor, would read Al's storyboards
and laugh out loud at the sketches. "Even before Al came to *MAD*,"
says Nick, "I knew his work from *Trump* and especially from *Hum-
bug*. I saw him as a rare talent, one who could write as brilliantly as
he drew. Not only were you looking at something somewhat realis-
tic, but it was realistic in a clever disguise so that the humor was
evident at first blush. You saw the gag immediately. You didn't have
to labor." Nick took Al's work to Al Feldstein and said, in effect, "Jaf-
fee turns in scripts with these funny sketches, and then we hand
them over to an artist who takes the life out of Al's work. You cannot

separate Jaffee's writing from his art. He's a whimsy writer-artist. Let Jaffee draw." After that, Al became a writer-artist. Only occasionally did he illustrate other writers' work.

When Al finished a job, he'd call Al Feldstein to arrange a time for him to deliver it. Then he'd sit down with the whole staff: Feldstein, the editor; the two associate editors, Nick Meglin and Jerry DeFuccio; John Putnam, the art director; and Leonard Brenner, the assistant art director. "Each one would read my submission for five or ten minutes and then vote. Even when there was a chuckle or a smile here and there, it was a rather demeaning experience to have your work discussed in front of you. These days they don't do that. I deliver the article and go home. They have a meeting, vote, and give me their verdict by phone. It's an up-or-down thing. They don't bring me in to discuss the script unless they want it rewritten." Since Al's acceptance rate has always been in the high ninetieth percentile, he is rarely called back to the *MAD* offices to discuss changes.

The key to his success, he believes, is that he rarely queries the editors in advance to test their reactions to his ideas. "What I learned is that if you test your idea out on the editors, sooner or later everyone's little ego gets into it and they start making additions or subtractions and pretty soon you've got nothing." Instead, he writes and draws the article in advance and presents it to the editors as a fait accompli.

Al noticed a sea change when Feldstein took over. "Al Feldstein and Harvey were equals on the level of writing," says Jaffee, "except that Kurtzman was a funny writer and artist and Feldstein was a serious writer and artist. Feldstein could recognize funny stuff, but he, himself, was not a jokester.

"The two men had different ambitions for *MAD*. If Harvey was successful at what he was doing, he wanted to take another step forward, make it fancier, better written, more expensive, more sophisticated. Harvey imagined editorials written by prominent people. He wanted *MAD* to have the stature that *Punch* enjoyed in England. Kurtzman was always on the lookout for new talent, whereas Gaines and Feldstein were interested in holding on to their freelance staff. The group had established a sense of identity with the reader. Feldstein was happy to exploit what was working and just do more of it."

While Al was a great admirer of Harvey's innovative drive and his ability to attract the best artists, temperamentally he was in Feldstein's more pragmatic camp. "Trying to invent a new magazine every month is a big job. Why kill yourself? *MAD* served my purposes. I didn't evaluate *MAD* on the basis of whether it was up to my sophisticated taste. I recognized it for whatever it was, and if I could be useful to them, they could be useful to me. I had no notions that I was better than *MAD*."

While more conservative than Kurtzman, Feldstein remained open to new material. The fold-in began under Feldstein's leadership, as did *Snappy Answers to Stupid Questions* and later, during the Vietnam years, *Hawks and Doves,* an antiwar strip.

"As an editor Feldstein considered his job to be the boss, not one of the boys. He was friendly and appreciated good work, but he was tougher than Harvey. He would tongue-lash his subordinates before he'd go on vacation, leaving the staff a quaking mass. I think he did it out of insecurity. It was as if he was afraid of a palace coup."

"It was my policy to remain aloof from the freelance staff and not socialize so that I could maintain a professional relationship with them," says Feldstein. Al Jaffee and his wife were the only members of the freelance staff that my late wife, Lee, and I did socialize with. I felt that Al was 'professional' enough to separate our business and our social relationships."

Al Jaffee won't say whose editing style he preferred, but he will say this: "*MAD* was a commercial enterprise. Feldstein made a lot of money for *MAD*. Would Harvey have made money? Maybe not."

Jaffee saw Gaines as a benevolent ruler. "He didn't want his stable of artists to sit around twiddling their thumbs waiting for work. He also didn't want them going elsewhere looking for outside assignments. Gaines ran a tight ship." He not only paid his freelancers the same day they delivered their finished work to the *MAD* offices, but he paid more than most publishers of similar magazines. Al was amazed. "Other magazines could take weeks to come through with a check. Nowhere in publishing had I ever heard of paying on the barrelhead; it was Gaines's policy, and it was both generous and selfish. He gave with one hand and took with the other."

With the hand that took, Gaines kept all rights to his freelanc-

er's work, a practice that was common in the industry at the time. Al doesn't own anything he has ever drawn or written for *MAD*, including the fold-ins and even the sketches for the fold-ins. Adele Kurtzman, Harvey's wife, recalls that Bill Gaines sold Harvey's first *MAD* cover to Steven Spielberg for fifteen thousand dollars. "Harvey didn't get a dime." Each time a freelancer endorsed a check from *MAD*, he simultaneously signed a brief contract stamped on the back of the check, giving away all rights.

When Al started to work for *MAD* on an irregular basis in 1955, he remembers, the magazine paid one hundred dollars a page for art and seventy-five dollars for the script. Comic books had always paid less for script, but writing for *MAD* was more demanding than writing for comic books, and the writers rebelled. Nick Meglin went to bat for his rebels, and the price for a page of script was raised to one hundred dollars. It wasn't until the last decade that the fee per page for writer-artists such as Al reached a peak of sixteen hundred dollars—eight hundred for art and eight hundred for the script. (Now, with *MAD* cut from twelve to six issues per year, the fee is down to five hundred and five hundred and, Al fears, probably going lower.)

Gaines made sure that no one would woo away one of his stars by offering him more money. (After all, that's one of the reasons he'd lost Kurtzman to Hugh Hefner.) "Gaines was so concerned about losing talent that he used his assistant editor and closest confidant, Jerry DeFuccio, as both talent scout and cop." It was DeFuccio's job to read whatever script ideas came in over the transom—most of which he rejected—and to turn away offers from outsiders who wanted to hire *MAD* artists. Al hates to think about how many lucrative offers he never heard about. "If, God forbid, NBC should call up and want to pay me twenty-five thousand dollars to do a cartoon, it was Jerry's job to tell them I wasn't available. Everything had to pass through DeFuccio, but he was made of steel and nothing passed through." (Years later, in the seventies when *MAD* was at the height of its popularity, Gaines fired the once-trusted DeFuccio when some original art that was under DeFuccio's control went missing. John Ficarra, *MAD*'s current editor, took DeFuccio's place at Nick Meglin's suggestion.)

Gaines took a lot of friendly abuse from his staff, although never from Al. "I am totally uncomfortable insulting anybody. But Lenny

Brenner, the lowly assistant art director, had no qualms about walking into Bill's office and saying, 'Look at this cartoon, you big fuck. Do you think this is *funny*?' Bill would respond in kind and laugh. We lowered the level of respect to something approaching nonsense, and it worked. People didn't try that with Nick Meglin or Al Feldstein. I guess maybe we felt their egos wouldn't allow it."

Gaines was famous for treating his writers and artists to luxurious annual trips to faraway destinations. But there was a catch. In order to qualify for the trip, the artists and writers had to have contributed a minimum of eighteen pages to *MAD*. (The prolific Al always qualified.) "When Gaines's mother died, we were all notified of the funeral. Arnie Kogan, a writer who did a lot of work for *MAD* and later went on to Hollywood, joked in Gaines's presence that he hadn't done enough pages to get invited to the funeral. Gaines roared.

"The smartest thing Gaines ever did was to take us on those trips." The magazine's annual expeditions were the means by which the usually isolated writers and artists got to know one another and coalesced into a team, a family. Gaines was the father, a compassionate, mercurial, stern father, a role he not only relished, but insisted upon—except when he didn't. Then he wanted to be everyone's pal. Early in their association at *MAD*, Gaines expressed his desire to be "one of the boys" to Harvey Kurtzman, who was cool to the idea and not afraid to express his feelings to Gaines. "Bill, Bill," said Harvey in his usual deliberate search for words, "you control our lives. We're all dependent upon you to pay our rent and feed our children. How can you ever be one of the boys?" The accommodating Al would not have been so forthright. "If Bill had said that to me, I would have said something like, 'Sure, that would be fun.' But Harvey, who had a very low bullshit threshold, went to the heart of the situation."

With the exception of the *MAD* trips, even the boys had very little opportunity to be "one of the boys." "Whenever I run into *MAD* readers, they invariably comment about what fun I must have brainstorming and kidding around all day with the other writers and artists at the *MAD* offices. They imagine 'the usual gang of idiots' hard at play in the *MAD* conference room, inhaling cheese Danish, exchanging good-natured ribbing and cross-pollinating comic ideas for the next issue in an environment of ever-escalating high jinks

and merriment. They conjure up images of Don Martin speaking in tongues—*SPAZAT, KAZOP, SLURK, PLOBBLE, GLUNK;* Frank Jacobs speaking in verse, and Sergio Aragones emptying a jar of rubber cement on Bill Gaines's Eames chair. How, they wonder, do we ever get any work done surrounded by so much hilarity?"

The demythologized truth is that there is no Danish, no Eames chair, no cross-pollinating, and no kidding around. Nor is there a conference or even a conference room to hold one in. The twenty-five or so writers and artists employed by *MAD* are freelancers who, like Al, work at home in their studios in what feels more like solitary than hilarity. It is *MAD* magazine itself that colludes in creating the false impression of bonhomie by referring to their contributors as "Madmen" and "the usual gang of idiots."

Al had been hoping for a family, but what he got was "a family at arm's length. *MAD* wasn't that cozy. I almost never went out after work with any of them. We didn't get into each other's lives all that much."

There wasn't a lot of love lost at *MAD* between the paid staff and the freelancers. "Those on salary were the nobility. The rest of us were second-class citizens who brought our little offerings to them. We freelancers were dispensable. We were only as good as the last thing we brought in. That attitude was very clear to every one of us who worked for *MAD*. The staff sought and wanted our work; they tried to keep everyone employed, but working freelance for *MAD* was still like a shape-up. We were the longshoremen at the dock waiting for a day's work. No one was nasty to us. Bill liked to regard us as a family, but we were the poor cousins. It was a two-class system. They were the power; we were the peons."

Just as *MAD* readers liked to imagine *MAD* writers and artists horsing around in the *MAD* offices, they imagined that the famous annual *MAD* trips were wild bacchanals. They weren't. In fact, Al considers them maddeningly tame—"a lot of sightseeing, food, wine, adolescent humor—and no bordellos."

After each trip, to show their gratitude to Gaines, the freelancers presented him with a souvenir album filled with photos and cartoons. "We were in Russia before glasnost. People were coming up to us in the street, offering to buy our clothing. I was wearing Pierre Cardin shoes that I'd bought on Madison Avenue. This guy sidles up

to me and offers me—I don't remember—let's say one hundred rubles for them. Bill was a known slob. He was grossly overweight, and he didn't care about clothing. My contribution to the album was a cartoon in which Russians offer to buy our clothes, but the one who approaches Bill offers to sell Gaines *his* clothes.

Over Al's fifty-five-year association with *MAD,* it seems that no aspect of American culture has escaped his merry but jaundiced eye. "I've wandered all over the field." The late Charles "Sparky" Schulz, creator of *Peanuts,* put it plainly and definitively: "Al Jaffee can cartoon anything."

Al doesn't think of himself as a political cartoonist, but upon occasion his offended liberal feelings assert themselves. Al cannot abide fanatics. "A true believer is a danger to humanity." Jesse Helms, the one-time ultraconservative senator from North Carolina, Al's signature target, turned up frequently in Al's cartoon crowd scenes, doing something reprehensible. "My secret passion would have been to be an editorial cartoonist. You get to vent your spleen." Many of his fold-ins are origami-style editorials.

During the Vietnam War, Al created a short-lived gag cartoon called *Hawks and Doves* in which Private Doves, an Inferior Man in army clothing, consistently outwits Major Hawks by contriving, in the last frame of each cartoon, to incorporate peace signs into whatever

activity he's been assigned—such as cleaning the major's windows or mowing the parade-ground lawn. "The cartoon was kind of simpleminded, but if I say so myself, immodestly, it was the visual novelty, a departure from *MAD*'s usual kind of humor, that made it work."

The sight of a chest full of medals on a military man puts Al in a ranting mood. "I hated the Vietnam War. And then on top of it, to pour acid into an open wound, you've got these fucking generals and colonels coming home from the war and they have the temerity to fill their chests with medals announcing how wonderful war is

GIVIN' 'EM A RIBBIN' DEPT.

Why restrict the awarding of medals to the military? After all, Civilians perform heroic acts while fighting life's daily battles as well! Let's recognize them with

THIS ISSUE'S PROPOSED
MAD MEDALS
... TO BE PRESENTED TO DESERVING DOCTORS

THE MISSING FORCEPS MEDAL

Awarded to Doctors who successfully pass on to their patients the higher costs of Malpractice Insurance while in no way attempting to cut down on the causes of these increased costs, mainly greed and actual malpractice.

THE FULL CALENDAR CITATION

Goes to Doctors who demonstrate the efficiency and diligence necessary to see an unbelievable amount of patients per hour in their offices and on their hospital walk-throughs while managing to collect full fee charges for each.

THE LITTLE GREEN PILL MEDAL

For prescribing without conscience or trepidation certain extremely expensive name-brand drugs, thus insuring both warm and lasting relationships with pharmacists, and rewarding free vacation trips from drug companies.

THE GOLDEN SCALPEL AWARD

Awarded to Doctors who have performed surgery above and beyond the call of necessity. These procedures involve the removal of patients' appendixes, tonsils, gall bladders, ovaries, etc., whether they needed to be or not! The motto inscribed on the reverse side of the medal reads, "A removed organ can never become a really diseased organ!"

THE A.M.A. MEDAL OF HONOR

This decoration represents the medical profession's highest award ... and can only be presented to those doctors who distinguish themselves with an unbroken record of heroically fighting the battle against Socialized Medicine, Public Health Care, lower fees, and any other profit-cutting ideas that lawmakers and do-gooders periodically come up with. 19

ARTIST & WRITER: AL JAFFEE

and how many people they killed." Al's anger was explosive, but his satiric response was sly and subtle, like a stone hidden in a snowball. "If soldiers are awarded medals for valor, why not award satiric medals to civilian heroes like teachers, doctors, and corporate executives? And why not more than one medal to each profession?" To honor doctors, Al painstakingly crafted, among others, the Missing Forceps Medal, the Golden Scalpel Award, and the A.M.A. Medal of

Honor for "heroically fighting the battle against Socialized Medicine, Public Health Care, [and] lower fees."

If "Why not?" is the question that ignites in Al a creative and lucrative chain reaction, "Why don't they?" is the springboard that launches him into the wild, blue yonder of mad invention. It's true that Al can and does cartoon anything, but he understates the case when he says, "I tend to be *MAD*'s inventor and product satirist. It's an easy angle for me, and I love the engineering of it." So far, in addition to those that have appeared in *MAD*, there's a bookful of originals, *Al Jaffee's MAD Inventions.*

Al is convinced that no matter how you put it together, life doesn't work, which is why he likes to invent things that look as if they'll work but don't. Pet peeves are his inspiration. "I've heard people say 'Why don't they' so many times in so many situations. You're sitting on a bus and somebody will say, 'Why don't they have the people get on in front and get off in the back?'" By Al's standards, that's too tame and practical a solution. It might even work, which to Al's way of comical thinking would not be funny.

HOT HAND HANDBAG

BREAKAWAY HANDLE
POWERFUL BATTERIES
HEATING COILS

Bag is completely wired with heating coils. Powerful batteries are concealed in its bottom. When bag is grabbed, handle breaks away causing short circuit. Bag instantly reaches 300 degrees Fahrenheit, searing flesh off miscreant's hands.

More to his absurdist inventive fancy is a pet-powered energy-generation system in which a dog, chained to a pole, chases a stuffed cat in circles on the lawn, thereby producing the energy to meet the home owner's needs. Why don't they make a pocketbook wired with heating coils to foil purse snatchers? Why not a Rube Goldberg–ish extra-knot-finger contraption that holds down the knot, thereby allowing you to use your two hands to tie up the package, or a window rigged with a powerful yokelike gripping device that holds the intruding burglar tight? Al doesn't want to solve the problem, he wants to over-solve it. It's in the overkill that fun and satire reside.

COMPLETELY SELF-CONTAINED ASHTRAY FILTER SYSTEM

This compact and effective device runs on batteries or house current, and will draw smoke from as far as twenty feet away. Can also be used as ordinary air-cleaner for pollen dust, etc.

SMOKE SUCKED INTO ASH TRAY

SUCTION FAN

CHARCOAL AIR PURIFIERS

BATTERY

PURIFIED AIR EXHAUSTED HERE

ASHES COMPARTMENT

REMOVABLE BOTTOM FOR CLEANING AND BATTERY REPLACEMENT

Sometimes Jaffee's so-called patently absurd inventions have inadvertently crossed over the line between fantasy and patentable reality. This is not surprising, since Al believes that the most effective satire gets so close to the real thing that they are virtually inseparable. "A lot of inventions that have actually been produced looked ridiculous when I did them. They were bizarre when I thought of them, but they aren't bizarre anymore." In 1976 he invented an ashtray that sucked up and then filtered the captured smoke. A patent for a smokeless ashtray was issued in 1994. A hand-powered, rotating four-bladed razor was satire to Jaffee when he invented it in the late seventies. In 1998, the triple-bladed Mach 3 looked like a really good idea to Gillette. (Gillette has since gone on to parody itself with the five-bladed Fusion.) What seemed to Al to be one of his maddest inventions, a Ferris wheel parking garage that was part of a 1977 *MAD* article about solutions to big-city parking problems, was proposed for the city of Providence, Rhode Island, in 2008.

Al made satiric mincemeat out of the puzzle pages that appeared in popular children's workbooks. In Al's perverse version of the classic needle in the haystack, the reader examines the drawing of the haystack but cannot find the needle. The reader turns the page upside down to find the answer. "Couldn't find it? Boy, are you blind. This is not a haystack! It's a big pile of needles!"

The puzzle pages, in turn, gave Al the idea for the sometimes grisly *MAD Book of Magic and Other Dirty Tricks,* in which a magician

THE MULTIBLADE RAZOR

SELF-ADJUSTING
HINGED BLADES

The Multiblade Razor will be created especially for people with special skin problems. Anyone who's ever shaved with an ordinary razor and lopped off pimples, boils and other parts of their uneven face will welcome it. Dozens of tiny hinged blades adjust themselves to user's craggy, bumpy face.

RAZOR HEAD

BOIL | WHISKER | KNIFE SLASH | PIMPLE
POCK MARK | GROWTH | WART | YECCH

SKIN SURFACE

FRONT AND SIDE VIEWS OF UNEVEN SKIN SURFACES SHOWING
HOW SELF-ADJUSTING BLADES HANDLE THESE TOUGH PROBLEMS

THE AUTOMATED FERRIS WHEEL RAPID PARKING FACILITY

ENTRANCE
CONSOLE

ENTRANCE
"A"

EXIT
"B"

EXIT
CONSOLE

Occupying the space of only six surface-parked cars, the Automated Ferris Wheel Rapid Parking Facility provides parking for twenty-four cars, and its operation is fast and simple. Driver enters at "A" and takes a Computer Punchcard from Entrance Console. This instantly brings an empty space down to him. He parks and leaves. Elapsed time: 30 seconds. To retrieve car, he goes to "B" and inserts Punchcard with proper coins into Exit Console. The Ferris Wheel spins car to him and he drives off. Elapsed time: 30 seconds.

swallows a hand grenade with predictable results, or gets blood from a stone by concealing glass shards in the hand that's squeezing the stone. ("Remember to inform the stage manager of your blood type before each and every performance.")

Of all the thousands of cartoons Al has produced, the one he enjoys the most is the retching jackal, drawn to accompany a piece about the rare discovery of the animal, written by Larry Siegel for the *National Perspirer, MAD*'s parody of the *National Enquirer,* a tabloid still notorious for reporting Elvis and Bigfoot sightings. Al might have drawn the jackal heaving over a cliff or spewing out on all fours, but instead he chose to anthropomorphize the jackal and drew him standing on his two hind legs, leaning against a tree, exhausted and teary-eyed from his ordeal. One paw hangs on for dear life to a tree branch, the other rests on his belly. The vomited contents of his stomach lie in a puddle on the ground. Look closely and one can detect, among the gastric detritus, a chicken bone, a severed finger, and the jackal's false teeth. Look again

to enjoy a classic Jaffee double take—a tiny mouse running from the deluge toward the edge of the panel, holding a leaf over his head.

"Every once in a while I have an inspired moment. It's only a tiny piece of my entire oeuvre, but the jackal stuck. Sometimes I'm introduced as the retching-jackal guy, especially to other cartoonists. Often I don't remember my work, but the retching jackal has always stayed with me. It may be my most successful drawing. It's utterly silly, I know, but I'm utterly silly. I'm eighty-nine years old, and I'm the silliest person in the neighborhood. Serious people my age are dead." If you want to pay Al a compliment, call his humor "sophomoric," "tasteless," "irreverent," or just plain "off-the-wall."

His fellow comic artists have tried to define that certain je ne sais quoi that makes Al's humor unique. *MAD*'s current art director, Sam Viviano, remembers a prototypical Al moment that took place on a *MAD* trip to Zermatt, Switzerland, the site of the Matterhorn, one of the world's most spectacular mountains. The sheer size and jagged beauty of the mountain rendered all of the *MAD*men

FIND THE NEEDLE

WE'VE HIDDEN A *NEEDLE* SOMEWHERE IN THIS **STACK**! CAN YOU FIND IT? LET'S SEE HOW **SHARP** YOU ARE!

ANSWER: COULDN'T FIND IT? BOY, ARE YOU BLIND! THIS IS NOT A *HAYSTACK*; IT'S A BIG *PILE OF NEEDLES*; NOW DON'T YOU FEEL LIKE A DUMB STUPID IDIOT!

THE CORPUSCULAR "BLOOD FROM A STONE" TRICK

Produce an ordinary stone and let your audience examine it. After they are convinced it is genuine, tell them you intend to squeeze it until blood flows. To their utter astonishment, and disgust, you proceed to cover the stage with blood.

Ordinary stone

HOW THE TRICK IS DONE

Any idiot knows you can't get blood from a stone. If you've heard that once, you've heard it a dozen times. But did you ever hear anyone say, "You can't get blood from a magician...?" That's why they'll never suspect you did it with a quantity of broken glass shards concealed in your hand.

Caution: Remember to inform the Stage Manager of your blood type before each and every performance.

News Photo Of The Week

In keeping with our policy of presenting our readers with all the vital news in these troubled times, here is an exciting photograph of a jackal retching.

speechless, except Al, who enthusiastically flung his arms outward as if to embrace the scene and pronounced, "Only in America."

Al's particular brand of hu-mor reminds Arnold Roth of a joke. "A friend takes Henny Youngman to see *Swan Lake*. Youngman had never been to a ballet before, and when the ballerinas come out *en pointe,* Youngman leans toward his friend and says, 'You'd think they'd just get taller girls.' Al's humor is just like that. Ridiculous. He sees common sense and then he skews it. That's the essence of his sense of play."

AL WAS BUSY FREELANCING for *MAD* and turning out *Tall Tales* when, in 1963, he received a frantic phone call from the former family patriarch, Uncle Harry. He had been calling Al's father, but Morris wasn't answering his phone. Al and his brother Harry drove in from Babylon to their father's Rego Park apartment. Apparently, Uncle Harry had alerted David as well. David arrived before Al and Harry to find his father on the floor, dead of an apparent heart attack. He

was seventy-three years old. "As we were heading for my father's apartment door, David emerged in tears and told us.

"I dealt with my father's death the way I dealt with every disaster in my life. The first thing that came into my mind was 'What do I do now?' I shifted into operational mode. I called Uncle Harry and told him the news. He advised me to call the police. Then I negotiated the funeral and, in spite of my reluctance for confrontation, almost bit the casket salesman's head off when he suggested the gilded, top-of-the-line moveable mausoleum. I told him I'd leave my father with him permanently if he didn't come up with a no-frills casket to match my father's no-frills life. A simple pine box was provided.

"I don't have time in a crisis to beat my chest and go 'Woe is me.' I have to take care of the situation. I keep my emotional reactions inside."

Al's "inside reaction" to his father's death took the form of a dream. "After the funeral was over, my father came to me in a vivid dream. He was covered with dirt. 'Look what they've done to me,' he said. The dream was so clear. He wanted me to help him, and I couldn't."

In 1964, Al Jaffee invented the masterpiece for which he won a National Cartoonists Society award in 1972. Al Jaffee's *MAD* fold-ins, all (so far) 412 of them, have appeared in *MAD* from 1964 to the present day. Almost every issue of the magazine has included one. Ultimately, the Al Jaffee fold-in would distinguish him to the point of defining him, just as surely as Rube Goldberg's contraptions defined him.

The sixties were the heyday of glossy magazines. Foldouts were trendy. All the magazines Al subscribed to—*Playboy, Sports Illustrated, National Geographic,* and *Life*—had them. As he folded out the nude women in *Playboy* and the wild African animals in *National Geographic,* he was thinking. "*MAD* is so cheesy compared to all of these magazines, yet *MAD* ought to do something about this new publication phenomenon. What kind of a twist can I put on the foldout?

"It's almost as if there's a little buzzer in my head that goes off when I'm looking for something. The buzzer says, 'How about a

foldout-foldout-foldout, one that goes on for twelve feet?'" He imme-
diately rejected the idea of satire-by-exaggeration as impractical.
Then he heard another inner voice say, 'If I can't do foldouts, how
about fold-ins? *MAD* could do a cheesy black-and-white fold-in.' I
don't know where the idea came from, but ideas come when I'm
looking for them."

Ever since graduating from high school, Al feared that while he
was skilled at many artistic disciplines, he wasn't outstandingly good
at any one in particular. His judgment turned out to be half true. In
the judgment of his peers, he is good at a lot of things, and in par-
ticular, he is outstandingly good at the fold-in. "The fold-ins drew
me to Al," says Arnold Roth. "His mind works well with concrete
construction and composition. Not all artists have that ability. He
can see order in chaos. He sees behaviors; he sees cause and
effect."

For his first fold-in, in the April 1964 issue of *MAD,* Al chose the
hot news of the day, the affair between Richard Burton and Eliza-
beth Taylor. "There were dotted lines showing the reader where and
how to fold the page, which kind of gave away the gag, but we knew
we were onto something.

"Nine out of ten times even aficionados can't guess the fold-in. I
work very hard to misguide them. Black and white has fewer limita-
tions than color. Suppose a woman's dress has to turn into an uphol-
stered chair. With black and white, it's no problem." But when Al
has to do it in color, he's multiply challenged because both women
have to be wearing the same-colored dress in order to form an
upholstered chair. This means he needs to have a lot else going on
to divert the eye. When Gaines asked Al how he'd feel about doing
the fold-in in color, Al jokingly replied that he'd throw himself out
the window. "It presented a new challenge, but it didn't cause me
even the slightest hitch. I've had to leave old worlds and go into new
worlds before." It also didn't hurt that Gaines offered him three
times the money to do a color fold-in. Al was thrilled until he real-
ized that color took three times the work.

People who are interested in the fold-in invariably want to know
which he does first, the full-page image or the folded image. The
answer is the folded image; Al works backward. "I carefully draw

the folded image and then cut it down the middle and separate the two halves. Then I try to fill in the center so that it becomes a cohesive whole. It's pretty elementary," Al says with the same easy confidence that Sherlock Holmes displayed to Watson, but he "sweated" the first two hundred or so.

First he has to have an idea. What does the zeitgeist have to offer? A presidential election? A war? The gay rights movement? A resurgence in Mafia activity? In April of 1969, for two unrelated reasons, Al chose to depict Snoopy, Lucy, and Charlie Brown. First, he wanted to make a satiric commentary on a new cultural phenomenon that everyone was talking about—nonrepresentational modern art. He also intended the fold-in to be an homage to Charles Schulz and his extremely popular *Peanuts* cartoon. (It was so popular that *MAD* satirized *Peanuts* a number of times. "Happiness is a warm puppy" was curdled into "Misery is a cold hot dog.")

The artists at *MAD,* including Al, were contemptuous of the stripes and squiggles that were earning millions for abstract artists. Roy Lichtenstein's cartoon portraits really annoyed them. The way Al says it, "Lichtenstein was doing what all of us at *MAD* were proficient at doing." And he was getting a lot more adulation and money. But Al knew he had allies among bewildered museumgoers who were standing in front of Mirós and whispering, "This is art? I've got a drawing on my refrigerator done by a four-year-old that's as good as that."

Al had his idea. The fold-in would ask the reader, "Which American artist is most successfully communicating with his audience?" Under the folded-in image of the *Peanuts* gang, the answer would read, "Good Grief."

"I can always make the words work. The English language has so much leeway. Trying to figure out word character counts on a typewriter was a nightmare, but with the advent of the computer, the job is simpler. Still, it's a huge puzzle. On the left you had half of what the final response would be, and on the right you had the other half, and what you're filling in between has to relate to the picture you're looking at, but that's not all—it has to disappear after you fold it. If the letters run too long, I look for shorter synonyms. But then you have a double problem. When you read the full paragraph

WHICH MODERN ARTIST IS MOST SUCCESSFULLY COMMUNICATING WITH HIS AUDIENCE?

HERE WE GO WITH ANOTHER RIDICULOUS **MAD FOLD-IN**

"Modern Art" has taken some pretty wild turns in recent years. But no matter which direction it takes, it seems to be headed more and more toward total incomprehensibility. Reactions like "What is it?" and "What does it mean?" are almost guaranteed. But there is one modern artist whose work is understood by everyone! To find out who this phenomenal genius is, fold page in as shown.

FOLD PAGE OVER LIKE THIS!

A▶ FOLD THIS SECTION OVER LEFT ◀B FOLD BACK SO "A" MEETS "B"

MANY MODERN ARTISTS HAVE LONG FELT THAT GREAT ART NEED NOT NECESSARILY BE UNDERSTOOD BY THE GENERAL PUBLIC, AND SOME HIDEOUS GROTESQUERIES HAVE BEEN CREATED IN THIS BELIEF!

ARTIST & WRITER: AL JAFFEE

A▶ ◀B

under the big picture, it has to pertain both to the full-page image and, after it's folded, to the folded image and the answer. They can't be separated. The whole thing has to work together. Shiite Muslims relax by flagellating themselves. I do fold-ins."

The art is harder, although that wasn't the case with the *Peanuts* fold-in. Al imagined half a Lucy, half a Charlie Brown, and half a Snoopy. But what was he going to do in the middle to

WHICH MODERN ARTIST IS MOST SUCCESSFULLY COMMUNICATING WITH HIS AUDIENCE?

FOLD PAGE OVER LIKE THIS!

A ▶◀ B FOLD BACK SO "A" MEETS "B"

ARTIST & WRITER:
AL JAFFEE

GOOD

GRIEF!

A ▶◀ B

connote contemporary art? Could he make a Roy Lichtenstein or a Picasso out of *Peanuts* characters? Pollock was definitely out—too drippy. Al lightened his engineering burden by deciding to draw his own legitimate-looking piece of contemporary art.

Start to finish, Al works on a fold-in for at least two weeks. He makes a lot of preliminary sketches on tracing paper until he is satisfied that he's surmounted his greatest challenge—fooling the reader's eye. In the instance of the *Peanuts* fold-in, the biggest challenge was hiding such familiar characters. "If you have any imagination, you should be able to put it together mentally, but when I look at it years later, even I can't do it on the first take."

After Al has finalized an idea, he transfers the pictures to a two-ply illustration board that measures fifteen by twenty-four inches and is about an eighth of an inch thick so that it cannot buckle or shrink. "The board has its advantages in that nothing can become misaligned, but the disadvantage is that I can't see what it will look like when the finished product is folded." Like everybody else, Al has to wait to test his fold-in until he gets his copy of *MAD*.

Unlike the fold-in, the inspiration for "Snappy Answers to Stupid Questions" came from a personal experience. Writers and artists are often asked, "Where do you get your ideas?" It's a question they can rarely answer, since ideas usually spring from an

accidental, split-second union between the chaotic stimuli of the outside world and the artist's ever-searching subconscious. But in the case of "Snappy Answers," Al can identify the eureka moment. "Ruth and I were living in Babylon. A storm had bent over the TV antenna that was attached to the chimney. I have a terrible fear of heights, but I decided I had to fix the antenna, so I borrowed an extension ladder and tremulously climbed it, rung by rung, until I got to the roof. I'm balancing on the top rung of the ladder and I'm

clinging to the chimney with one hand and with the other I'm try-ing to straighten out the antenna. While I'm doing this, I hear foot-steps on the ladder behind me. I'm too terrified to turn around to see who it is. I'm holding on to the chimney and the antenna, and I can't move. The footsteps get closer and closer, and I can sense that there's someone right behind me. Then a voice says, 'Where's Mom?' and I answer, without missing a beat, 'I have killed her and I am try-ing to stuff her down the chimney.' "

Once Al got over feeling guilty about terrifying his son, he played around with the title—should it be "Smart Answers" or "Clever Answers"—until he settled upon "Snappy Answers." When he took the cartoon to *MAD*, Feldstein made a major contribution to the idea by suggesting that there ought to be more than one snappy answer. Then Jaffee suggested a blank space where the readers could fill in their own answers, and the concept was com-plete.

Charmingly hostile "Snappy Answers to Stupid Questions" was Al's way of getting back at everyone who had ever put him down, beaten him, starved him, neglected him, abandoned him, or hit him on the head with a log. "Oppressed people resort to humor. They can't afford to get angry." His weapon was ridicule, not rage. "I learned to suffer fools. There is anger and violence in my humor, but I package it entertainingly. I'm not exactly your Avon lady."

When the going gets rough in the real world, Al just slips into something more comfortable, like a cartoon. "You can't vent your hostility in real life. You give that kind of a wiseass answer to some-body, and they'll say, 'Screw you,' and walk away. Nobody's going to stand around and take it—but in a cartoon I can capture and freeze the moment. We've all had to be polite when we'd like not to be." Al himself cringed with compassion when a Madison Avenue bus driver was rude to an old lady who had asked redundantly if the bus goes up Madison Avenue. "You can't do satire without doing hostility. There's no such thing as constructive satire."

Once Al gets a good idea, he plays it for all it's worth. "Snappy Answers to Stupid Questions" was supposed to be a one-shot car-toon but after several appeared in *MAD* and were greeted with reader enthusiasm, Al saw the possibility of a book and then more

books of "Snappy Answers"—*More Snappy Answers to Stupid Questions, Still More Snappy Answers to Stupid Questions, Good Lord! Not Another Book of Snappy Answers to Stupid Questions,* and so forth. "The universal appeal of 'Snappy Answers,' " says Arnold Roth, "is that we all live that moment eighty times a day."

Ultimately there were eight books of "Snappy Answers," all containing cartoons that had never appeared in *MAD*. The first two sold more than two million copies. Six more were published at two-year intervals for a total of eight books. In all, Al has more than sixty paperback and hardcover books to his credit, including a four-volume boxed set of his fold-ins, due to be published in Spring 2011.

Inspired by the amortizing of "Snappy Answers," Al saw a way to eat his cake—enjoy the freedom of the freelance life—and still have the steady income of a salaried man. "I can't come up with blockbuster ideas all the time, so I cheat by repeating myself." Al used and reused another idea—"Don't You Hate?"—in the pages of *MAD*, starting with *The MAD Hate Book*. He followed up with *The MAD Car Owners Hate Book* and then *The MAD Christmas Hate Book*. In captions that simmer with adolescent wiseass disdain, Al asks his readers, "Don't you hate meatheads who let other people in ahead of them in line, dentists with hairy arms, fat slobs who go back and forth to their theater seats?" No one is spared. "Don't you hate," he asks in the last panel, "magazines that print articles like this?" Al's

THE MAD CHRISTMAS HATE BOOK

ARTIST & WRITER: AL JAFFEE

DON'T YOU HATE...

... having to explain all the Santa Clauses to your 5-year-old.

DON'T YOU HATE...

... having the smallest feet in the family.

motivation was more pragmatic than creative. "I always tried to think of as many themes and variations as I could so that I could get as many pages as possible; the more pages, the more money."

JUST WHEN AL was riding high professionally, his income and reputation buoyed by the success of the fold-in and "Snappy Answers," his personal life hit an all-time low. Just before Christmas 1966, after twenty-one years of marriage and two children, Al and Ruth separated. Ruth instigated the separation, but the marriage had been "cold" for years. Both had resisted divorce—Ruth because of the children and Al because he didn't think he could tolerate another separation.

"I was in a deep depression. I had not had any intimate relationships before Ruth. I didn't know how to reconstitute my life." To help fill up his lonely evenings and to energize himself by rising to the challenge of something new and different, he took a yearlong course in conversational French at the Alliance Française. He also sought the help of a psychiatrist, who gave him a pep talk. "You're a desirable male, you're interesting, your profession is interesting. You are going to find a whole new world." Eventually and reluctantly, Al did.

At the MAD Christmas party that year Al peeked into his envelope and a check for ten thousand dollars—three times his usual generous bonus—winked back. Some months later, Gaines invited himself to accompany Al on his quickie Mexican divorce, involving visits to lawyers and bars in El Paso and Tijuana. Two New York Jews with beards did not go over well in a saloon in El Paso. After overhearing a menacingly anti-Semitic remark coming from the direction of the bar, the two abandoned their drinks and left quietly.

After the divorce, John Putnam, the art director, concerned about Al working at home in isolation, suggested that Gaines offer Al studio space in the MAD offices. "My MAD family came through for me. They recognized my travails, and they took me in."

The move to the MAD office was good for Al's depleted spirits, his professional productivity, and his social life. It was also good for MAD. Because he was in the office, he was able to make extra money when last-minute projects presented themselves. Jerry DeFuccio

asked Al to join him and his dates at restaurants. Harvey and Adele Kurtzman invited him to their dinner parties and to hang out with them on what would otherwise have been long, lonely Sundays. Bill Gaines's wife, Nancy, invited Al to their mansion in Oyster Bay to join other guests for lavish weekends of food and drink. "What comes naturally to me," says Al, "is making jokes. I have a drink or two and I can be a bon vivant."

Gaines rarely showed up at the Oyster Bay parties. "He didn't drink at the time, although later he became an oenophile. Is that the right word? I don't mean to suggest that he was a masturbator—I mean a wine lover. He wasn't at Oyster Bay a lot because his marriage was deteriorating, as did almost all the *MAD* marriages. Lenny Brenner got divorced. John Putnam got divorced. Nick Meglin got divorced. Don Martin got divorced. Al Feldstein got divorced. Jaffee got divorced. Jerry DeFuccio was never married; otherwise he would have gotten divorced, too."

Al's brother Harry was profoundly distressed by the divorce. "What will become of me?" Harry asked when Al sold the house in Babylon and moved to a bachelor pad in Manhattan. Harry went back to the Village, where he rented a room in a seedy hotel.

Harry's fear of losing the relative mental stability he had enjoyed while living with Ruth and Al was justified. It wasn't long before Al received a frantic call. Harry had been mugged while trying to stop a gang of black men from attacking a white man over a drug deal. They turned on Harry, who had pulled out a heavy chain he always carried for self-protection.

"So now he's Mr. Nuclear Armaments, strutting around the Village. Of course they grabbed the chain and started beating the hell out of Harry. The chain made him brave, in the same way that he believed the toy gun he carried in Zarasai protected him from the wolves. He had such demons in his head! He continually endangered his own life because of his twisted amulet syndrome.

"I took him to live in my apartment on West One Hundredth Street across from Central Park to keep him safe, even though it wreaked havoc with my bachelor life. The next time I went to the *MAD* offices, I remember telling the guys, 'I may be Ruth-less, but I'm not un-Harry-ed.' I was desperate to get rid of Harry."

AL JAFFEE'S MAD LIFE

Separation and death continued to stalk the star-crossed Jaffee family. In 1967, David's heart gave out; he was forty years old. David, the baby and his mother's pet, had contracted rheumatic fever in Zarasai. The resulting faulty heart valve threatened his life every winter. The medical team at Montefiore Medical Center recommended open-heart surgery and reassured David and his family that he was a good candidate, since he was otherwise healthy.

David wanted to talk with Al before making up his mind about surgery, and Al encouraged David to have the operation, telling him that it was his chance at a normal life, that one of these annual attacks was bound to kill him. Al rounded up all the members of the family to give blood in case David needed a transfusion during the surgery. Then he sat all day at the hospital with his cousin Sonie anxiously awaiting some word from the doctors. After twelve hours he was allowed in to see his brother. What he saw was a nearly dead man being worked on frantically by surgeons. "Go home," they said. "We'll keep working on him."

"When I got home, I got the call that he had died. The heart pump failed during the operation, and the hospital had no backup pump. They asked me to go to the morgue and identify his body. I called my brother Harry and asked him to do it. I couldn't do any more. I went home, got into bed, and collapsed in tears. I was furious with the hospital for botching it. I was sobbing for my poor brother. After his death, David's family dropped me; I became a pariah. I've only cried two times in my adult life: when Harry was taken away by the police to Bellevue and when David died.

"Living with Harry was becoming increasingly difficult. I needed to change the situation, but I couldn't just dump him. He was totally without means, and I couldn't let him become a homeless person. If I had been near a circus where they needed a human cannonball, I would have volunteered Harry for the job.

"Then fortune smiled upon me." Al's agent told him about an available one-bedroom apartment in her building in midtown Manhattan on Fifty-sixth Street, where Al lives to this day, which meant that Al could have a private life and wouldn't have to take subways to get to *MAD*'s offices. Then, by greasing the palm of a superintendent in a building just two blocks away—an uncharacteristic act that

207

further demonstrated Al's desperation—he secured an apartment for his brother, which would serve as both a residence for Harry and a studio for Al. Al paid the rent on both apartments.

From 1970 to 1977, Harry assisted Al with his work for *MAD* and Al paid him a salary. Harry, who couldn't draw a funny face or figure, had an outstanding talent for detail. The brothers complemented each other; Harry loved to do everything that Al was either terrible at or hated doing, such as complex mechanical drawings, research, and lettering. Harry's talent for lettering was especially useful, since for many years, Al had suffered a slight tremor in his right hand.

Harry was so outstanding that Feldstein took note of his talents and asked him if he'd like to do some original artwork for *MAD*. "Feldstein's invitation brought out the paranoia in Harry. He became furious at the mere suggestion that he would work for a rich tyrant who took advantage of working people. This was during Harry's anti-Jewish phase. He became an anti-Semitic Nazi. He exempted me because he thought of the Jaffees as upper-class. During another period, he wouldn't ride in an elevator with an African American."

One might imagine that collaborating day after day for years, with plenty of time to talk, would have brought the brothers closer together, but it didn't. Now and then, in an effort to rekindle their lost intimacy, Al would talk about their childhoods in Zarasai, how they made fishing poles, begged scraps of glass from the glazier for their lanterns, and played in the lake. Harry would join in for a few moments, and then his paranoia would reassert itself.

"Harry was living in a world I couldn't conceive of. I was dealing with a person whose aims in life and lifestyle were diametrically opposed to mine. If I said, 'Harry, why don't you let me buy you a suit of clothes,' he'd tear into me with 'You and your fancy clothes. You think you're superior.' It was hard for me to engage him in conversation; most of the time we chatted about things that were not dangerous.

"He idolized our mother; he missed her. He told me that one of the many reasons he married Lenore was that she looked like our mother." Al believes that another of Lenore's attractions was that

she was as passionate about art as their mother had been about religion. To the extent that it was possible to do so in America, Harry replicated his life in Zarasai. He made his own clothes, and he rarely bathed. The Village was as close as he could get to shtetl life.

If Al hadn't fallen in love with Joyce Revenson in 1976, Al and Harry might have gone on working together indefinitely. Al and Joyce had known each other for a long time. When they first met at a party in 1960, it was laughter at first sight. She was twenty-nine years old, the mother of two young girls, and married to an artist, Max Revenson. Al was thirty-nine, still married to Ruth, and living in Babylon. Like Al, Joyce had a rapier wit. Al remembers sharing jokes with Joyce in their hostess's kitchen. "Joyce was very, very attractive—not the Hollywood-beauty type, but beautiful in that she had a lot of character in her face and a beautiful figure."

Still, nothing more than humor passed between them when they met again in 1967, after Max had died and Al and Ruth had just divorced. "I always liked Al," says Joyce. "I loved his wry, satiric sense of humor. He would come up with these wonderful observations that were a step beyond how anyone else would see a situation. It amazes me to this day." "I'm going to diet," Joyce once announced to Al. "What color?" Al responded, without missing a beat. "We made fun together," says Joyce, "but there was no physical attraction at the time."

Their platonic humorous relationship changed radically when they met again in 1976. All of a sudden, the chemistry was there. "Al waits for things to come to him," says Joyce. "He doesn't go after them, or if he does, it takes him months and years to get himself revved up to do it. The females who crossed his path, those were the ones he'd take up with. I happened to recross his path at a time when things were right. Neither of us was dating anyone, and it didn't hurt that by then our children—my daughters, Tracey and Jody, and Al's kids—were all in college or beyond. After that meeting we talked on the phone for hours—and neither of us enjoys talking on the phone. A month later—it was Memorial Day 1976—he took me to Provincetown for a week."

They married in March of the following year. Joyce was "stunned" when he took her out to dinner and proposed, although she had

taken note of the fact that that evening he was, uncharacteristically, wearing a tie. "I didn't think Al would ever want marriage. He has to trust someone all the way. The desertion issue is a big one for him."

Six years earlier, in 1970, a cartoonist friend had introduced Al to the charmingly ramshackle fishing village the natives call "P-town," at the far end of Cape Cod. The village evoked happy memories of Zarasai—the chockablock arrangement of the cottages, many built in the eighteenth century by Yankee and Portuguese settlers, the few remaining dirt roads, and, most of all, the town's setting on the water. "I liked the old-fashioned feeling of the town." Al also liked the fact that the town was full of artists and art galleries. He had been looking for a place to buy ever since his first visit, but it took a passionate week in P-town with Joyce to make the usually cautious Al jump at the chance, just one week later, to buy a one-bedroom apartment on the beach overlooking Provincetown Bay. They have spent every summer in Provincetown for the past thirty-four years, from Memorial Day through Labor Day. Al is a man of steady habits. In the wintertime the Jaffees have vacationed on the same beach in Puerto Vallarta, Mexico, with their Provincetown friends Will and Rhoda Rossmoore, since 1979.

Al has no separate studio in Provincetown, so he sets up his drawing board in a corner of the living room. Just before Memorial Day, they pack their rental car with the few critical items they must transport to their summer home: Al's favorite paintbrushes, some illustration boards for the fold-in, and his collection of houseplants.

The windowsill in Al's New York studio is a small greenhouse. Since he left Babylon, it's as close as he can get to gardening. Al is particularly gifted at cultivating violets, so gifted that he has cloned sixteen plants from fallen violet leaves. "I love to see things grow. When I find seeds lying around on the ground, I feel compelled to find out what's going to come out of them."

His current vegetative triumph is a fifteen-inch-tall stem of a plant that looks suspiciously like marijuana but is, Al believes, on its way to being a tropical tree. He found the seed on the ground in Mexico. Stuck in the same pot is a tiny faux stem with leaves and, where a flower ought to be, the face of *MAD*'s mascot, Alfred E.

Neuman. Nearby, in the intensive-care section of the windowsill, Al continues to tend to a desiccated tropical orchid plant that's been dormant for seven years. "I'm afraid it may have had an orchidectomy," he explains.

Joyce has needed to lay down the law about just how many plants Al can bring with him. "Al used to build elaborate boxes for each of the plants so that nothing would happen to the flowers in the car." Now she permits the orchid, a few violets, and maybe a cactus.

Provincetown is Jaffee's reward for enduring yet another winter in Manhattan. After a subdued nine months living, working, and dressing like an adult in Manhattan, Jaffee, by the time he gets to P-town, is more than ready to let his "bad kid" out. For special occasions he keeps and sometimes even wears a pair of high-topped lace-up boots that might have belonged to Li'l Abner. On the tip of each shiny toe, Al has painted the reflection of a window. "That's a cartoon standard from way back—it's the way Rube Goldberg and Al Capp showed a shine on a shoe."

A few years ago, just for the fun of it, the Al that doesn't want to grow up created life-sized cardboard caricatures of himself and Joyce, which now sit upright against the headboard of their double bed. "That way," Joyce explains, deadpan, "we know which side of the bed to get into.

"There are two Al Jaffees," says Joyce. "One doesn't want to grow up; he wants to remain a little boy. He wants to make light of everything, but the other one, underneath it all, is very serious."

Al tries to be on vacation when he's in Provincetown but with little success. When he was younger, he allowed himself at least some free time each day for fishing and tennis, but no longer. The grip of work keeps him pinned to his drawing board, except for a break for lunch at a restaurant or dinner out with friends. He keeps promising himself that he'll retire, that next summer he won't do any work on the Cape, but he never keeps his promise.

"My ideal day at the Cape is a day I've never had. Somewhere way in the distant past, I hated work. I looked for every possibility to goof off. I hated being tied down. I wanted freedom, the freedom I had in Zarasai. When I came to America, I saw that everything was so rigid, so controlled. At school I had assignments. Then when I

got to the army it was the same thing—more work, more assign-
ments, more duties. And when I got out of the army I got married
and had kids, and that was more work. All this work finally squeezed
out any sense of indulgence that I used to enjoy. Some kind of
meshugge work ethic established itself in me, so that I don't really
enjoy free time anymore. If I'm not working, I'm kind of miserable."
In this post-Freudian era, Al tends to interpret as pathological what
might, in another age, be appreciated as a consuming passion for
his work.

"My obsession is directly related to my lifelong fantasy that as
soon as I finish this damn assignment I'll be free, I won't worry. I'll

blow up an outhouse, I'll swipe some fruit, I'll go down to the lake, I'll build a raft, and I'll just float around."

Yet as much as Al loves Provincetown, feeling more relaxed there than anywhere else, he never quite feels at home. "I have the fear of the outsider who is behaving himself in America. I have a desire not to rock the boat. I envy people who feel comfortable. I envy the people I see in downtown Provincetown who flout the law. There's a sign in front of the Lobster Pot restaurant that says PRIVATE PARK-ING, PLEASE KEEP CLEAR. Invariably somebody's parked there. Some people have the balls to park in an illegal zone in the middle of a resort town, and then yell at the cops for even implying they have no right to park there. A guy who can do that is *home*.

"When Joyce asks me to drop her at the library in downtown Provincetown, where there's never a legal parking place, right away I ask her, 'Do you mind jumping out of the car while it's moving?' Sure, I'm fearful. I see the shlumpy things I do. I'm uneasy ordering food in a restaurant. I'm afraid to spend money. Every once in a while I tell myself, 'Live it up, you're an American.' I don't know what I'm afraid of; maybe that they'll send me back."

WHEN JOYCE AND AL MARRIED in 1977, Harry recognized that his rela-
tionship with Al would change completely. It wasn't just the mar-
riage that sent Harry packing; it was Joyce herself. During her
decade of widowhood, she had transformed herself from a Long
Island housewife and mother into a guitar-playing vocalist with a
folk group and had received a degree from the Columbia University
School of Social Work. It was the fact that Joyce was a social worker,
a profession that was allied, at least in Harry's mind, with psychia-
try, that frightened Harry off. He'd had enough of psychiatrists.
They kept trying to make him take his medication.

Harry had also had enough of Al. In Harry's mind, Al had
become the big boss to his slave laborer. Harry abruptly decided he
no longer wanted to work with Al and went to live in a cheap hotel
nearby. "He had saved practically all the pay I'd given him—he had
three or four thousand dollars in the bank—and he was free as a
bird to wander the streets. It was the right time for him to split and
the right time for me to be free of him. We parted amicably. We
didn't need each other anymore, and we didn't keep in touch."

On Father's Day 1985, Joyce and Al were in bed asleep when the
phone rang. It was Lenore. She'd been calling Harry's number all
day and into the evening. Would Al please go over and seé what was
wrong? It was unlike Harry to be out so late.

Al begged off. "Lenore, I've had a long day, we're in bed, and
I'm not going to go over to Harry's hotel on a wild-goose chase.
Who knows what he's doing?"

Lenore and Marilyn went over themselves and found Harry dead
in his bed. Like his father, he had died of a heart attack, alone. He
was sixty-three years old.

Al was not devastated by Harry's death the way he was by David's.
"His death coincided with the new and exciting life I had started
with Joyce. I had my sights set on life. I had dealt with so many
deaths and separations that I experienced Harry's death as another
split-up. I had been through enough to know that I must deal with
reality. I mourn in my own way. I'm caring, but I'm not sentimental.
Sentimentality gets you nowhere. Hurling yourself onto the casket is
just your latent acting ability coming to the fore. Harry's early death

was inevitable. He didn't trust doctors. He once came up with the notion that eating tremendous amounts of bacon fat is good for you. A year of eating bacon fat three times a day is going to do it.

"It's not as if Harry died suddenly overnight. Harry's demise was a long time building. When you finally get there it's like in a play, when you reach the expected denouement. It's sad. It brings to mind the nice things you did together, but then you say good-bye."

Bernard, aged eighty-five, is Al's only surviving brother. He married a partially deaf woman and had three children. Although he lives in Astoria, in Queens, Al sees him perhaps twice a year. One of Bernard's daughters brings him to Al's apartment. They hug each other with shared, abundant affection, but communication remains a problem that makes their visits mutually frustrating.

Al is proud of Bernard for maintaining a happy, loving disposition and for functioning well in spite of his multiple problems. When he graduated from the New York School for the Deaf, Bernard, along with a deaf companion, traveled all over the country selling sign language cards. Later he took a job in a silk-screening factory. When the fumes from that job made him sick, he tried his hand at art. "He figured that with two artistic brothers he might have some talent, too," says Al. "He didn't. It was kind of touching." Ultimately, Al helped Bernard find a job in a Long Island workshop that had a government grant to hire handicapped people. There Bernard supplemented his income by driving three other handicapped workers to and from work, charging them for the price of gas. "That's something for a man who is as handicapped as he is." Al regards his three brothers as casualties of Europe. "None of us escaped scot-free, but they took a bigger beating."

7

OUR MAN FROM MARS

"You can't go on
forever."

STARTING IN THE EARLY 1960s, *MAD* magazine was bought and sold several times. In 1961, Bill Gaines sold it to Premier Industries. "Gaines called all the freelancers together," says Al, "and assured us that nothing would change. Although he no longer owned the magazine, he would still control it. I put my faith in Gaines—he was 'Big Daddy'—and hoped for the best. My whole life has been about dealing with things over which I had no control."

A few years later, Premier sold *Mad* to National Periodical Publications. Then, in 1969, National Periodicals merged with the Kinney Parking Company, bought Warner Brothers Movies, and changed the name to Warner Communications. In 1989, Warner Communications became Time Warner. Throughout this succession of owners, Gaines was allowed to run the magazine without corporate interference, although Kinney put pressure on him to move *MAD* from its eponymous offices at 485 MADison Avenue to Time Warner's corporate office at 1700 Broadway. Gaines resisted and got his way. "Essentially," says Al, "he told the executives at Time Warner that *MAD* would move over his dead body." Gaines told Al that he was sure that a move to corporate headquarters would be the death knell for *MAD*, that a zany magazine could not thrive in

an atmosphere where corporate suits were always looking over your shoulder.

In 1992, Bill Gaines died, and over his dead body, *MAD* moved to the Time Warner headquarters. "There was a big shake-up. A lot of the people that Gaines kept on out of his sense of loyalty were eased out. I was asked to limit my work to the fold-in and, now and then, a 'Snappy Answers to Stupid Questions.' Our loyal little crew was no more." Then, in 2001, the magazine took another step down the corporate road and, after nearly fifty years, began taking advertising.

Bill Gaines's prediction turned out to be true. The new corporate offices are laid out like an insurance company: not a bit welcoming, not a bit zany, although poster-sized reproductions of *MAD* covers line the walls of all the corridors. Among them is a blast from the past, the first *MAD* magazine cover ever, illustrated then by artist/editor Harvey Kurtzman, which greets visitors as the elevator doors glide open on the fourth floor. Still, Al thinks of the place as a fortress. Security measures initiated after 9/11 have certainly impeded accessibility. "I call in ahead when I want to deliver something and ask them to lower the bridge over the moat," says Al. The old headquarters on Madison Avenue were small, intimate, cluttered, and easygoing. Class trips traipsed through constantly. Kids poked their heads into editorial offices—Gaines's in particular, where a life-sized head of King Kong, fashioned by Sergio Aragones, hung suspended outside his office window. At today's *MAD,* it's the interns, part of a recruiting program initiated by John Ficarra to help keep the magazine razor-sharp and relevant, who poke their heads into editorial offices, sometimes to remind Ficarra that the joke about *Star Wars* won't work. Most of *MAD*'s current readers weren't yet born when that movie was released.

Under the coeditorship of Nick Meglin and John Ficarra—Al Feldstein had retired in 1984—it soon became clear that *MAD* was going to become a different magazine, one that had less of a need for Al Jaffee. The word went out that the suits wanted the magazine to be "edgier" to appeal to a more modern generation as well as an older audience. To Ficarra, this meant less whimsy, less sweet stuff about pets, and no more Mother Goose satires. Those soft days were

over, and with them went a large part of Al's output and income. Television and movie satires—which Al rarely did even in his heyday—would continue to be included in the new *MAD*. Politics would play a much larger role, reflecting Ficarra's personal passion and the 24/7 cable news coverage that has made politics into a form of entertainment and an easy satiric target. "Edgier" also meant more celebrities, whose multiple marriages, divorces, adoptions, drug addictions, and plastic surgeries were the red meat of satire, but Al no longer wanted to keep up with the zeitgeist if it meant having to watch celebrities on TV and read about them in *People*. Most significant, everything in the new *MAD* would be shorter. There would be no more of the seven-page spreads that Al depended upon for his living. "People have shorter attention spans," says Ficarra. "We've deliberately chopped all the articles and made them shorter."

Meglin and Ficarra made another critical change that would cramp Al's style. They didn't want so many repeat features, as with the *MAD Hate Book*s and *More MAD Hate Book*s that appealed to pre- and postadolescent kids in the seventies. "We had gone to this well too many times ourselves," says Ficarra. "We had kept on too many writers we shouldn't have." The new *MAD* would never buy a cartoon in which it is recommended that, instead of hiring babysitters, parents should cover a wall with Velcro, dress their baby in Velcro,

VELCRO PAJAMAS AND SHEETS...
VELCRO

..prevent sleepwalking and falling out of narrow beds.

VELCRO BABY CLOTHES, WALLS AND CARPETS...
VELCRO

...so kids can be safely parked, and kept out of danger.

and stick the kid on the wall. Al didn't disagree. "Today a joke like that would be old-fashioned and silly."

About ten years ago, *MAD* polled its readers. "The biggest shock to us," says Ficarra, "was that the magazine had aged *up*. The average age of our readers was twenty-four; the median age was about sixteen. We learned that we had a two-hump readership. We got kids at about twelve, lost them when they started getting interested in sex and cars, and then picked them up again when they got out of college. Then again, we get some readers at twelve and we never lose them. Harvey Kurtzman, originally inspired by college humor magazines, had aimed for college-age kids at the beginning," says Ficarra, and then *MAD* started to evolve downward toward younger readers.

The fact that kids were reading less and watching TV more was just one of the reasons that *MAD*'s circulation had fallen from its high of more than 2 million in 1974 to 233,408 in 2000. All magazines were seeing their numbers drop precipitously. Another was that under an aging Gaines, the magazine's arteries had hardened. "It didn't change enough editorially," says Ficarra. "Even its look was off. Video games were coming along with their vibrant colors while *MAD*, printed in black and white on cheap paper, looked like it was produced in a third-world country." *MAD* also didn't keep up with what Ficarra feels obliged, but not happy, to acknowledge is the coarsening of society. *MAD* had been kept very "safe."

The new *MAD*'s in-your-face crudity bothers Al. "In the old *MAD*, if you wanted to indicate that someone was passing wind, you would draw wiggly lines behind him. No one would say, 'Is he farting?' Now they do." In the current *MAD*, they use *boobs* and rely on stars (*g*d damn*) to avoid what some might consider blasphemy, or *sh*t* to divert accusations of bad taste.

There are mature, sensitive grown-ups at large today, former *MAD* readers, people who enjoy chamber music and novels by Henry James, who still remember and revere Jaffee's cartoon parody of New York City's pooper-scooper law. "Ever notice how TV commercials handle unpleasant subjects?" he asked his readers in an editorial disclaimer. "Like when they substitute nice clean plastic discs for cruddy

MOBILE REAR COVER PORTABLE POOP CART SNAP-ON TAIL BAG

All of the above "Self-Service Devices" serve the same to roam freely while protecting the enviroment. In each
function, are easy and convenient to use, and permit dogs case, disposable plastic liner is removed and discarded.

false teeth? Well, *MAD* is going to substitute nice clean link sausages for you-know-what. So if you see anything else depicted in this next article, don't blame us for your disgusting imagination." Al would rather use euphemisms, but he concedes that "for each of us, crude is a different thing." One man's euphemism is another man's *sh*t.*

But Al has no real argument with the changes at *MAD.* "They made a legitimate judgment. *MAD* is now soliciting work from underground cartoonists. They've taken on some wonderful new people. That's the way it goes. You can't go on forever.

"I've gone to bar mitzvahs where someone introduces me. 'This is Al Jaffee of *MAD* magazine,' the person says, and the kid says, 'What's that?'" But to his older fans, and to the generation who first discovered him who are now in their fifties and sixties, Al Jaffee's celebrity remains intact and unique. Stephen Colbert celebrated Al's eighty-fifth birthday on *The Colbert Report* with a fold-in birthday cake that featured the message "Al, you have repeatedly shown artistry & care of great credit to your field." When the center of the cake was cut out and the two ends moved together, what was left of the message read "Al, you're old."

"The fold-in and 'Snappy Answers' are evergreen," says Ficarra. "The fold-in is one of the few things we have that requires reader involvement. It's a signature piece for the magazine that nobody else does." While Al is content to fade away as a freelancer for *MAD,* he draws the line at "entirely"; he can't imagine life without what he calls his "fucking fold-ins."

Al used to think up all the ideas for his fold-ins, but that was when he prided himself on his astute reading of the zeitgeist. Today he doesn't really care to stay au courant with pop culture in order to pro-

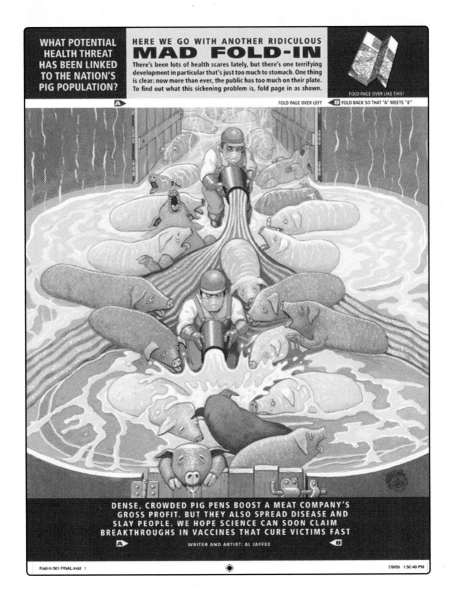

duce relevant fold-ins. "I could," he says, "but I'd rather be irrelevant."
To make up for this deficit, *MAD*'s editorial staff now provides Al with
subjects for his fold-in. Does *MAD* want a swine-flu fold-in in which
some pigs in swill turn into a Denny's Grand Slam Breakfast with sau-
sage, eggs, and bacon? Al, blissfully out of touch with both Denny
and his breakfast, is happy to rise to someone else's occasion. He
doesn't need to own the idea anymore; it's the challenge and the work

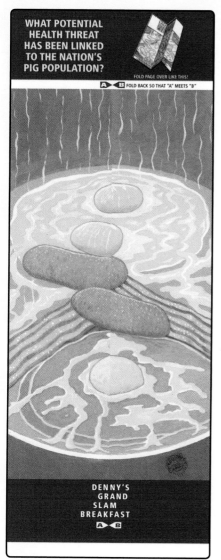

of the fold-in that he loves with an abiding, if ambivalent, passion.

Sam Viviano, who has tried his hand at creating fold-ins, is astounded by the multiple talents and variations Al brings to the endeavor. "He never repeats himself. His well never runs dry. His sense of color is always evolving so that he is finding new and more rascally touches to mislead the reader." At eighty-nine, Al is content to limit his *MAD* work to six fold-ins a year and a "Snappy Answers" or two when the mood moves him.

Not surprisingly, *MAD* is on its way to becoming a zine in cyberspace. For the time being, the magazine depends upon other sites to promote the four issues it publishes each year, but that, according to Ficarra, is merely a transitional move. While *MAD* will continue to publish six print magazines a year for readers who like the traditional format, Ficarra has every intention of going digital. "*MAD* wants to be where the readers are, and the readers are digital. Subscribers will read the magazine online, and it will appear as an app on their iPods."

Ficarra is already thinking about how to digitize a fold-in quickly, when needed for a rapid site positioning. "If we had a great idea for a fold-in," he says, "Al, who is willing to work with technology, could do the heavy lifting, figuring out how to turn, for instance, a drone attack into a kid at the breakfast table eating his cereal." Viviano has worked out the details: "He could overnight it to us, and we would give it to another artist to ink and color on the computer and

get it out in a day. Al does a tremendous amount of noodling that would certainly be lost in this process. I hate to say it, but because of the Internet, expedience is more prized than polish.

"Others have tried," says Viviano, "but no one yet has approached the thrilling and puzzling intricacy of a Jaffee fold-in. Nobody ever will." But should Al prove not to be immortal, Viviano feels certain that the fold-in will live on. "A lot of people have done fold-ins as an homage to Al, but they lose something that Al brings to the fold-in. He has this long history of creating wacky inventions, and the fold-in is a wacky invention. Anything we might do would be in deference to Al and influenced by Al, but a new fold-in artist would put his own mark on his work."

The arc of Al's career has followed the evolution of the magazine. *MAD* and Al arrived on the scene in the 1950s, just as the American notion of childhood was changing radically. When *MAD* started out it was subversive. In retrospect Al sees *MAD*'s life trajectory in human terms. "The magazine was a revolutionary college kid, then it had a pleasant middle age, and now it's a snappier old coot, more representative of our current time."

Due to a coincidence of longevity and talent, Al Jaffee has been with *MAD* magazine longer than anyone, staff or freelancer. He was there nearly from the beginning. In a sense he was there *before* the beginning; Harvey Kurtzman had his eye on Jaffee in high school. One might even say, at least in retrospect, that given his artistic gift, Al's mad childhood seems to have led him inevitably to satire and to *MAD*. For more than fifty years he has spoken to the awkward social outcast and the nerd in every *MAD* reader. He knows their fears. He verifies their suspicions. Adults *are* bluffing. Politicians *are* lying. He, of all people, understands their feelings of alienation. Jaffee is our man from Mars, by way of Lithuania, suspended between two worlds, in a state of plausible impossibility.

His family was broken by the persistent emotional and physical traumas of Zarasai, yet Al survived and thrived. He is held aloft by his own determined good humor and by the perpetual blast of hot air escaping from all the balloons of pomposity he has punctured over his lifetime. Like Bugs Bunny, he, too, has managed to stay aloft all these years by not looking down.

ACKNOWLEDGMENTS

THIS BOOK HAS BEEN a happy collaboration from start to finish, for which we would like to acknowledge our own good natures and decades-long friendship. But we did not work alone. Voices from the distant past in the form of Yiskor Books, the memoirs of Jews who lived in Zarasai at about the same time as Al, have added richness to our story. So have the meticulously detailed unpublished memoirs of Al's brother Harry, portions of which his wife, Lenore, generously shared with us. The Yivo Institute was another source of historical information about Zarasai, but it would have been Hebrew to us, were it not for the translating skills of Rabbi Yehuda Kantor of Connecticut and Tova Lichtman of New York. Reference librarians at the Westport Public Library in Connecticut researched obscure American and European train and boat schedules.

Serendipity, in the form of a chance online encounter, put us in touch with Paul Hattori, a London businessman, cartoon collector, and director of LitvakSIG, Inc., an all-Lithuanian-Jewish data base devoted to family history and genealogy. To add to our good fortune, Mr. Hattori's database specializes in the Zarasai region. He found more Jaffee relatives than Al ever knew he had, and was able to provide us with ships' manifests detailing Al's transatlantic

comings and goings, and with obscure Nazi records that shed light, for the first time, on Mildred Jaffee's fate.

We are also grateful to Danny Fingeroth, comic book writer and editor, for his expertise, and to colorists Ryan Flanders and Doug Thomson. We thank Michael Vassallo for his work unearthing examples of Al's art from his early days at Timely Comics.

We were lucky that our energetic agent, Sandy Dijkstra, loved the proposal at first sight, as did our editor, Mauro DiPreta, whose thoughtful editing made this a better book. Ms. Dijkstra's executive assistant, Elise Capron, was a marvel of courtesy and efficiency, as was HarperCollins associate editor Jennifer Schulkind. We are also indebted to art director Milan Bozic and designer Kate Nichols, both of whom devoted talent and time to the challenging task of integrating art and text.

Al's wife, Joyce, and my husband, Larry, deserve far more than pro forma thanks for their "loving support." There isn't a word or illustration in this book that has escaped their critical attention.

The hyperbolic phrase "there would be no book were it not for so-and-so" is too often lavished upon individuals without whom there would, in fact, have been a book. But in our case, *Al Jaffee's Mad Life* would not be were it not for the insight, encouragement, and non-stop gentle nagging of James Sturm, cartoonist and cofounder of the Center for Cartoon Studies in White River Junction, Vermont. Years ago James read this author's profile of Al Jaffee in *Provincetown Arts* magazine and convinced us that the material was so compelling that it ought to be a book.